GAUGUIN'S VISION

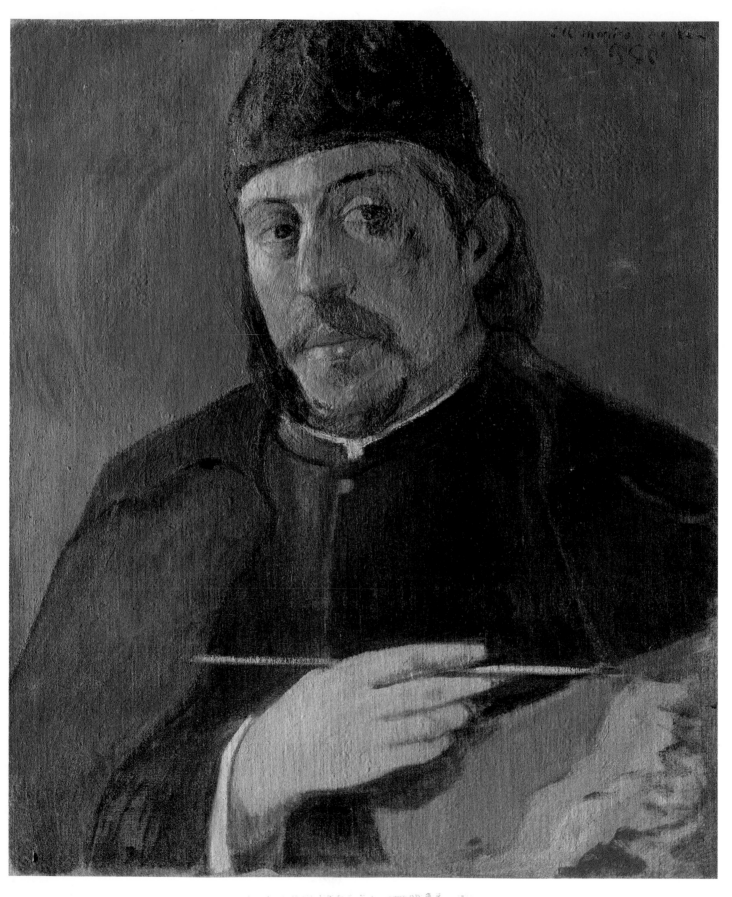

BELINDA THOMSON
with Frances Fowle and Lesley Stevenson

Gauguin's Vision

NATIONAL GALLERIES OF SCOTLAND
EDINBURGH 2005

Published by the Trustees of the National Galleries of Scotland
on the occasion of the exhibition *Gauguin's Vision* held at the
Royal Scottish Academy Building from 6 July to 2 October 2005

ISBN 1 903278 68 6

Designed and typeset in Aldus and Strayhorn by Dalrymple
Printed in Belgium by Die Keure

Front cover: Paul Gauguin, *Vision of the Sermon: Jacob Wrestling
with the Angel*, 1888 (detail)
National Gallery of Scotland, Edinburgh

Frontispiece: Paul Gauguin, *Self-portrait with Palette*, c.1894
Private Collection

Contents

Lenders to the Exhibition

6

Amsterdam, Van Gogh Museum
Boston, Museum of Fine Arts
Brest, Musée des Beaux-Arts
Brest, Collection R.T.
Brussels, Musée Royaux d'Art et d'Histoire
Brussels, Musée Royaux des Beaux-Arts de Belgique
Buffalo, Albright-Knox Art Gallery
Cardiff, National Museums and Galleries of Wales
Copenhagen, Ny Carlsberg Glyptotek
Edinburgh, National Gallery of Scotland
Edinburgh, National Library of Scotland
Edinburgh, National Museums of Scotland
Glasgow, Hunterian Art Gallery
Glasgow, The Burrell Collection
Indianapolis, Museum of Art
Le Havre, Musée Malraux
London, Courtauld Institute of Art Gallery
London, The Fan Museum
London, Collection Waldemar Januszczak
Madrid, Museo Thyssen-Bornemisza
Martigny, Collection Fondation Pierre Gianadda
Montréal, The Museum of Fine Arts

New York, The Metropolitan Museum of Art
Oxford, The Ashmolean Museum
Paris, Brame & Laurenceau
Paris, Galerie Hopkins-Custot
Paris, Galerie Saphir
Paris, Musée du Louvre
Paris, Musée d'Orsay
Paris, Musée Gustave-Moreau
Paris, Musée national des Arts et Traditions populaires
Paris, Petit Palais, Musée des Beaux-Arts de la Ville de Paris
Quimper, Musée des beaux-arts
Quimper, Musée départemental breton
Pont-Aven, Musée de Pont-Aven
Saint-Germain-en-Laye, Musée Départémental Maurice Denis
Senlis, Musée d'Art et d' Archéologie
Tacoma, Tacoma Art Museum
Linda and Mel Teetz
The Netherlands, Triton Foundation
Vienna, Österreichische Galerie Belvedere
Warsaw, National Museum
Washington, National Gallery of Art
and anonymous lenders

Foreword

This exhibition celebrates one of the truly iconic images in the National Gallery of Scotland. Gauguin's *Vision of the Sermon: Jacob Wrestling with the Angel* has been reproduced in countless histories of Western art and is well known throughout the world. It was purchased by the Gallery as early as 1925 for the princely sum of £1,150 from an exhibition mounted that year in Edinburgh by the Society of Eight. At that time it was one of the earliest Impressionist or Post-Impressionist paintings to enter the collection and great credit is due to the director, James Caw, for such an inspired acquisition. Since then, of course, the Gallery has built up, by purchase and bequest, a small but choice holding in this area. *Vision of the Sermon*, however, still has claims to pre-eminence in this field and our exhibition is mounted in celebration of this fact. Wherever possible we endeavour to make the masterpieces in our care the centre of our exhibitions and *Gauguin's Vision* follows on from other such shows on artists as diverse as Bernini, El Greco, Titian and Velázquez, all of whom are represented by superb examples in our collection.

We are fortunate that Edinburgh nurtures a lively and distinguished art-historical community both within and outwith the National Galleries of Scotland. This exhibition has been curated by Belinda Thomson, a freelance art historian resident in the city and an acknowledged authority on Gauguin. We thank her for her expert labours on our behalf and for setting Gauguin's great masterpiece in its proper context. We also extend our gratitude to our colleagues in the National Galleries, Frances Fowle, Leverhulme research curator, and Lesley Stevenson, paintings conservator, both of whom have contributed essays to the accompanying exhibition catalogue. That publication has been expertly seen to press by Janis Adams and designed by Robert Dalrymple. The sympathetic exhibition installation has been created by Jan Newton.

Above all, we thank the many lenders to the exhibition, without whose understanding and generosity such an undertaking would be impossible. And finally, it gives us great pleasure to acknowledge the continuing support of the fund managers Baillie Gifford who have, once again, come to our aid with such generous sponsorship.

SIR TIMOTHY CLIFFORD
Director-General, National Galleries of Scotland

MICHAEL CLARKE
Director, National Gallery of Scotland

Sponsor's Foreword

At Baillie Gifford, a primary aim is to be one of the world's leading investment management firms. We are also proud of our long-standing sponsorship of the arts in Scotland. Thus, we are delighted to be sponsoring the exhibition *Gauguin's Vision*, which focuses on one of the world's great paintings, and brings together works by some of the world's finest artists in a world class venue.

INVESTMENT MANAGERS

Acknowledgements

For lending or facilitating the loan of works to this exhibition the organisers owe an enormous debt of gratitude to John Leighton, Martine Kilburn, Aly Noordermeer, Fieke Pabst, Sara Verboven, Van Gogh Museum, Amsterdam; Kim Pashko, Malcolm Rogers, George Shackelford, Museum of Fine Arts, Boston; Wulf Harzogenrath, Kunsthalle Bremen, Françoise Daniel, Musée des Beaux-Arts de Brest; Anne Cahen-Dalhaye, Alexandra De Poorter, Claire Dumortier, Musées Royaux d'Art et d'Histoire, Brussels; Helena Bussers, Dr. Leen, Musées Royaux des Beaux-Arts, Brussels; Louis Grachos, Laura Fleischmann, Kenneth Wayne, Albright-Knox Gallery, Buffalo; Tim Egan, Oliver Fairclough, Michael Tooby, National Museums and Galleries of Wales, Cardiff; Fleming Friborg, Sidsel Maria Sondergaard, Ny Carlsberg Glyptotek, Copenhagen; John R. Lane, Dallas Museum of Art; Joseph Marshall, Martin Wade, National Library of Scotland, Edinburgh; David Caldwell, Jane Carmichael, Rosalyn Clancy, Gordon Rintoul, Lyn Stevens Wall, Jane Wilkinson, National Museums of Scotland, Edinburgh; Vivien Hamilton, Mark O'Neill, The Burrell Collection, Glasgow; Peter Black, Mungo Campbell, Hunterian Art Gallery, University of Glasgow; Ellen Lee, Rebecca Marshall, Gayle Vlantis, Museum of Fine Arts, Indianapolis; Françoise Daniel, Annette Haudiquet, Musée Malraux, Le Havre; Julia Blanks, James Cuno, Deborah Swallow, Courtauld Institute of Art, London; Helen Alexander, The Fan Museum, London; Ann Dumas, MaryAnne Stevens, Royal Academy, London; Robert Upstone, Tate Britain, London; Tomas Llorens, Guillermo Solana, Foundation Collection Thyssen-Bornemisza, Madrid; Léonard Gianadda, Fondation Pierre Gianadda, Martigny; Guy Cogeval, N. Bondil, The Montreal Museum of Fine Arts; Philippe de Montebello, Colta Ives, Susan Alyson Stein, Gary Tinterow, Jim Voorhies, Frances Redding Wallace, The Metropolitan Museum of Art, New York; Christopher Brown, Colin Harrison, Chezzy Brownen, The Ashmolean Museum, Oxford; Marie-Cécile Forest, Musée Gustave-Moreau, Paris; Catherine Legrand, Arlette Sérullaz, Françoise Viatte, Départment des arts graphiques, Musée du Louvre, Paris; Michel Colardelle, Frédéric Maguet, Musée National des Arts et Traditions Populaires, Paris; Gilles Chazal, Musée des Beaux-Arts de la Ville de Paris, Petit Palais; Serge Lemoine, Dominique Lobstein, Laure de Margery, Caroline Mathieu, Claire Frèches-Thory, Musée d'Orsay, Paris; Corinne Bolou, Catherine Puget, Musée de Pont-Aven; André Cariou, Musée des Beaux-Arts, Quimper; Isabelle Le Bal, Adjointe au Maire, Ville de Quimper; Philippe Le Stum, Margareth Le Guellec-Dabrowska, Catherine Troprès, Musée départemental breton, Quimper; David Liot, Musée des Beaux-Arts, Reims, Frédéric Bigo, Agnès Delannoy, Musée Départemental Maurice Denis, Saint Germain-en-Laye; Bénédicte Ottinger, Musée d'Art et d'Archéologie, Senlis; Janae C. Huber, Patricia McDonnell, Janeanne Upp, Tacoma Art Museum; Gerbert Frodl, Andrea Gausterer, Osterreichische Galerie Belvedere, Vienna; Ferdynand Ruszczyc, National Museum of Warsaw; Philip Conisbee, Earl A Powell II, Alicia Thomas, Elaine Vamos, National Gallery of Art, Washington DC, Eva Afuhs, Museum Bellerive, Zurich

Thanks are also due to Denis and François Lorenceau, Brame & Lorenceau, Paris; Anna Greutzner Robins; Waring Hopkins, Galerie Hopkins-Custot, Paris; Didier Imbert, Paris; Waldemar Januszczak; Simon Keswick; Daniel Malingue, Paris; Eric Wolf-Verdi, Maurana Art Ltd.; Alan Hobart, Pyms Gallery, London; M. Szapiro, Galerie Saphir, Paris; Jonathan Pratt, Sotheby's, London; Charles Moffett, Melissa Doumitt, Sotheby's, New York; Linda and Mel Teetz; Sandra Box, Dr and Mrs Cordia van der Laan, Triton Foundation, The Netherlands; Nick Stogdon; Robert Stoppenbach, Stoppenbach & Delestre, London; Linda and Mel Teetz; William Weston; Ruth Ziegler, New York and the lenders who wish to remain anonymous.

10

A highlight of the research for the exhibition was spending a month in Pont-Aven in June 2004. For offering me this opportunity I would particularly like to thank Caroline Boyle-Turner, Director of the Pont-Aven School of Contemporary Art. Her able colleagues Gwen Pacollet and Chris Cruz made my stay enormous fun, as did working alongside my fellow colleagues Dana Duff; Pam Marks, Brian McFarlane, Robert Reed and Melanie Yazzie; and the students with whom I discussed Gauguin in the Pension Gloanec itself, Emily Ackerman, Jennifer Chu, Sara Douglas, Suzanne Merrell, Ramon Vega, Mike Weller. For assistance with local research my thanks to Alain Le Cloarec; Professor Denise Delouche; Anne Le Gall; Jean Le Reste; Catherine Puget; Dr Ronan Taburet; Mme la Comtesse de la Villemarqué. It was a great pleasure to meet Fernande Rivet-Daoudal and share her personal memories and knowledge of the history of Pont-Aven.

For help with miscellaneous research questions, I am grateful to Michael Archer; Martin Bailey; Jobelle Boone; Isabelle Cahn; Anne Cowe; Julian Campbell; Timothy Clifford; Douglas Druick; Stephen Edidin; Emilie Gordenker; Gloria Groom; Geneviève Lacambre; Ann Murray; Professor Shigeru Oikawa; Henry Pisciotta; Rodolphe Rapetti; David Sellin; Antoine Terrasse; Ully Wille; Peter Zegers. For hospitality and other kindnesses I should like to offer my thanks to Faya Causey; Ann Dumas; Thierry Dussard; Samuel Josefowitz; Général Georges Maldan; Daniel Morane; Emanuelle and Pierre Mutricy; Philippe Sénéchal. Alan Bowness should take credit for first inspiring my interest in Gauguin.

I would also like to thank my colleagues at the National Gallery of Scotland most warmly for their hard work and professionalism. I am indebted to Michael Clarke for entrusting me with this exciting project and to Charlotte Robertson for her unflappable administrative assistance. My particular thanks to Penelope Carter; Frances Fowle; Helen Monaghan; David Simpson; Lesley Stevenson; Christine Thompson; Agnes Valencak-Kruger. For her patience and inspired design solutions it has been a great pleasure to work again with Jan Newton; and with Janis Adams and Robert Dalrymple, responsible for the elegant design of the catalogue. Finally my thanks to my sons Rupert and George for their varying degrees of encouragement and scepticism about the project, and to Richard for his unfailing enthusiasm and willingness, once again, to give literal and virtual house room to that uncompromising guest, Paul Gauguin. I dedicate this essay to the memory of Mary Thomson, my mother-in-law, who sadly did not live to see its completion.

BELINDA THOMSON
Edinburgh, June 2005

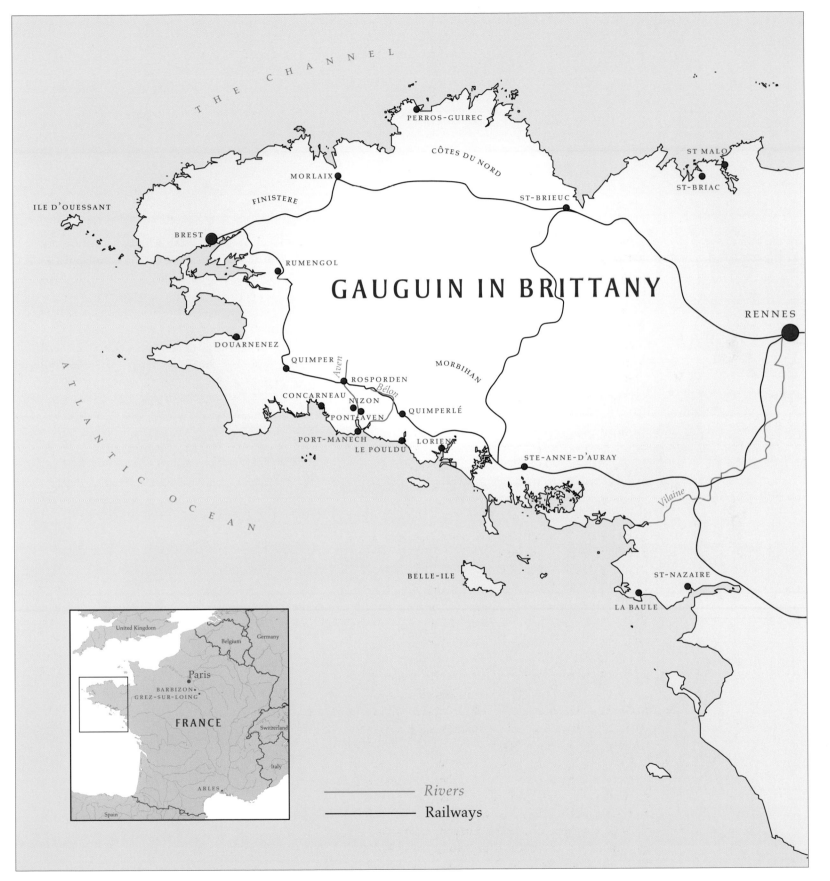

THE CHANNEL

PERROS-GUIREC

CÔTES DU NORD

ST MALO

ST-BRIAC

MORLAIX

ST-BRIEUC

ILE D'OUESSANT

FINISTERE

BREST

GAUGUIN IN BRITTANY

RENNES

RUMENGOL

DOUARNENEZ

QUIMPER

Aven

MORBIHAN

ROSPORDEN

Bélon

CONCARNEAU

NIZON

QUIMPERLÉ

PONT-AVEN

PORT-MANECH

LORIENT

LE POULDU

STE-ANNE-D'AURAY

Vilaine

ATLANTIC OCEAN

BELLE-ILE

ST-NAZAIRE

LA BAULE

United Kingdom

Belgium

Germany

Paris

BARBIZON

GREZ-SUR-LOING

FRANCE

Switzerland

Italy

ARLES

Spain

———— *Rivers*

———— Railways

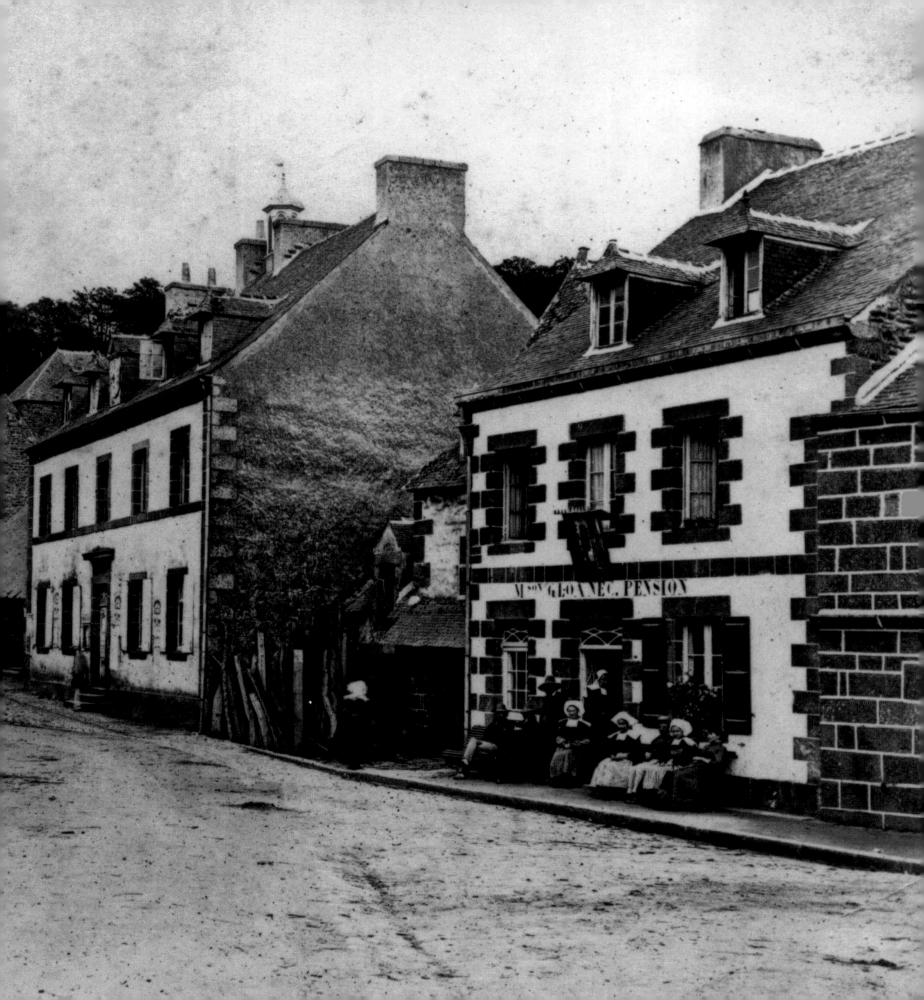

Introduction: Paul Gauguin's *Vision of the Sermon*

BELINDA THOMSON

It is eighty years since the National Gallery of Scotland acquired one of the most important works in its collection. When first painted in 1888 this work broke with convention and marked a radical departure from its author's previous style. Its bold, decorative, anti-naturalistic look announced an aesthetic revolution. If in 1925 the purchase of Paul Gauguin's *Vision of the Sermon: Jacob Wrestling with the Angel* seemed a somewhat risky one, today the painting is considered a masterpiece, helping to assure Gauguin's, and the Gallery's, fame the world over.

In its usual context *Vision of the Sermon* hangs alongside works by the Impressionists but differs markedly from them. It makes an immediate and arresting formal impact, simple clear-cut shapes of white and black starkly contrasted with a background of glowing red. These elements quickly resolve themselves into a group of women in Breton costume, a tree, a cow, two figures wrestling. The painting's apparent simplicity of form belies a complexity of meaning that takes time to apprehend. Few paintings of its period can have given rise to more analysis and critique, more speculation, admiration or recrimination.

Considerable claims have been made for its art historical importance and for Gauguin's. In his lifetime *Vision of the Sermon* was pronounced prodigious, illuminating, revelatory, capable of giving the initiated access to hidden mysteries.[1] In 1969 it was called 'the greatest and most mysterious of Gauguin's works', the key by which 'all the doors of the twentieth century were unlocked'.[2] More recently Gauguin was described as 'the most important Symbolist artist in *fin-de-siècle* Europe and, for Art Nouveau, the single most influential painter' because of his ability to fuse 'the aesthetic means of expression'…'with the subject matter of the work'.[3] Discussed and reproduced in countless books, films, exhibitions and articles, *Vision of the Sermon* finds a place in all general histories of nineteenth-century European art. Some sort of measure of its perceived art historical significance is the fact that a repro-

duction of the painting, blown up to the size of a whole building, overlooked a square in Madrid for several weeks in 2004.[4]

The painting itself is full of paradoxes: executed in a crude, deliberately 'primitive' modernist manner it marked a break with past styles, although, on the surface, its subject – peasant women in prayer – was conventional enough. But there was a supernatural twist: Gauguin's women were experiencing a vision, some sort of spiritual intervention. Gauguin considered himself to be – and was considered – an Impressionist and set much store by his acceptance within this prominent avant-garde group. But what kind of Impressionism, what kind of rational perception of visible nature could justify a composition in which a field has turned red, a cow has shrunk in size and an angelic struggle appears to praying women? What was Gauguin trying to do in this radical work?

In Gauguin's strangely slow-burning career, *Vision of the Sermon* is the first acknowledged masterpiece. As soon as it was completed it became clear that it represented a new form of painting, one that was the virtual antithesis of Impressionism. For Gauguin himself it literally refocused his vision, opening up the mystique of the 'primitive'. The painting had a profound effect on his subsequent artistic development and laid the foundations of his future reputation. To a considerable degree he was defined henceforth by this 'magisterial canvas'; for his first biographer, Jean de Rotonchamp, Gauguin was 'the savage painter of the *Struggle of Jacob and the Angel*'.[5] Its sale at auction in a sense launched him on his first voyage to Tahiti.[6]

In other ways too it altered Gauguin's fortunes. For one thing it transformed his relations with his peers, and gave him a new standing with artists of the younger generation who were seeking alternatives to the artistic creeds then on offer – Impressionism, Neo-Impressionism – both still dependent to differing degrees on the study of nature. The new adherents to Gauguin's cause proclaimed him leader of

The square in Pont-Aven, view from the bridge, *c.*1876
David Sellin Archives, Washington DC

the 'School of Pont-Aven'. The first critic to write at length and appreciatively about the painting went further: Gabriel-Albert Aurier hailed Gauguin as leader of a new pictorial style, 'Symbolism'. But this rapturous acclaim had the effect of alienating the artists who had been most intimately involved with his progress to date. Gauguin's espousal of religious themes compounded the misunderstandings already creeping into his relations with his peers. The painting made him enemies. Emile Bernard was thrown off course by the way Gauguin rapidly rose to fame on the back of its success, turning from being Gauguin's devoted supporter to his resentful, implacable opponent. In Bernard's view *Vision of the Sermon* derived everything it had of value from his own earlier composition *Breton Women in the Meadow* [plate 54]. Bernard would devote a lifelong campaign to accusing Gauguin of ruthless plagiarism and having his prior claim to stylistic daring recognised.

Such modernist claims and counter-claims have obscured another, more important aspect of the painting's legacy. For it represented a swingeing attack on the dominant mode of the late nineteenth century, naturalism. At a time when the general public had difficulty judging art by any other criterion than that of photographic 'truth to life', in this canvas Gauguin laid claim to the artist's right to depart from the appearance of things, to use colour in an arbitrary and decorative way and to use distortions of line and form to translate ideas. This insight, allowing art to tap once again into intuition and the imagination, to evoke the realm of the visionary, the irrational and the dream, bore immense fruit not only for Gauguin himself in the work he executed in Tahiti and the Marquesas, but also for emergent and future artistic movements – Art Nouveau, Fauvism, Expressionism and Surrealism. And within the narrower sphere of religious art to which the *Vision of the Sermon* made a challenging contribution, it offered a new freedom to artists to interpret biblical scenes or subjects of religious observance in ways that were not answerable to Catholic authority but to the artist's subjective response.

The present exhibition tells the story of this celebrated painting's creation afresh and enables us to see it in a suggestive historical context, surrounded by other works by Gauguin that relate to it in direct or indirect ways and by works of the wide range of artists – contemporaries and past masters – that can be seen to have sparked his thinking, by affinity or aversion. It re-examines the dispute with Bernard. Accounting for the gestation of Gauguin's *Vision of the Sermon* is a different affair from looking in depth and in context at the masterpiece of Neo-Impressionism, Seurat's *A Sunday on La Grande Jatte, 1884* [plate 7] by which it was so closely preceded.[7] Where Seurat's manifesto painting grew in a logical way out of his previous work and concerns – technical and iconographic – Gauguin's audacious painting seems to have arrived almost unannounced. Yet for Gauguin, painting *Vision of the Sermon* was a similarly calculated bid for recognition that carried an element of performance. It did not, in reality, come out of the blue, but was a brilliant intervention brought into being by a particular cluster of ideas, circumstances, pressures and individuals.

In an attempt to retrieve its historical complexity, the exhibition considers the painting's specific geographic and thematic context. Its main theme – the piety of Brittany – is presented in the light of the work of Gauguin's predecessors, collaborators and followers who were similarly inspired by this ancient Celtic kingdom. While one can do no more than guess at Gauguin's intentions, an attempt has nevertheless been made to reconsider the various traditions which he sought to emulate, and the contemporary conventions against which he railed. His wide range of reference, his reading and his lack of conventional training led Gauguin to nurture eclectic tastes that were in certain respects ahead of their time. He set as much value on popular art forms – simple woodcuts, crude pottery and

carving, Japanese prints, then still considered a form of 'primitive' art – as on certain old master traditions. The range of media covered is wide, for Gauguin himself made no hard and fast distinction between the activities of drawing, painting, printmaking, carving and modelling, all of which he practised in a highly personal way. Finally, the painting's critical reception and its impact on Gauguin's contemporaries are explored, as well as its reception in the twentieth century. Acknowledging that as an image *Vision of the Sermon: Jacob Wrestling with the Angel* has demonstrated its enduring power, the exhibition seeks to recover an interpretation acceptable for our time.

THE TITLE

The question of the correct title for the painting is a vexed one. Gauguin himself was none too precise in his use of titles. The title given in his 1891 Paris sale catalogue, *Vision après le sermon* (Vision after the Sermon), has been the most widely used historically.[8] However, there is no certainty that such sale-catalogue titles were the artist's own; they could have been invented by the auctioneers. When Gauguin's first mentioned the painting in letters to Vincent and Theo van Gogh he called it, respectively, a 'religious painting'[9] and a 'church painting' or 'painting for a church'.[10] In late 1888, forced to come up with titles for the pictures he was sending to the organisers of *Les Vingt*, an exhibition group in Brussels, Gauguin listed it as *Vision du Sermon* (*Vision of the Sermon*).[11] He had previously considered and rejected the less specific title *Apparition*.[12] *Vision of the Sermon* is the title that has been adopted for this exhibition. One further document, a list in Gauguin's hand, refers to the painting descriptively and none too accurately as *Femmes en prière et lutte d'anges* (Women in prayer and struggle between angels).[13] A suggested price is given of 600 francs. All the paintings on this list are described visually and some have colour notes, as though to help someone unfamiliar with the works to identify them. It was

clearly drafted before the February 1891 sale, and the fact that the prices indicated are considerably lower than those in the sale may suggest it was drawn up several months before.[14]

The alternative or secondary title *The Struggle of Jacob and the Angel* or *Jacob Wrestling with the Angel* also has a long history. Most people mentioning the painting at the time of the February 1891 auction sale use it, omitting all reference to the vision or the sermon.[15] When the painting was exhibited posthumously at a major retrospective exhibition in 1906 it was called, mysteriously, *The Flight of Jacob and the Angel*; one supposes that clerical error substituted *Fuite* (Flight) for *Lutte* (Struggle).[16]

NOTE

In the captions to the illustrations an asterisk* denotes that the work was included in the exhibition, *Gauguin's Vision*.

1 The Search for a Style: Gauguin and his Artistic Peers

When Paul Gauguin (1848–1903) painted *Vision of the Sermon* in the summer of 1888 he was a mature artist who had travelled, exhibited and worked in a variety of media. Latterly a number of younger painters had been looking to him for guidance. Yet at forty years of age he had only been painting seriously for a little more than a decade. In order to understand what kind of a painter Gauguin was by 1888, and how his development prepared the way for him to make this advanced statement in paint, we need to look back over his early career. Assessing Gauguin's relations with the artists he chose as his mentors and peers is as good a way as any of building up a picture of the kind of man that he was.

Gauguin first exhibited with the Impressionists in 1879 and, with a few notable exceptions, his paintings up to 1888 were conceived within an Impressionist framework; that is using direct pictorial means – light, dabbed brushwork and bright, prismatic colours – to convey the artist's immediate *sensation* of light in nature. A stockbroker until 1883, with a wife and growing family to support, he had come late to his artistic vocation. It would be unkind but perhaps not entirely untrue to say that he bought his way into the favour of the Impressionist group, thanks to his imaginative and far-sighted picture-buying between 1878 and 1883, when he was earning a comfortable income. Camille Pissarro (1830–1903), Gauguin's chosen mentor, devoted considerable time to encouraging the talent he saw latent in this unusual amateur, admiring his energy and ideas and defending him against his detractors. Although in age Gauguin could almost have been Pissarro's son, the tone he adopts in his letters to Pissarro is often one of pushy confidence; at other times it is more circumspect, revelatory of the hesitations and obstacles he was finding in developing a consistent Impressionist style.

Pissarro was predominantly a landscapist and when he painted the figure, like Millet before him, it was almost invariably to depict working peasants. The most politically committed of the Impressionists, Pissarro was a radical anarchist, and his commitment to rural themes was a deliberate *parti pris* in line with his ideological beliefs. For the more conservative Auguste Renoir (1841–1917) this made Pissarro, and by extension his pupils Gauguin and Armand Guillaumin (1841–1927), dangerous revolutionaries [plate 1].[1] In reality, given his background in stock market speculation, Gauguin's politics were considerably more opportunist, nor did he restrict his painter's vision as Pissarro did, although he painted landscape in a manner heavily dependent upon his teacher. He tackled some uncompromising rural themes, such as an isolated quarry unrelieved by any human incident [plate 2], which can perhaps be seen as an extension of certain unpicturesque subject choices made by Pissarro. Although he was occasionally drawn to figure subjects, Gauguin did not share the commitment to modern life of Manet, Renoir or Degas; on one occasion he painted his wife in evening dress, on another a *Nude Sewing* (Ny Carlsberg Glyptotek, Copenhagen), which won him the fulsome praise of Joris-Karl Huysmans at the sixth Impressionist exhibition of 1881.[2] He was versatile too, carving a wooden plaque representing a cabaret *chanteuse*. But for the most part, Gauguin concentrated on rural motifs.

In tune with his eclectic range of subjects, when in 1882 Gauguin listed the artists of the day whose talent instilled in him the greatest spirit of emulation, he cited Pissarro, Degas and Monet.[3] This mention of Claude Monet (1840–1926) is surprising, for as recently as 1881 Gauguin had expressed disapproval of the crowd-pleasing direction Monet seemed to be taking in his handling and subject choices – too many views of the riverside – and he had deplored Monet's return to the Salon the previous year. Nevertheless Gauguin's readiness to measure himself up to Monet – the absentee figurehead of the Impressionist movement – is a telling indication of his high ambition. Even though he had few direct dealings with the artist – for Monet did little to encourage younger artists who sought

his advice, preoccupied as he was in this decade with exploring ever more personal, idiosyncratic landscape motifs – Gauguin was always aware of Monet as a benchmark of the Impressionist art market. He was more than happy, particularly, one imagines, when away from Paris, to bask in his reflected glory. In 1888 Gauguin wrote to his artist friend Emile Schuffenecker (1851–1934), a fellow former stockbroker: 'It won't bother me if the price of the Monets goes up; it will be another example for the speculators as they compare yesterday's prices with those of today. And in that sense 400 francs for a Gauguin does not seem excessive compared with 3000 for a Monet.'[4] And in 1891, it would be of burning importance to him to know what Monet thought of *Vision of the Sermon*. Evidence of Monet's direct influence is scant in Gauguin's early work, at least until 1886 when Gauguin tackled coastal scenes in southern Brittany using a touch and coloration reminiscent of Monet's recent seascapes on the Normandy coast [plate 12].[5]

Gauguin shared Pissarro's admiration for the talent of Edgar Degas (1834–1917) but was equally wary of his difficult character.[6] Differences of opinion over Impressionist exhibiting policy created an obstacle to Gauguin's establishing a friendship with Degas in the early 1880s but his desire to merit Degas's approval already existed. In 1880 the critic Armand Silvestre, writing about Gauguin's works at the fifth Impressionist exhibition, had criticised their rough, 'crumbly' (*gratinée*) surface, a technical shortcoming they shared at the time with Pissarro. Silvestre had immediately gone on to say, 'It's quite the opposite of the so very independent and resolute manner of M. Degas', pointing out that Degas, like all true masters of the figure, used unified tones. There was much to learn from this 'incontestable master's … admirable sense of movement in drawing and harmony of colour'.[7] This advice is likely to have counted for Gauguin. By 1884 he was setting himself the goal of

working 'in a very broad and not monotonous way, although I have the idea that things in nature are on the whole simple'.[8] Degas's resolution and unified tones are well exemplified by his *Woman Adjusting her Hat*, 1884 [plate 3], based on a masterful charcoal drawing. Confident of his forms, in the oil Degas simplifies them to their essence. He applies the paint thinly in broad areas, seeing no need to labour the surface as Pissarro or Gauguin would have done, creating a dynamic composition through the judicious conjunction of striking silhouette and a uniform, unbroken coloured background. It is likely that Gauguin remembered Degas the painter's use of simplified blocks of colour when he came to paint *Vision of the Sermon*.

Gauguin made one of his first direct references to Degas in a still life – *The Vase of Peonies*, 1884 [plate 4] – including in the background a Degas drawing of a dancer he owned. Gauguin had never been in a position to buy Degas's work and had acquired this pastel, which he valued highly, in exchange for one of his own still lifes prior to the 1881 Impressionist exhibition.[9] Despite a surprise encounter with Degas in Dieppe in 1885, it was not until a year or so later in Paris that Gauguin was ready to turn openly to his example and seek his advice more directly. But already there were obvious signs of Degas's influence in Gauguin's figure drawings and ceramics.

Still life was a theme shared with Paul Cézanne (1839–1906), an artist who fascinated Gauguin but with whom he never established a relationship of mutual trust. This was hardly surprising given Cézanne's touchiness and unwillingness to share his thoughts on painting. The two artists met in Pontoise in 1881, but did not sympathise. Gauguin's over-eager desire to extract a workable formula from the Aix artist was undoubtedly off-putting. By 1883, when Gauguin had to curtail his picture buying, he had acquired six paintings by Cézanne, including the major canvas

18

1 | Camille Pissarro, *Rest, Young Peasant Woman Lying on the Grass, Pontoise*, 1882
Kunsthalle, Bremen

2 | Paul Gauguin, *Quarry on the Outskirts of Pontoise*, 1882
Kunsthaus, Zurich

3 | Edgar Degas, *Woman Adjusting her Hat*, 1884*
Private Collection

4 | Paul Gauguin, *The Vase of Peonies*, 1884
National Gallery of Art, Washington, collection of Mr and Mrs Paul Mellon

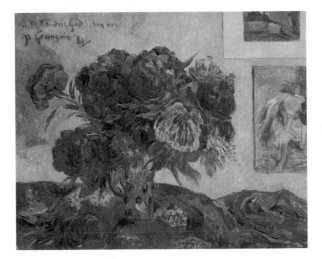

Mountains, L'Estaque [plate 5], bought for around sixty francs from their mutual colour merchant Julien Tanguy. He admired it hugely: 'A view of the Midi unfinished yet very resolved. Blue green and orangey. I regard it quite simply as a marvel.'[10] At times, notably in *Martinique Landscape*, 1887 [plate 6], Gauguin takes on Cézanne's parallel brushstroke, but it remains a superficial, decorative feature, whereas Cézanne used his characteristic warm-to-cool colour modulations to give his composition structural tautness.

In 1883–4, determined he could no longer combine his job as Paris stockbroker with his passion for painting, Gauguin decided to concentrate on his art. Rouen, he reasoned, would be a more affordable city than Paris, an important consideration given the size of his family – his fifth child was born in late 1883. He felt sure Rouen's enlightened citizens would be ready to invest in modern art. In reaching this decision he took the advice of Pissarro, who loved Rouen, its thriving modern port and picturesque old

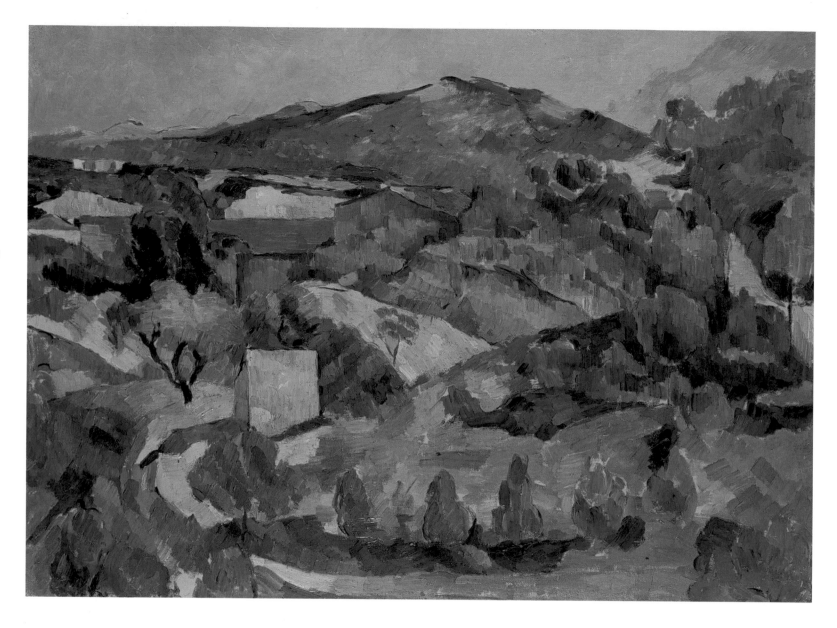

town dominated by a major Gothic cathedral. Where
Gauguin miscalculated was in believing his own work was
as yet of a consistent, saleable quality. His attitude to Rouen
alarmed Pissarro: 'Decidedly Gauguin worries me', he told
his son. 'He, too, is terribly commercial, at least in preoccu-
pations.'[11] If their tendency to view painterly opportunities
from such a different perspective was already a cause of
friction, it would eventually drive a wedge between the two
painters.

The preponderance of architectural elements in
Gauguin's Rouen landscapes, walls, gates, roofs, recall some
of Cézanne's Provençal motifs. These canvases show little
preparedness to explore the ancient or the modern aspects
of the city, but instead dwell on slightly oblique views of
churches seen from across fields or walls, or from within

gardens. Cézanne's influence was to be of lasting duration
in Gauguin's oeuvre; but in *Vision of the Sermon* he argu-
ably shuffled it off, completely, for the first time.

ART THEORIES

By 1884–5 there was an uncomfortable mismatch between
Gauguin's thinking about art and his ability to execute his
ideas on canvas. In a letter drafted in 1884 he expressed the
wish to be 'free of all encumbrances', and spoke in an
extreme way about creating an art 'made up of bold convic-
tions, even if they are wrong'. He spoke of the inherent
exaggeration that accompanied great acts of humanity. His
greatest hatred was of mediocrity, art 'based on diplomacy,
that is to say the *juste milieu* which does not upset any-
one'.[12] Living now in Copenhagen, the city of his wife

Mette's family, a humiliating stay lasting just under a year, he confronted that mediocrity in the art of his Danish contemporaries, and in what he considered to be the loathsome bourgeois taste of Danish interiors. The growing international success as a painter of his Norwegian brother-in-law Fritz Thaulow probably reinforced his views and the two doubtless engaged in arguments of an aesthetic as well as a familial kind. Thaulow's style, a tempered version of the broad handling of Manet and early Monet, was a good example of the kind of plein-airism beginning to be seen in many parts of Europe, a compromised form of Impressionism which Gauguin eschewed. Gauguin's new aspirations translated themselves into the 'synthetic notes' he drafted in a sketchbook, musing on what have been correctly seen

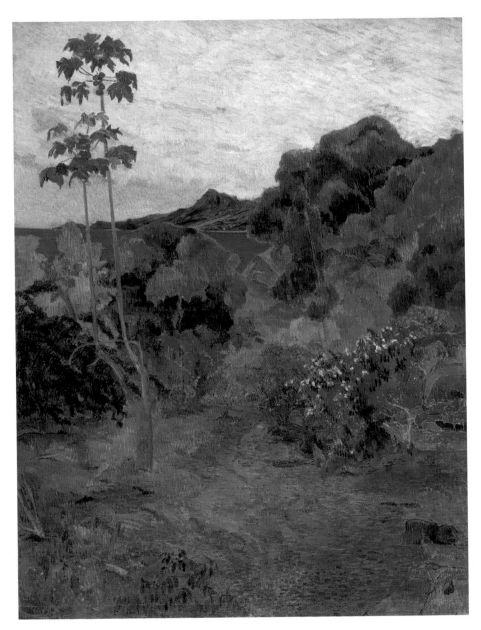

6 | Paul Gauguin,
Martinique Landscape, 1887*
National Gallery of Scotland,
Edinburgh

as proto-Symbolist ideas.[13] What was the essence of great art? Was there not a secret language of form which determined the viewer's emotional response to certain lines, certain colours? Did numbers have a part to play?

Symptomatic of this restless search was the way Gauguin latched onto the new pseudo-science of graphology, which claimed to reveal hidden personality traits from the idiosyncratic ways in which given individuals formed their letters. He analysed Pissarro and Cézanne's handwriting in this way. Removed from his familiar artistic milieu, his mind ranged free, contemplating painting as an art form, and its superiority, in his view, to the sister arts of literature and music through its appeal to the sense of sight: 'Only sight produces an instantaneous emotional response.'[14] For want of colleagues, in his solitude he communed instead with the old masters and in his writings the names Raphael, Rembrandt and Rubens crop up. He was able to visit the museums in Copenhagen, as well as the private collection of Count Frederik de Moltke, a friend of the family. But Eugène Delacroix (1798–1863) was the artist most on his mind. He seems to have derived many of his ideal artist's traits – traits of intelligence and passion – from the example of Delacroix. In Paris a major retrospective exhibition was being held at the Ecole des Beaux-Arts, which Gauguin, stuck in Copenhagen, had to learn about at second hand. The artist's ideas were becoming more accessible in the mid–1880s; that decade saw the publication of extracts from Delacroix's letters and journal.

Gauguin's period of enforced reflection in 1885 came at an important juncture, for there was much public debate in the art world just then about the current state of French painting. For artists and critics unhappy about the ever greater dominance at the Salons of a photographic kind of realism, or naturalism, artists like Delacroix, or those contemporaries who had consciously taken up Delacroix's legacy, Gustave Moreau (1826–1898) and Odilon Redon (1840–1916), offered a vital alternative. Compared to the legions of artists who had jumped on the bandwagon of modern life, Moreau's work, with its obstinate perpetuation of age-old themes drawn from legend and myth, history and religion, gave space for the imagination and the dream. A symptom of the shifting climate was Joris-Karl Huysmans' *volte-face* from his position in the essays collectively published as *L'Art moderne* – enthusiastically supporting naturalist subjects drawn from modern life – to his proto-Symbolist novel published the following year, *A Rebours*, 1884, in which he championed Moreau and Redon.

Contemplating the achievements of the artists he admired, Delacroix and Degas, bachelors with private means, Gauguin, bowed down by family responsibilities, made a

21

radical decision. He could not hope to aspire to their greatness unless he overturned his whole way of life. Aggravated by his wife's complaints and in-laws' scorn, he took the step which he believed to be necessary of leaving Mette and his children – with the exception of his son Clovis whom he kept with him – in Copenhagen and returning to Paris to concentrate on his art. Eventually he hoped his art would support them, but for the time being they would have to fend for themselves.

Although he had chosen his artistic mentors with discrimination, it was still unclear in the summer of 1886 what Gauguin's distinctive personality would be as an artist. That

7 | Georges Seurat, *A Sunday on La Grande Jatte, 1884*, 1885–6

The Art Institute of Chicago

problem came to the fore at the eighth Impressionist exhibition. Gauguin had looked forward to this exhibition with keen anticipation. He was well aware that a new version of Impressionism would be presented by what he called 'some talented new Impressionists',[15] meaning the artists who had formed a group in the recently formed Salon des Indépendants and now looked to Georges Seurat's leadership. The exhibition was held from May to June and Gauguin took an active role in organising the opening dinner. He was not out of sympathy, after all, with the principles on which the new artists were working, their research into colour division in many ways according with his own reflections on the superior effects one could produce by juxtaposing pure tones rather than mixing them on the palette. Ideas about the emotional properties of certain colours, red for instance, which tended to advance when juxtaposed with less dynamic colours such as green or blue, were of interest to him. Such theories were in the air,

prompted in part by the publication of the aesthetic writings of Charles Henry and the findings of the German physicist Helmholtz. Félix Bracquemond referred to them in the treatise on art terms he published in 1885.[16] Gauguin, like Seurat, Pissarro and others, was searching for a formula that could resolve some of the problems inherent in the instinctive, untheorised colour practice of Impressionism.

What then changed his tolerant attitude towards the Neo-Impressionists? The generally accepted explanation is that the surge of interest their new style aroused among the younger writers was humiliating for him. Gauguin's group of works in 1886 mostly consisted of dense rural landscape motifs from Rouen, Dieppe and Copenhagen painted in strong colours and flecked brushstrokes. They met a distinctly mixed reception. There was praise for his striking colour contrasts from Jules Christophe in *Le Journal des Arts*.[17] However, several critics overlooked him altogether. According to the Belgian critic Octave Maus, Gauguin was a newcomer to Impressionism who had too close a dependence on the work of Guillaumin.[18] This dismissal would have been all the more galling as Maus was responsible for selecting the foreign artists to be invited to the annual *Les Vingt* exhibitions in Brussels. Although Gauguin's works depicting the figure showed more assurance – and his bas relief of a child, carved in 1882, drew praise from Félix Fénéon – his inconsistency and occasional clumsiness looked unconvincing alongside the marked tendency towards a poised and controlled handling revealed in the work of Seurat and his followers [plate 7]. The objective of the Neo-Impressionists was to remove the haphazard personal element associated with Impressionist brushwork and at the same time to find a sound scientific method of maximising the light-projecting qualities of the paint surface – which they did by dividing tones systematically into points or dots, hence the names 'divisionists' and, pejoratively, 'pointillists'. The screen of dots, like the painstakingly smudged forms of Seurat's conté crayon drawings, enforced a simplification of forms, a synthesis of nature, and effectively distanced the artist and the viewer from the subject.

If Gauguin was disappointed by his own performance, the problem was exacerbated by the critical dominance of Seurat's group and by the central role his erstwhile teacher was playing in that group – Camille Pissarro having adopted the divisionist method over the winter of 1885–6. From this date on relations between the two, formerly so intimate, began to disintegrate, and Gauguin lost no opportunity to deride the Neo-Impressionists' methods and the extreme modernity of their subject matter. He decided to boycott the Salon des Indépendants because of its association with Neo-Impressionism, and later, for the same

reason, *La Revue indépendante*. In doing so, he was by default making an important career decision, setting himself on an alternative, more backward-looking, course. A few critics shared Gauguin's misgivings about Neo-Impressionism, Huysmans, for instance: 'Peel his [Seurat's] figures of the coloured fleas they are covered in, the underneath is empty; no soul, no thought, nothing.'[19] An art of surface and modernity was the very opposite of what Gauguin was now pursuing, namely an art that would somehow go beneath the surface and speak to the soul. By 1888 he was openly waging war on the 'little dot', an attitude not without relevance to the way in which he would develop his own synthetic style, compose *Vision of the Sermon* and subsequently bring it into the public domain.

FINDING A DISTINCTIVE VOICE

Quite who he himself was began to preoccupy Gauguin more and more. Seeking answers to his sense of alienation, to his difficulty in establishing easy social relations, Gauguin began making reference to his racial difference from his French peers. He began to refer to his mixed blood, to his Peruvian and Spanish forebears, the de Moscoso relations on his mother's side of the family in whose house he had spent his earliest years as a child. From them Gauguin inherited his dark colouring, his ability to speak Spanish, his passionate nature. Having warned Mette that he could turn into a '*bête féroce*' in 1887, he wrote in February 1888: 'You have to remember that I have two natures – the savage and the sensitive. The sensitive one has disappeared, which enables the savage to advance resolutely and unimpeded.'[20] Such was the persuasive power of this self-image that it was accepted without question by those in his close network. Theo van Gogh, for instance, who became his dealer in 1888, found it a plausible explanation for the inconsistency of his artistic production and for the difficulty of finding buyers for it: 'It is obvious that Gauguin who is half Inca and half European, superstitious like the former and advanced in his ideas like some of the latter, cannot work in the same way day after day.'[21]

We need to bear Gauguin's willfully contradictory character in mind when considering how he went about making his mark in the avant-garde. Henri Delavallée, who met him in the summer of 1886, recalled him as very proud, somewhat naïve, very mystificatory, a man of deadpan humour. A ruse he succeeded in pulling off in 1887 gives evidence of this. He circulated among the Parisian avant-garde a fake document purportedly drawn from the '*Livre des Métiers* of the great teacher Mani-Vehni-Zunbul-Zadi, Hindu painter, in the year X'. Seurat was taken in, as was Fénéon, who got the document published by *L'Art moderne*

de Bruxelles, the same journal that had just published his treatise on the Neo-Impressionist technique.[22] Mani's precepts have relevance to aspects of Seurat's technique and to the calm decorative mural paintings of Pierre Puvis de Charannes (1824–1898). But they are also consistent with the increasingly synthetic thinking of their actual author, who seems to have been Gauguin himself:

Have a model but work from memory. Who tells you that one must look for opposition in colours?
… Look for harmony not opposition, accord not discord.
… Let everything in your work breathe calm and the peace of the soul. Therefore avoid poses in movement. Each of your figures must be static.
… Concentrate on the silhouette of every object.
… Do not finish too much … In this way you cool the lava, and create a stone from blood on the boil. Were it a ruby, throw it far from you.

Troubled and alienated though Gauguin the man often seems between 1885 and 1887, one positive sign for the future was his aptitude for the decorative arts. In the summer of 1886 Gauguin established a fruitful relationship with the artist Félix Bracquemond (1833–1914), a master etcher, ceramicist and writer on art. Bracquemond was impressed by Gauguin's sculpture and tried to help him sell pictures, although finding them strange.[23] He introduced Gauguin to the ceramicist Ernest Chaplet (1835–1909), who, like Bracquemond, worked for the Haviland firm. Gauguin was much excited by the possibilities of working in the new medium and optimistic that working on 'artistic vases' would increase his chances of sales. It was a new hope on the horizon and a new focus for the work he would undertake that summer.

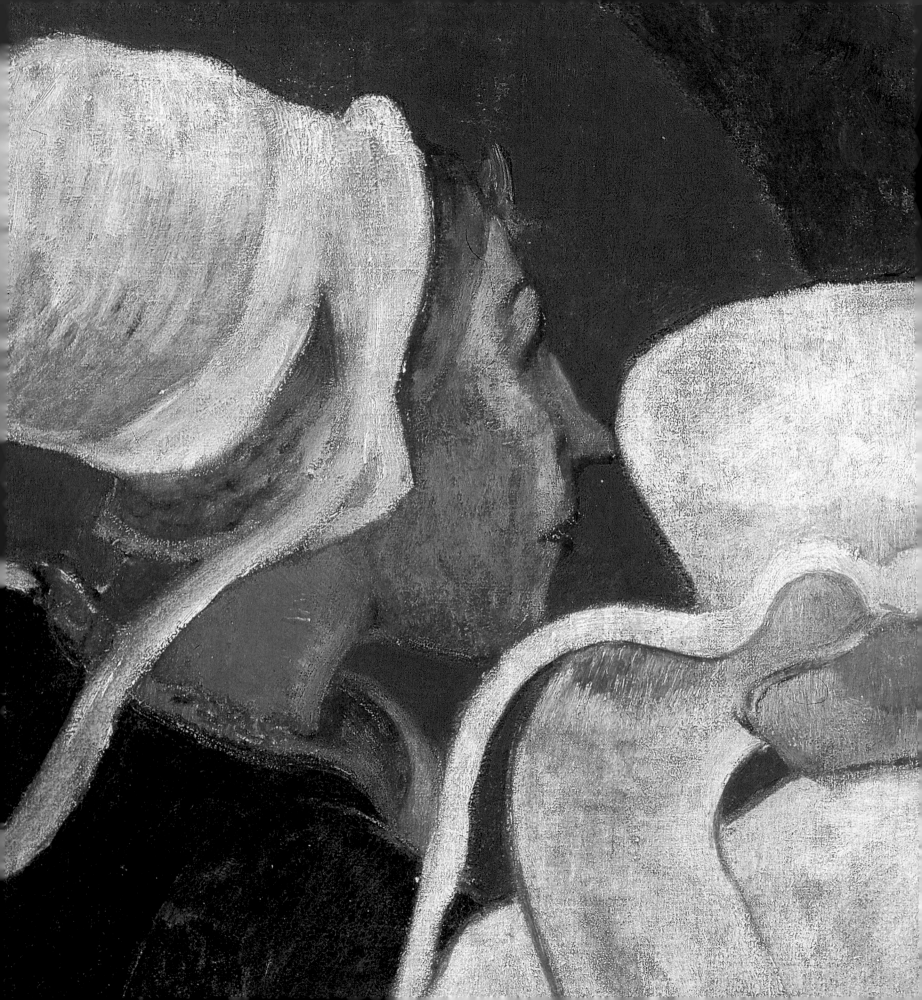

2 Gauguin in Pont-Aven, 1886

Gauguin placed his son Clovis *en pension* and took himself off to Brittany in late July 1886. It was habitual for artists to leave Paris and seek plein-air motifs in the summer months, but Gauguin had more negative than positive reasons for doing so – feelings of antagonism towards the city, its artistic rivalries and its expense. These gradually became rolled into a broad pessimism about the corrupt state of modern urban society, its blind belief in scientific progress, and its loss of contact with the soil and with the natural cycles of life. However, what began as a decision prompted essentially by the reports of cheap living was to turn out to be one of the most significant and positive steps in his career.

Gauguin had first mentioned Brittany in 1885 when staying in Dieppe, a popular resort on the Normandy coast frequented by its own band of artists. He had been disappointed by the difficulty of finding real landscape motifs nearby, hankering after staying 'in an inn in some corner of Brittany, painting pictures and living economically. Brittany is still the place where one can live most cheaply.'[1] Dieppe and Normandy by contrast were expensive: he could not afford to rent a villa, had little time for the fashionable Parisians who frequented its hotels, and lacked the wherewithal to dress the part for sea-bathing. A number of his acquaintances had been to Pont-Aven before him and could have advised him to try it – Félix Jobbé-Duval, Achille Granchi-Taylor and Fernand Quignon, a successful Salon painter and friend and neighbour of Schuffenecker's. But it is doubtful whether Gauguin was fully aware of the extent to which this enterprising region now exploited artistic tourism as a supplement to its other seasonal sources of income.

Although initially there was no indication that he had any special feelings towards Brittany or its people, Gauguin's criterion of being able to find readily paintable motifs close to where he was staying was one Pont-Aven was certainly able to satisfy. With its population of around 1400, the village was substantial enough in size to offer a variety of amenities, with models to paint, and hotels in a variety of price ranges; yet it was small enough to make it easy to immerse oneself in the surrounding countryside.[2] Attractively situated in a deep valley surrounded by hills and woods, at the point where the river Aven changed from a fast-flowing rocky stream capable of powering water mills to a broad tidal waterway heading south to the sea, its easy access to the coast meant it was a working port dealing in cargoes of wood, stones, sand and cereals. The bridge that gave the village its name was also the centre of communal life, surrounded by inns and cafés, small businesses and shops. Here a regular Tuesday market and a monthly pig-fair provided interest. Indeed farm animals were a regular sight in the streets. Pont-Aven would not acquire its own railway link until 1903, so visitors from Paris, after a train journey lasting about fourteen hours, alighted at nearby Quimperlé, hiring a horse and trap for the last few miles. Thirty kilometres to the north-west was the cathedral city of Quimper, the administrative centre for the Finistère region, while the nearest harbour, about thirteen kilometres along the coast to the west, was Concarneau, with its medieval *ville close* and sardine fishing industry, another favourite spot for painters. In fact both Pont-Aven and Concarneau were artists' colonies of several years' standing, and every summer they welcomed a substantial migrant population of artists from all corners of the northern hemisphere. While a good number of these were students enrolled at one of the Paris studios, following their teachers' advice to paint out of doors during the summer recess, others were more established figures. Only a few artists lived at Pont-Aven all year round. Among these, well before Gauguin's time, was the American Robert Wylie (1839–1877), the artist who had put the village on the map for his fellow countrymen in the 1860s.[3]

Novel though the experience of staying in Finistère would be for Gauguin, there was no sense in which he could

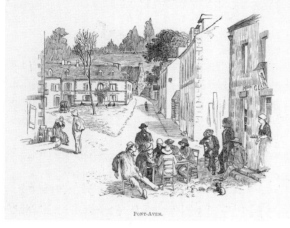

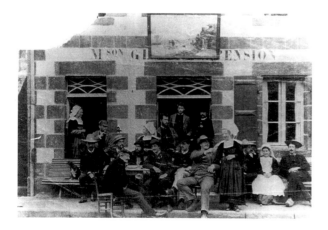

8 | Herman van den Anker and Fernand Quignon, *Signboard of the Pension Gloanec, Pont-Aven*, c.1880–1
Musée de Pont-Aven

9 | Randolph Caldecott, *Pont-Aven*, from Henry Blackburn, *Breton Folk, an Artistic Tour in Brittany*, London 1880 (first published in *Magazine of Art*, 1879)*
National Library of Scotland, Edinburgh

10 | Ferdinand du Puigaudeau, *Photograph of Artists Seated Outside the Pension Gloanec*, 1886
Musée de Pont-Aven

claim to be discovering this remote corner of Brittany from an artistic point of view. The Pension Gloanec where he took board and lodging for sixty francs a month had a jovial sign hanging above its entrance, jointly painted by two of its regular guests, the Dutchman Herman van den Anker (resident in Pont-Aven from 1868 to 1881) and Fernand Quignon (whose presence is recorded in 1880–2); the sign featured artists working *sur le motif* on a sunny day at the beach of nearby Port-Manech [plate 8]. The size of the village was, and remains, such that there was little chance of privacy and the artists would inevitably run into each other every day. Indeed a major aspect of the Pont-Aven experience, as it was at other artists' colonies such as Grez-sur-Loing, was the spirit of camaraderie and competition this proximity engendered, cemented by sharing communal meals of hearty fare and cider provided by the local inn-keepers. With drinking and conversation came the chance to compare notes at the end of the day, exchange professional tips and ideas.[4] In concentrated form, Pont-Aven contained much of the rivalry and academic art chat Gauguin had thought to escape on leaving Paris.

Photographs and illustrations from the early-to-mid 1880s abound showing artists relaxing in convivial groups. Randolph Caldecott's illustration for a popular British guidebook represents a typical gathering of artists seated at a table and spilling into the square outside the Pension Gloanec [plate 9].[5] Their presence was monitored in the local press, where reports of goings-on in the artistic community began to appear regularly. Interestingly, and for reasons that may have a bearing on the role he chose to play in Pont-Aven, none of these group photographs can with certainty be said to include Gauguin [plate 10].[6]

The remarkable percentage of foreign artists in Pont-Aven was noted immediately on arrival by Gauguin, in a letter to his wife: 'There are almost no French, all foreigners, a Dane and two Danish women, the brother of Hagborg and lots of Americans'.[7] Although this fact is often mentioned, the implications for Gauguin of finding himself in the midst of such an international community deserve further consideration. For when Gauguin went on to tell his wife, 'My painting is arousing a lot of discussion and I must say finding a pretty favourable welcome among the Americans. It's a source of hope for the *future*', this was a state of affairs relevant not just to his temporary sense of optimism and self-esteem but, arguably, to his longer-term market prospects. By the late nineteenth century, increasing numbers of well-to-do Americans travelled across the Atlantic for purposes of leisure or education. Paris art schools enrolled large numbers of foreign students and by 1888 the number of foreign painters whose works were on show at

11 | Paul Gauguin, *Sketchbook studies*. Right: *A Man with a Moustache and a Boy with a Hat*, 1886*
National Gallery of Art, Washington, The Armand Hammer Collection

A number of Gauguin's 1886 sketches represent his fellow artists. The man shown here could well be one of them.

12 | Paul Gauguin, *Breton Coast*, 1886
Konstmuseum, Göteborg

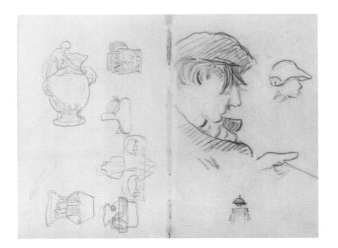

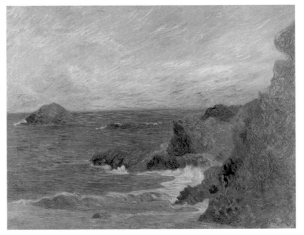

the Paris Salon was estimated at a quarter of the total.[8] So the art world in which Gauguin was seeking to make his mark in the 1880s was an increasingly international one. Arriving in Pont-Aven gave him, both as a businessman and as an artist, an unusual opportunity to reflect upon that fact [plate 11]. The social experience of Brittany gave Gauguin a useful understanding of the impulses and goals behind artistic travel. Small wonder that Gauguin was one of the first French artists to engage in exploratory travel and exploitation of the colonies for his own art's sake, or that after his death his fame was established more quickly abroad than in his native France.[9]

The usual account of Gauguin in Brittany supposes him to have behaved in a stand-offish and unfriendly way towards Pont-Aven's largely conservative population of French and foreign visitors. This is certainly the impression conveyed by a number of his letters and he later frequently referred to the arguments he was 'forced to have' with these benighted practitioners. Yet he liked nothing better than a good fight. (Gauguin was reputedly a fine swordsman, and regularly practised fencing, a sport for which he owned gloves and mask). He clearly relished the cachet his status as an exhibitor with the 'revolutionary' Impressionists gave him. Indeed he seems to have been the first Impressionist to set foot in Pont-Aven, although their elder supporter Eugène Boudin (1824–1898) had long been an enthusiastic

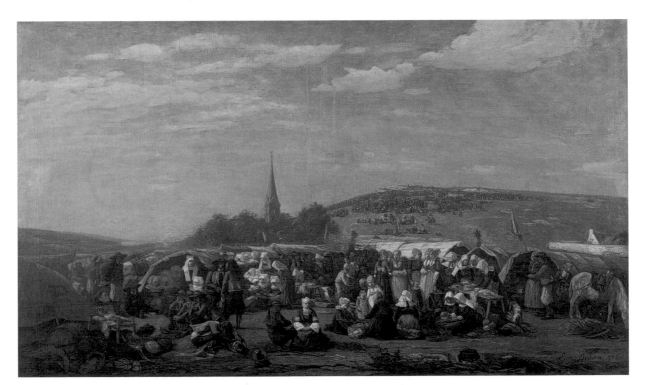

13 | Eugène Boudin, *The Pardon of Sainte-Anne-La Palud*, 1858*
Musée Malraux, Le Havre

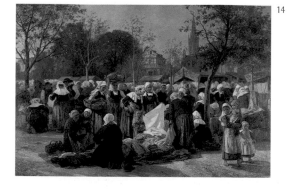

14

15

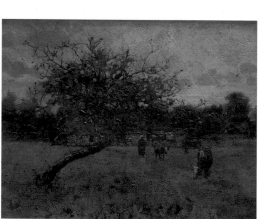

16

14 | Jules Trayer, *Cloth Market, Finistère*, 1886
Musée des beaux-arts, Quimper,
On loan from Musée d'Orsay, Paris

15 | Archibald Standish Hartrick, *Back of Gauguin's Studio, Pont-Aven*, 1886*
Courtauld Institute of Art Gallery, London

16 | Arthur Wesley Dow, *Old Orchard*, 1886
Beard and Weil Art Galleries,

visitor to Brittany. Renoir was also to spend some weeks in Pont-Aven, but not until 1892. We know Gauguin was required to answer a lot of questions about the Impressionists' ways of working, and it seems plausible that he even painted the occasional demonstration picture. The fact that Monet was working that summer on Belle-Ile, off the Finistère coast, may have prompted discussions about his techniques and methods. As already noted, Gauguin produced a number of seascapes that summer that are similar in touch and palette to Monet [plate 12]. So for all his complaints, Gauguin probably delighted in this chance to be the centre of attention and to communicate new ideas to the young, especially when those ideas might upset their cherished beliefs. It suited the didactic and cocky side of Gauguin's temperament and restored his confidence, badly shaken by his recent experience in Paris.

What sort of artist was Gauguin encountering? Essentially they were either genre painters or painters of landscape and seascape. There was already a long tradition going back to mid-century of artists pursuing their interest in local colour and regional variation in Brittany. Religious spectacles were particularly popular. Eugène Boudin's major composition, based on one of the most celebrated of Brittany's Pardons, *The Pardon of Sainte-Anne-La Palud* [plate 13], had scored him a notable Salon début in 1859. A Breton

Pardon involved a pilgrimage to a specific church or chapel dedicated to a local saint and associated with some miraculous intervention or vision. The faithful assembled from far and wide, identifying themselves by their regional costumes; indeed such occasions could easily become competitive fashion displays, attracting non-Breton onlookers. This is the moment shown by Boudin in his broad panoramic view, appropriately staged for its Salon destination. The penitents then processed towards and around the church, sometimes on their knees, where mass was celebrated, respects were paid to the venerated saint, forgiveness and blessing were received. Following the religious ceremony, secular festivities, eating, drinking, dancing and wrestling took over, often continuing into the night. Breton paintings also featured market or agricultural scenes, or pictured the harsher existence led by fisherfolk or seaweed gatherers, the so-called 'peasants of the sea'. Gauguin can scarcely have been unaware of the success such artists as Jules Trayer (1824–1909) [plate 14], Jules Breton (1827–1906), Léon Lhermitte (1844–1925), Théophile Deyrolle (1844–1923) and most notably Pascal Dagnan-Bouveret (1852–1929) were having by exploiting this Breton vein [plates 77, 78].[10] Certainly he came across them or their followers on his tramps around the village, as they made sketches and took photographs with a view to preparing their next big Salon

machine. The extraordinary numbers of such peasant scenes, the size to which they had grown and their puzzling familiarity preyed on the mind of the novelist Guy de Maupassant, reviewing the 1886 Salon in a bantering tone. Suddenly he realised where he had previously encountered all these peasants, now so busy digging, sowing, ploughing, harrowing, reaping, and so on. They were the very same models that had in the previous generation paraded themselves in Greek and Roman armour. 'Ah you jokers!' he exclaimed, 'I've got you! ... you've buried your helmets, your shields and your swords and you've put on cotton *coiffes* and clogs to trick me!'[11]

Among the landscapists, most of the younger artists were working in a naturalist vein strongly indebted to Jules Bastien-Lepage (1848–1884); his influence produced the predominantly grey tonal effects Gauguin had already observed among artists in Denmark. One of these younger artists was the Scot Archibald Standish Hartrick (1864–1950), an Académie Julian student who was in Pont-Aven in 1886, painting unprepossessing corners of the village in a drab palette. Many years later Hartrick would publish a lively first-hand account of his encounters with Gauguin.[12] One of his paintings that year, *Breton Laundry* (*Un blanchissage breton*), was exhibited at the following year's Salon. It is probably identifiable, given its motif of laundry strewn on the grass to dry and bleach, with the picture now known as the *Back of Gauguin's Studio, Pont-Aven* [plate 15], whose present title was clearly found later. The reference is to the studio at the *manoir* of Les Avens or Lezaven which Gauguin was invited to use that summer. Another Julian student Gauguin is likely to have met was Arthur Wesley Dow (1857–1922) from Massachusetts. Most of the Americans in Pont-Aven preferred, and could afford, the greater comfort of the larger hotel, the Hôtel Julia, but Dow

stayed at the Pension Gloanec. Dow's *Old Orchard*, 1886 [plate 16], a peaceful view of cattle grazing, features an apple tree with crooked trunk remarkably similar to the tree Gauguin would use dramatically to divide the composition of *Vision of the Sermon* two years later.

If Gauguin's paintings caused a stir in 1886, as Hartrick records, it was in contrast to the drab-toned naturalism of the other artist residents. Exemplifying a different form of Impressionist naturalism, they are mostly landscapes, sometimes animated by small-scale figures, a young girl minding a flock of goats and sheep for instance [plate 17], boys bathing, or women washing clothes in the river. He seems to have wished to map his new locale from a distance, take in the village as a whole. The paintings juxtapose bright broken touches applied in a kind of directed shower, but Gauguin avoided the systematic division of tone associated with the 'scientific Impressionists'.[13] He never left off drawing. Drawing for Gauguin served a multitude of purposes. His few surviving sketchbooks indicate that he thought most creatively with a pencil in hand. Indeed one suspects he used drawing to prove a point in discussion, for his sketchbooks veer from one subject to another, and are often interspersed with diagrams, notes, names and addresses. He also made a number of fine figure drawings on large sheets of superior paper, working in charcoal and pastel from the life [plates 18, 19, 36].

These drawings study individual models but are principally concerned with noting the intricacies of the different Breton ceremonial headdresses and costumes still worn with pride, particularly on high days and holidays, by the local women. Whether or not he was aware of the fact, different headdress shapes denoted the wearer's class, occupation, and marital status as well as geographical origin. The Pont-Aven costume being one of the most distinctive Breton styles it was regularly recorded in nineteenth-century repertories of regional costume [plate 20]. The tight-fitting coloured artisanal *sous-coiffe* seen in the sketchbook drawings [plate 21], a more practical form of headgear than the intricate white *coiffe*, would be worn when engaged in physical work; the more elaborate white ceremonial *coiffe* was worn on top of this bonnet, its broad white bands pinned asymmetrically above the head.[14] However, if a woman was in mourning for a close family member, once she had discarded the black cape of full mourning, these white bands were worn hanging down for some months, forming the winged effect seen in the two right-hand *coiffes* in *Vision of the Sermon* [plate 22]. Coloured ribbons were used to attach the *coiffe's* basic shape, and left to hang loose at the back as Gauguin observed faithfully. These and colourful neckerchiefs offered

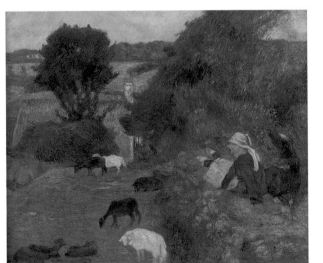

17 | Paul Gauguin, *Breton Shepherdess*, 1886
Laing Art Gallery, Tyne and Wear Museums

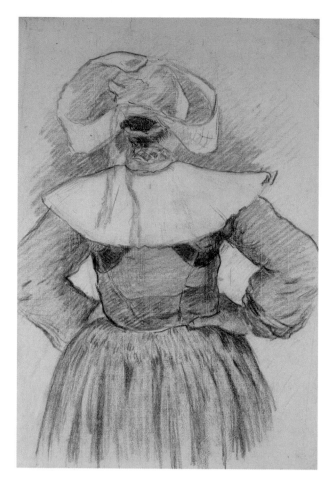

18 | Paul Gauguin, *Breton Girl*, 1886*
Glasgow Museums: The Burrell Collection

Although Gauguin seems to have given away certain drawings, he was to keep and constantly reuse others: this powerful pose, a study for *Four Breton Women*, [plate 24], reappears in simplified form in his ceramic vase [plate 29], in two 1888 paintings and in the 1889 print *Breton Women by a Gate* [plate 97]. Its emphasis is on the bulky stolidity characteristic of the Breton woman's costume, so different from the elegant corseted silhouette of contemporary Parisian fashions.

19 | Paul Gauguin, *Breton Woman and Study of a Hand*, inscribed: *'à M. Newman, souvenir affectueux'*, 1886
Private Collection

Like other artists, Gauguin was fascinated by the Breton costume, some of whose forms, particularly the ruff-like collar, harked back to the sixteenth century. Using delicate strokes he differentiates the flimsy muslin *coiffe* and finely pleated starched collar from the dense velvet-trimmed bodice, which, like the skirt, was of a heavy wool fabric. The apron, an essential and highly practical part of the ensemble, was of a loose hemp and wool weave.

20 | Anonymous, *Woman from Pont-Aven*, from the series *France, Musée des Costumes*, 1850*
Musée départemental breton, Quimper

21 | Paul Gauguin, *Four Studies of Breton Women*, 1886*
National Gallery of Art, Washington, The Armand Hammer Collection

The women here are represented wearing the close-fitting, coloured *sous-coiffes* worn for work.

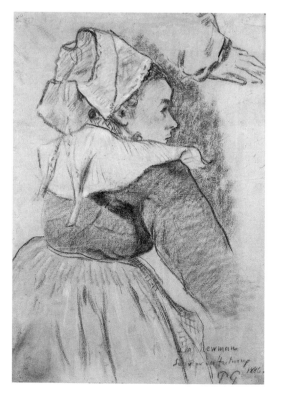

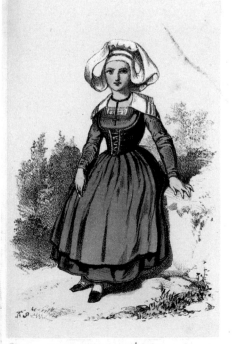

PONT-AVEN, Arrond.t de Quimperlé.

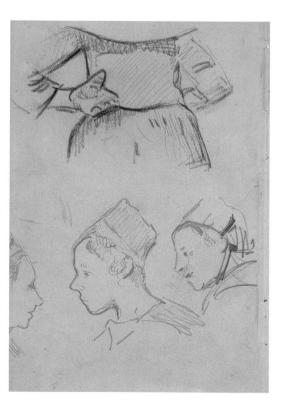

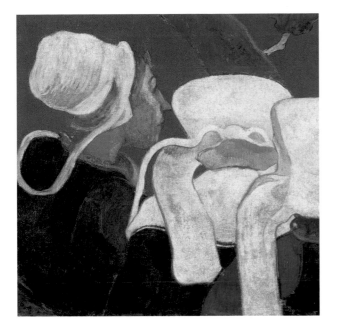

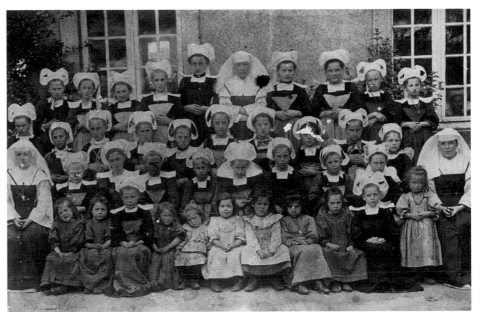

22 | Detail of *coiffes* in *Vision of the Sermon*, 1888
National Gallery of Scotland, Edinburgh

The woman on the left wears a smaller style of *coiffe*, denoting her artisan status.

23 | Unknown photographer, *The Pupils of Saint Guénolé Convent, Pont-Aven*
courtesy Fernande Rivet-Daoudal

Girls did not start to wear the traditional costume and *coiffe* until they had taken their first communion, as can be seen from a photograph of the Saint Guénolé girls' convent in Pont-Aven dating from c.1900.

the chance for young women to display their individuality. Otherwise the costume's elements were relatively unchanging, although minor adjustments were made to keep up with the fashion of the day, for instance to the amount of hair allowed to show. One theory has it that the woman in profile in *Vision of the Sermon* is showing a single curl on her forehead to indicate her marriageable status.

The models' poses and technique recall Degas's dancers. It seems probable from the way Gauguin truncated their bodies in his drawings that he already had his composition *Four Breton Women* in mind [plate 24]. It has sometimes been suggested that this major composition was painted back in Paris over the winter, but one of these drawings is dedicated affectionately to a 'M. Newman'. Assuming it was given to the dedicatee in Pont-Aven, Gauguin had presumably already fixed the design of his painting and had no further need to refer to this particular preparatory study. Or perhaps he could spare it because he had made another more simplified, caricatural study of the same figure in watercolour [plate 25]. It was this version rather than the more correct, even pretty, physiognomy found in the Newman pastel that he would use in the final painting, in itself a telling adjustment; Gauguin's thinking was taking him away from the academically correct, towards the exaggerated. *Fumisterie*, a word that was applied to and by Gauguin to denote pranks and mischievous behaviour, was also, arguably, becoming a central plank of his artistic strategy. In the final painting he inserted the heads of a gaggle of white geese behind the four Breton women, surely a deliberate and unflattering analogy.[15]

Gauguin's drawings are a useful index of his friendships.

The dedicatee M. Newman, for instance, can now be identified with the American Benjamin Tupper Newman (1858–1940), present in Pont-Aven in 1886, who would exhibit a charming landscape with children picnicking in the following year's Salon [plate 26].[16] Another drawing done at this time was dedicated to M. Laval, probably Charles Laval (1862–1894), the painter who would accompany Gauguin the following year to Martinique. A third artist with whom Gauguin struck up a friendship that summer, and who, like Laval, considered himself Gauguin's pupil, was Ferdinand Loyen du Puigaudeau (1864–1930). And finally there is the dedication on the caricatural watercolour to '*l'ami Bernard*', presumably the artist Emile Bernard (1868–1941). But when was the gift made? Bernard's first meeting with Gauguin occurred in August 1886. A renegade from art school in Paris, Bernard was then making a walking tour of Brittany. He met Schuffenecker painting on the beach at Concarneau, who suggested he sought out Gauguin at the Pension Gloanec. According to one version Bernard gave of events, Gauguin treated him dismissively and with disdain and he in his turn had little enthusiasm for the work he saw in Gauguin's studio, too reminiscent of Pissarro and Puvis de Chavannes.[17] But a letter Bernard wrote to his parents on 19 August suggests a different reaction: 'There is also [at the pension Gloanec] an impressionist named Gauguin, a very strong fellow; he is 36 years old and draws and paints very well'.[18] This, together with the gift of a drawing, if it was indeed made that summer, would seem to suggest more of an exchange.[19] Their decisive meeting, however, occurred two years later.

Drawings are also revealing of Gauguin's private

24 | Paul Gauguin, *Four Breton Women*, 1886
Neue Pinakothek, Munich

25 | Paul Gauguin, *Breton Woman from Pont-Aven in Profile*, inscribed: *'à l'ami Bernard'*, 1886
Galerie Bailly, Paris

26 | Benjamin Tupper Newman, *Lunch – Bretagne*, 1886 (whereabouts unknown), illustrated in *Salon Illustré*, 1887

preoccupations at this time. Two sheets covered with rapid doodles, evenly spaced, represent animals and children in schematic outline. They look like caricatures or children's storybook illustrations [plate 27]. This may indeed be where their simplicity of form originated, for, as Hartrick recorded, Gauguin had with him some of Randolph Caldecott's picture books, and admired the artist's geese, evidence, he claimed, of the 'true spirit of drawing' [plate 28].[20] Decorative geese with arching necks became a favourite motif for Gauguin, seeming to symbolise something of the special character of Brittany, interchangeable with the somewhat similar outline of the Breton *coiffe*. Indeed childlike simplicity of style had been encouraged by Pissarro, who had a keen appreciation of English children's-book illustrators. Gauguin would have seen two humorous illustration projects by Lucien, Pissarro's eldest son, at the eighth Impressionist exhibition.

Gauguin's apparently informal sketches were made for a specific purpose. He introduced the simplified geese together with a goat into the coloured and incised surface decoration of his vase decorated with Breton scenes [plate 29], one of the most accomplished ceramic pieces Gauguin decorated in Ernest Chaplet's studio that winter. For

Gauguin, ceramics brought together in a single activity a number of seemingly incompatible artistic impulses, towards non-Western traditions, the childlike and the 'primitive'. His mother had brought back from Peru a collection of pre-Colombian pottery which, together with the pots assembled by his guardian Gustave Arosa, gave him ideas for moulding strange pots in the form of heads. Japanese ceramics, brought to public attention at the Universal Exhibition of 1878 and regarded as the height of sophistication by Bracquemond and Chaplet, informed his graceful flat decorative drawing of trees and animals. His cultivation of the childlike and synthetic in drawing style was possibly encouraged by the Haviland firm's dinner service using Kate Greenaway designs dating from 1882, which was reissued in 1887. Finally there was his love of craft, which dated back to childhood – the fashioning of pots in clay meant handling materials that were as old as human existence, as Gauguin liked to recall. He found in this primitive activity and in the image of the infernal heat of the kiln a potent analogy for creation itself.

If the ceramic vase with its gold outlining harks back to the Japanese inspired sophistication of earlier rue Blomet productions, the childlike simplicity of the forms found on

27 | Paul Gauguin, *Sketchbook studies*. Left: *Studies relating to vases**
National Gallery of Art, Washington, The Armand Hammer Collection

28 | Randolph Caldecott, illustration from *The Diverting History of John Gilpin*, c.1878
National Library of Scotland, Edinburgh*

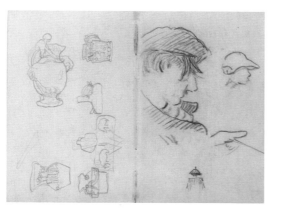

his astonishing *Jardinière with Breton Woman and Sheep* [plate 30] looks forward to Gauguin's more independent evolution as a sculptor in ceramics. Its basic rectangular shape is ornamented with additions modelled from odds and ends of clay. A toy-town Breton woman has been incised into the surface, the elements of her costume crudely indicated in coloured slip; she stands guard over her flock, their simplified brown forms merging with lumpy shapes of clay denoting grey rocks. Behind her Gauguin placed another heavy grey-green shape, which can be read as a tree, large boulder or lowering cloud.[21] He retained a roughness by leaving parts of the clay in their natural reddish brown colour. Pleased with the results he obtained and by the extravagant praise of both Chaplet and Schuffenecker, Gauguin would persevere in this direction in his later campaigns of ceramic work, preferring to model his clay shapes by hand rather than working from conventional shapes turned on the wheel. The decorative arts, by their very constraints, offered Gauguin the freedom to simplify form and experiment with colour as an element no longer tied to nature; in them Gauguin seemed to have found the new direction he was still seeking in his painting.

The three months he spent in Pont-Aven in 1886 were significant for Gauguin in a number of ways. Although the actual paintings produced on site were relatively unadventurous, the strategy of imbuing himself with the setting and the typical inhabitants, human and animal, through synthetic, even caricatural drawing, was one he maintained for the rest of his career. The motifs he isolated served to fix in his mind the character of Brittany and they would crop up time and again in his later work. His ability to hold his own in an alien environment and in an international crowd, even to win over followers and pupils, boosted his confidence and set a pattern for his subsequent visits to southern Brittany.

TROPICAL INTERLUDE – MARTINIQUE 1887

The experience of Brittany rekindled Gauguin's appetite for travel to more distant shores. In 1887 he took a more drastic step, leaving France altogether in order to find renewed energy living 'as a savage'. Having written to his wife asking her to take back Clovis, he set off for the Caribbean accompanied by Charles Laval. After an abortive period trying to earn money in Panama, where the canal was being dug, they spent several productive months in Martinique.

29 | Paul Gauguin,
Vase Decorated with Breton Scenes, 1886–7*
Musées Royaux d'Art et d'Histoire, Brussels

30 | Paul Gauguin,
Jardinière with Breton Woman and Sheep, 1886–7*
Petit Palais, Musée des Beaux-Arts de la Ville de Paris, Paris

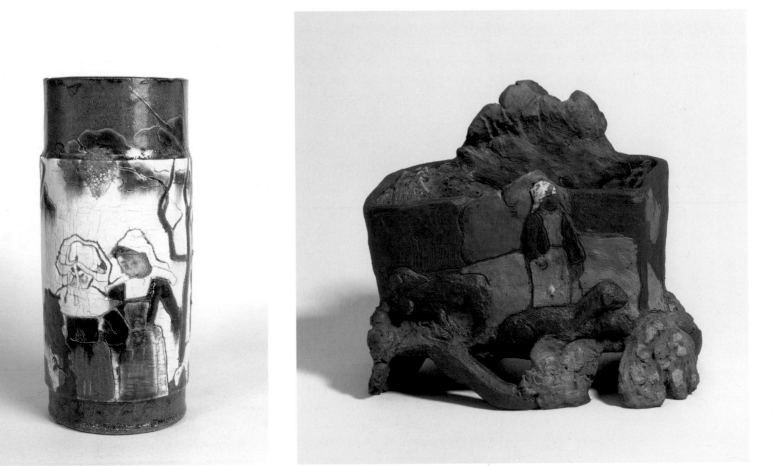

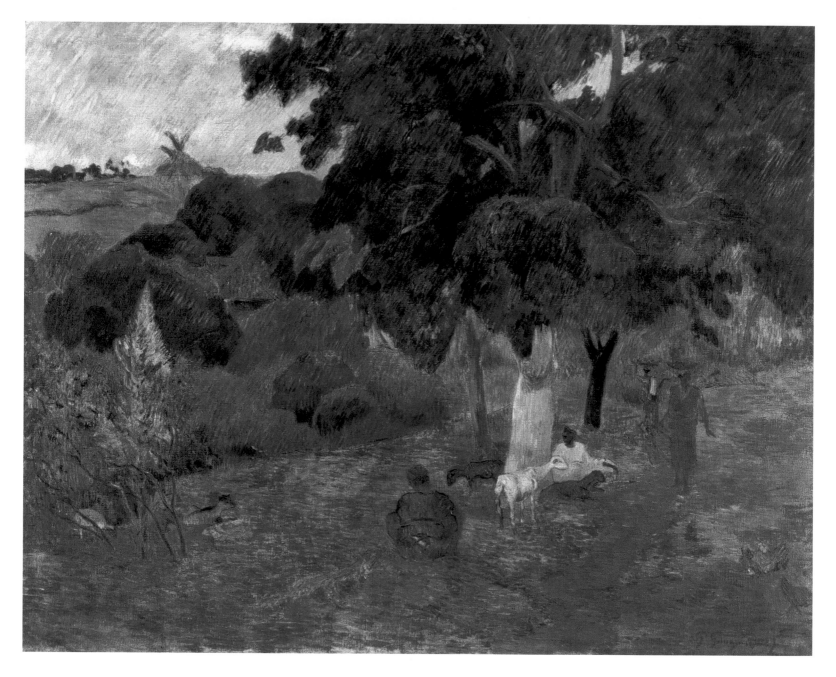

34

31 | Paul Gauguin, *Comings and Goings, Martinique*, 1887*
Museo Thyssen-Bornemisza, Madrid

When Gauguin returned to Paris in late 1887, although in poor health, he had a clearer sense of having an original note to develop in his art. He was armed with a number of new canvases, some of which were immediately put on show by the dealer Portier [plate 7]. In addition, from December 1887 onwards, Theo van Gogh began taking his work on deposit to show at the Boulevard Montmartre gallery which he managed for Boussod & Valadon [plate 31]. So Gauguin's financial prospects looked rosier. He had struck up a relationship with Theo through his brother Vincent van Gogh (1853–1890). The painters had probably met earlier in the year, and now exchanged examples of

their work. Theo made a point of going to see Gauguin, then lodging with Schuffenecker, and selected a few of his paintings and new ceramics. These he would display at regular intervals over the next few years, together with works by Gauguin's old Impressionist colleagues, Pissarro, Guillaumin and Degas.[22]

Vincent van Gogh was particularly enthusiastic about Gauguin's Martinique work, sensing that in this exotic landscape Gauguin had discovered himself and struck a novel note that was personal and unique in modern art. Henceforth he identified his own artistic struggle with that of Gauguin. Van Gogh left Paris for Provence not long after

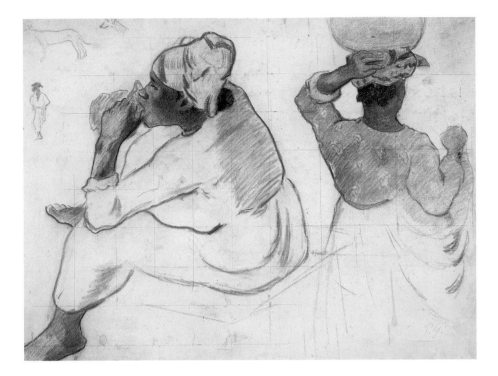

32 | Paul Gauguin,
*Martinique Women with
Mangoes*, 1887
Private Collection

to the artist's fearless savagery suggests that Gauguin's wish to discover and impose his artistic personality had begun to take effect.

Today it is not immediately apparent why Gauguin's Martinique canvases created such a stir. Apart from their heightened colouristic richness and new exotic subjects they are technically consistent with his paintings of the year before, albeit moving in the direction of a leaner, smoother paint surface which counteracts the impastoed effects of the broken impressionistic touch.[26] Perhaps Gauguin drew new confidence from the fact that several of these paintings were the outcome of a more disciplined method, close to that of Degas. They were worked up from powerful drawings and relied less on observation, more on imaginative rearranging and composing [plate 32]. The enthusiasm for the human figure which was revived by his time in Martinique contributed to his wish to deepen his understanding of Brittany.

Over the next few years Gauguin creatively recycled the figure drawings and tropical studies he had done in Martinique, adapting them to a variety of media. For instance he reused landscape motifs in a fan [plate 33], and elegant Martinique women form two subjects in his 1889 zincograph series *The Grasshoppers and the Ants – Souvenir of Martinique* and *Pastorales Martinique* (Van Gogh Museum, Amsterdam). In producing a series of fans Gauguin was again emulating Pissarro and Degas; the latter's fans, produced in a flurry of activity for the 1879 Impressionist exhibition, contained some of his most exciting and inventive approaches to his favourite theme of the ballet [plate 34]. The fan's parabola shape had a liberating effect and enforced a careful consideration of the dynamics of the composition. In both these fans the artists concentrate on broad defining shapes, spatial markers and small areas of figurative interest. In the Degas the mysterious silhouette of a tree-trunk cutting diagonally across the foreground takes time to resolve itself into a stage flat seen from an elevated viewpoint. In the Gauguin the emphasis is again forcibly on the decorative effect, pockets of animation, cow, figures, trees, huts and distant bay serving to articulate distances. Gauguin, a lover of double meanings, was fond of playing on the duality of the word *parabole*, which in French denotes both parabola and parable. Gauguin not only deployed the curved geometric shape in a number of his compositional structures, he also cited Christ's teaching through parables – which the dull of spirit failed to understand – as a model for the narrative complexity of his Symbolist work.[27]

While Degas's interest in his progress was one source of Gauguin's growing confidence over the next few years, another was sensing the positive influence he was capable

35

Gauguin left for Brittany, and over the course of 1888, despite their geographical separation, their relationship developed rapidly through letters, becoming intense, intimate and electric when Gauguin finally joined Van Gogh in Arles.[23] (It is significant that soon after arriving in Provence Gauguin painted a *Negress* (lost), a way of fulfilling his role in Vincent's eyes as the painter of the tropics.) In various articles published during 1888 the critic Félix Fénéon, despite his association with the Neo-Impressionists, drew attention to Gauguin's newly confident pictures. Gauguin's style, he felt, without getting any lighter or brighter (he had earlier pointed out the dense atmospheres typical of Gauguin's landscapes), was 'acquiring a virile eloquence of lines'. He wrote a tellingly detailed account of *Comings and Goings, Martinique* [plate 31], a picture subsequently bought by Degas, which he judged to be both evocative of old illustrations of the Caribbean and true to what he saw as Gauguin's distinctive voice in its use of colours – pink, ochre and 'between dense greens the red clamour of a roof, as in all authentic Gauguins'. The new canvases and ceramics struck him as having a 'barbarous and atrabilious character' in keeping with the personality of this '*grièche artiste*'.[24] Unflattering though the piece was about his personality, for *grièche*, with its implications of ill-tempered, grating vulgarity was a word more usually applied to a fishwife, Gauguin found Fénéon's comments 'passable' as far as his art was concerned.[25] Certainly the way this perceptive critic was now speaking of 'authentic Gauguins' in terms of their dense colour contrasts and drawing attention

33 | Paul Gauguin, *Landscape from Martinique*, 1887*
The Fan Museum, London

34 | Edgar Degas, *Dancers*, c.1879*
Tacoma Art Museum, gift of Mr and Mrs W. Hilding
Lindberg

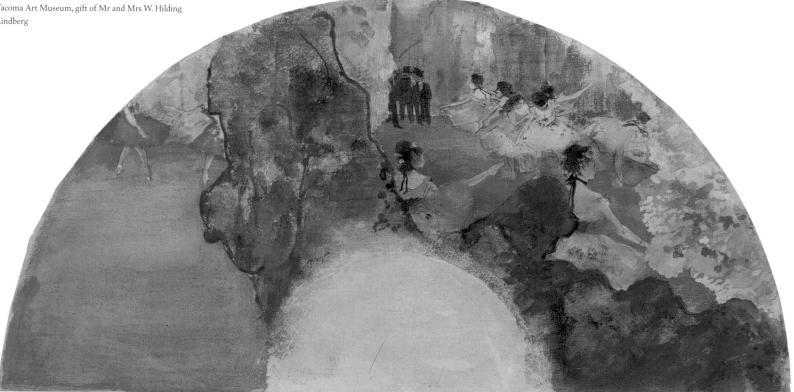

of having on younger artists. Laval, whom Gauguin had evidently saved from suicide in Martinique, now saw him as a messianic figure: 'You are an example and I will follow you with all the strength I have … You have widened my horizons and created space around me … I want to do well to prove that you have done nothing but good … I have faith in you, people will have their eyes opened and you will reach the top; you will rule for those who are capable of understanding. For my part, the more I develop the more I admire your talent and feel respect and affection for you.'[28] It is clear that Gauguin was now in the habit of passing on advice, however experimental and open-ended, to others. Just before returning to Pont-Aven, in January 1888 he took a teaching position in a private Parisian studio run by an Englishman, Rawlins.[29] His motives were presumably financial, but it was a short-lived phase as the studio was soon closed owing to arrears of rent. He would resume this didactic role in Pont-Aven, offering guidance by turns to such younger artists as Laval, Bernard, Ernest

de Chamaillard and Paul Sérusier, not to mention confronting and arguing with the English-speaking painters he found there. By the summer of 1888 the 'Impressionists' grouped around their master, Gauguin, were given their own separate table at the Pension Gloanec. His first recorded letter to Bernard from Arles was written as from a master to a pupil, answering a question about shadows: 'I consider Impressionism entirely novel research, necessarily as far removed as possible from everything mechanical like photography, etc.' Thus, he argued, as shadows tended to reinforce illusionism, it was better to dispense with them, 'unless they contribute an essential form to your composition'.[30] It is important to take note of these positive contemporary perceptions of Gauguin's sagacity if only to offset the confusing picture that can otherwise emerge from the sequence of works that precede *Vision of the Sermon* and from the accusations of ignorance, lack of curiosity and plagiarism that were later laid at the artist's door. [31]

3　The Making of *Vision of the Sermon*

When Gauguin arrived for his second stay in Pont-Aven in January 1888, he planned to stay for seven or eight months. He was set on a prolonged campaign of work that would bear fruit for his artistic development. He was now consciously seeking to imbue his art with the 'character of the people and the landscape'.[1] In a much-quoted letter to Schuffenecker written in February, he took up a newly self-conscious artistic stance: 'You're a Parisianist. Give me the country. I love Brittany: I find in it the savage and the primitive. When my clogs ring out on this granite ground I hear the dull, matt and powerful tone I am trying to find in painting.' So far so well known. But it is the final sentence of the letter, usually omitted, that clarifies why Gauguin felt himself suited to that particular 'tone': 'All that is very sad the *marsouin* [his friend C.A.C. Favre] would say, but to each painter his own character'.[2] Tellingly, in another letter to Schuffenecker written in June the following year, he came back to this theme, writing about his latest religious painting, then in train [plate 107]: 'It has an abstract sadness about it, and sadness is my line you know'.[3] Sadness then, as well as something primitive and savage, was one of the qualities he sought in Brittany. This sadness was in tune with his own mood, something he could play on in his art. But Gauguin's use of such terminology as 'savage', 'primitive' and 'abstract sadness' reveals an awareness of certain literary clichés – or myths – about the essential character of Brittany.

One of the most questionable allegations made about Gauguin, and one that can be countered by any number of literary references in his work and writings, is that he did not read.[4] First put about by Fénéon in 1891, it was roundly contradicted that same year by an artist who had recently spent time with Gauguin in Brittany, Armand Seguin. Writing for a local Breton paper, Seguin spoke of Gauguin's strangely diverse personality and the essentially literary character of his work: 'For all that certain of the Symbolists deny the fact, Gauguin is above all a painter of sensations, which either emanate straight from literary memories or assimilations or, in their entirety, correspond in our mind to certain literary reminiscences. He is almost – and I can find no other word to express my thinking – a philosopher painter, sadly ironic'[5] Without going so far as to seek a literary source for each canvas, it is vital to include literature among the complex of ideas that informed Gauguin's art.

For the author Pierre Loti (pseudomyn of Julien Viaud), then publishing a trilogy of Breton novels, the inherent sadness of this Celtic corner of France was mirrored in its grey granite architecture and rocks.[6] If Gauguin read Loti's bestselling *Mon frère Yves* (1883), he might well have identified with the viewpoint of the narrator, a naval officer based on Loti himself, whose sentimental attraction to Brittany leads him to adopt the native Breton Yves as his 'simple brother'.[7] Somewhat pedestrian though the narrative seems today, it describes two worlds that were particularly pertinent to Gauguin – the life of the sailor on board ship or in some exotic port, and the rural life of Brittany. It is replete with clichéd images of Brittany – tall and delicate church steeples, crude stone calvaries dotting the landscape, quaint Breton costumes and *coiffes*, 'primitive' looking cottage interiors with granite walls, box beds and religious prints. Other writers helped to reinforce the image. In *Le Calvaire*, a runaway success published in the year of Gauguin's first visit to Pont-Aven, Octave Mirbeau used the image of Brittany as a wild sea-battered land with 'tough and honest' inhabitants whose lives are truly touched by tragedy.[8] He offset them against the histrionic tragedy of his hero, sent there to get away from the frenetic and futile life of the capital, in the vain hope of finding consolation for his destructive and obsessive love for a worthless Parisienne. Even ostensibly factual accounts of Brittany, such as Joanne's guidebooks or Yves Kano's survey of *Les Populations bretonnes* (1886), constantly came back to the idea of the region's harshness, a result of its geology.[9] But

40

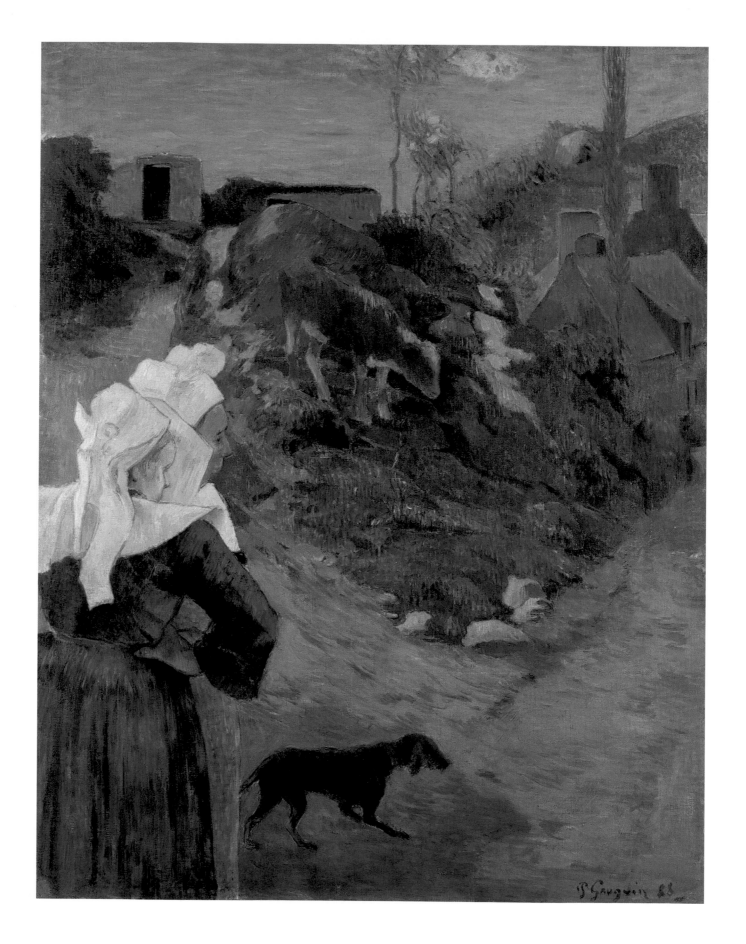

there were different aspects to Brittany. Kano contrasted the desolation of the barren gorse-covered heathland dotted with granite boulders – inviting the mind to reverie – with the pleasing prospect of the verdant valleys, bubbling streams, water mills and the checkerboard effect of stone-walled fields and varied crops.

Until he moved to Le Pouldu on the Finistère coast in 1889 Gauguin made little attempt to convey Brittany as harsh or arid, an aspect that is scarcely apparent in Pont-Aven. But he did seek to evoke its supposedly melancholy character through his cultivation of a more *âpre* – harsh or rough – style, discarding little by little the delicate aspects of Impressionism, the feathery brushwork and subtle colour harmonies. But there were other pitfalls to avoid: all around him he could see academically trained artists falling into the trap of superficiality, getting too involved in sentimental anecdotes or naturalist minutiae, having recourse to photography to inform their exact rendering of landscape or local costume. In building his verbal picture of Brittany's character, Kano coincidentally warned of this sort of pitfall: 'A superficial knowledge, however detailed and minute it may be, can never suffice. A photograph teaches nothing.

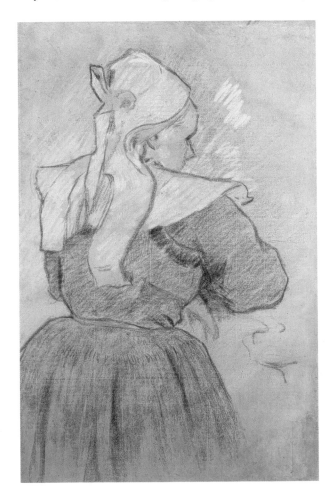

What is needed here is the work of the painter, capable of releasing and throwing light on the characteristic features while deliberately leaving the rest in the shade.'[10]

PAINTING 'PRIMITIVE' BRITTANY

By returning there in 1888, Gauguin was essentially buying into the clichéd view of Brittany's special nature, and accepting it as a source of ready-made subject matter.[11] However, to represent the already popular subject in a conventional naturalist way was not an option. In order to achieve the dull but powerful note of savagery and primitivism he was seeking, Gauguin needed to adopt alternative strategies. One, as we have seen, was to cultivate *fumisterie*. Gauguin was fond of taking a sidelong and amused look at Breton motifs. He played up the Bretons' characteristic, somewhat comical silhouette and their close relationship with the animals in their charge. Breton women and boys were frequently juxtaposed with geese and cows in his work, implying a symbiotic relationship in which each understood the other's language. One should not forget that most of the inhabitants of Pont-Aven spoke Breton to each other, even if they were able to converse in French when they needed to. This difference of language and the barrier to communication it created accounts to a large degree for the perceived strangeness and exoticism of the Bretons in Gauguin's eyes. To fuel his new highly personal approach to familiar Breton themes he also exploited unusual and 'primitive' source material – be it Breton vernacular, in the form of crude popular prints, decorative stained glass, carvings in wood or stone and local pottery, or oriental, in the form of Japanese prints.

In the late winter and early spring of 1888 Gauguin's methods followed the hybrid model of his Martinique work – plein-air, observed landscapes but compositions contrived from earlier drawings. In *Landscape from Brittany with Breton Women*, he turned to drawings from two years earlier [plates 18, 35, 36]. The head of the main figure relates closely to one of the large drawings of 1886, her hand on hip posture to another. In the painting Gauguin has merged her white *coiffe* with that of her companion whose features have the kind of sullen stupidity he would accentuate in other Breton compositions, including *Vision of the Sermon*. The landscape which stacks up behind these women – a faithful record of the steep gradients around the village of Pont-Aven – is articulated by a bend in the road and by two animals, a black dog and a calf. Pont-Aven's grey-toned buildings and church steeple emerge more clearly in *Landscape from Pont-Aven, Brittany* [plate 37]. The figure is again based on a Degas-like drawing; the calf, like the cow that appears to upper left in *Vision of the*

41

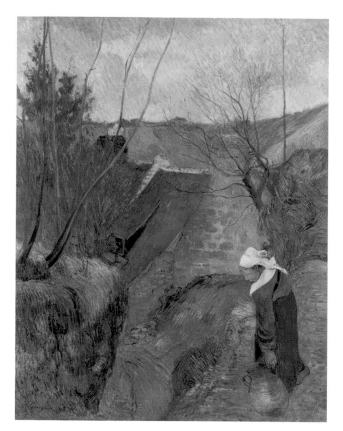

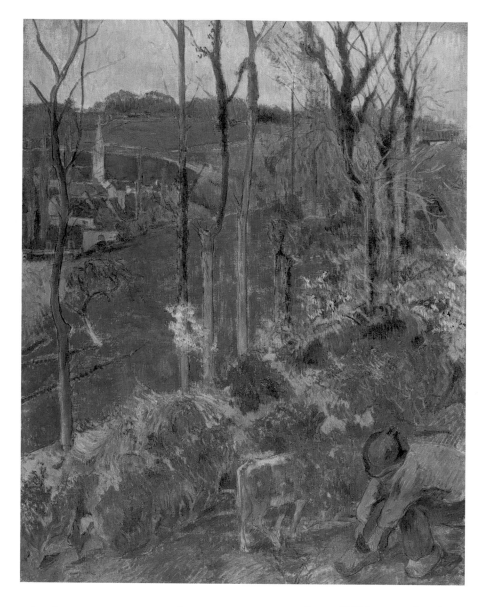

37 | Paul Gauguin,
*Landscape from Pont-Aven,
Brittany*, 1888*
Ny Carlsberg Glyptotek, Copenhagen

38 | Paul Gauguin, *Breton
Woman with Pitcher*, 1888
Niarchos Collection

Sermon, seems unnaturally small. Taken together these two compositions seem to imply that the Bretons treated calves as privileged animals and allowed them to wander free, albeit supervised, around the village.

For *Breton Woman with Pitcher* [plate 38] Gauguin once again turned to earlier drawings. The figure carrying her pitcher to the stream has the hunched foreshortened pose seen in the right-hand figure in *Four Breton Women* [plate 24]. Tellingly Gauguin's 1886 drawing was itself based on a Degas drawing of a dancer adjusting her slipper shown at the Impressionist exhibition of 1876.[12] Although the bare branches suggest another wintry or early spring day, the splash of brilliant orange foliage, which Gauguin may have introduced arbitrarily simply to counterbalance the vermilion of the woman's skirt, could imply an autumnal scene. What these three paintings have in common is their some-

what complex synthetic conception combined with a relatively naturalistic and impressionistic handling. They show clearly that Degas and Pissarro were still very much in Gauguin's mind. In all three, Pont-Aven's characteristic grey granite architecture is seen as of a piece with nature, the rocks, the boulders in the stream, the wintry tree trunks. But whereas greys and greens dominate and muffle the tonality of the first two, the brilliant accents of red and orange in the third lift the whole visual effect of the composition on to a new plane.

From some of his complaints about the weather in the spring of 1888, it is clear that Gauguin did still expect to work *en plein air* but could not rely on being able to finish anything out of doors as he had evidently done on his previous visit; often the season's changes got ahead of him. By August he had adopted a working method that was less reliant on outside conditions and stimuli, writing to Schuffenecker: 'Do not paint too much from nature. Art is an abstraction; extract it from nature while dreaming in front of it and pay more attention to the act of creation than to the result … I'm making good progress with my latest works, and I think you will find a new note, or rather the affirmation of my earlier attempts at synthetising one form and one colour, without either being the dominant.'[13] This letter was written soon after Emile Bernard's arrival and

betrays the need Gauguin felt at that juncture to take stock of his progress that year, but also to assert himself in the presence of this talented youth.

This progress is apparent in Gauguin's increasingly free and expressive use of colour. In a number of his late spring and summer landscapes he had found plausible naturalistic pretexts for introducing red, that strident colour which Fénéon had identified as his hallmark. But one is hard put to see the justification in nature for the decorative red patches in *Breton Woman and Goose* [plate 39], presumably a summer painting since it shows a bare-legged Bretonne paddling in the stream. And in *The Wave* [plate 40], there is an even more arbitrary synthesis of form and colour: a vibrant red denotes a patch of sand to the upper right of the composition. In its theme, its calligraphic rendering of the water and its use of non-naturalistic red, this composition shows Gauguin's awareness of prints on comparable themes by such Japanese artists as Hiroshige and Hokusai.[14] In another plunging cliff view, *Seascape with Cow* (Musée des Arts Décoratifs, Paris), Gauguin uses a startling red in the hay, cliffs and rocks, and the whole composition has a suggestive anthropomorphic strangeness.[15] In mid-August Gauguin wanted to offer a work of art as a birthday gift to his landlady, Marie-Jeanne Gloanec, as was customary in the Pension Gloanec, the walls of which were lined with such painted gifts. He composed a decorative still-life of galettes and fruit and contrived to treat most of the background as a single dominant block of red [plate 41].[16] Looked at this way Gauguin's decision in September to use vermilion for the field in *Vision of the Sermon* seems less of an extraordinary aberration, more the culminating point of a painterly obsession. Recalling his time in Arles at the end of the year, when he and Van Gogh had fought over their favourite colours, Gauguin remembered: 'I adored red; where could one find a perfect vermilion?' [17]

Strong vermilions could certainly be achieved in nineteenth-century prints. That Gauguin owned Japanese prints is confirmed by a number of witnesses. Rotonchamp recorded the appearance of Schuffenecker's house in early 1890, with its frieze of prints by Hokusai and Utamaro: 'These prints, as well as some interesting original Japanese drawings, belonged to Gauguin, who had also pinned up here and there a few photographs after well-known works by Manet and Puvis de Chavannes. The artist had been given by Joyant one Utamaro print worth 300 francs in exchange for paintings.'[18] There is good reason to suppose that Gauguin was already the owner of a number of Japanese prints by 1888, as were most artists in his circle.[19] Indeed documentary evidence is offered by his *Still Life with Japanese Print* of 1888 [plate 42], in which a

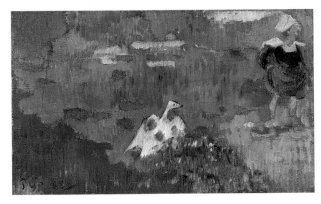

39 | Paul Gauguin, *Breton Woman and Goose*, 1888
Museum of Fine Arts, St Petersburgh, Florida, extended anonymous loan, TR 4386.3

40 | Paul Gauguin, *The Wave*, 1888
Private Collection

41 | Paul Gauguin, *Still Life, Fête Gloanec*, 1888
Musée des Beaux-Arts, Orléans

42 | Paul Gauguin, *Still Life with Japanese Print*, 1888
Private Collection

43 | Toyoharu Kunichika, *Two Sections of a Theatrical Triptych*, c.1870–80*
National Museums of Scotland, Edinburgh
The scene shows Nakamura Shigwan as Dengoro (out of image) brandishing a cudgel, Ichikawa Sadanji as Kuzo seizing Onoe Kikugoro as Kojiro, watched by Bando Shucho as the lady Matsugaye.

44 | Utagawa Hiroshige, *Plum Estate, Kameido*, 1857*
National Museums of Scotland, Edinburgh
This print, number thirty from *One Hundred Famous Views of Edo*, was owned by Vincent van Gogh. When Van Gogh copied it in 1887, during his stay in Paris, he intensified the colours, painting the sky an intense red.

Cézannesque still-life with fruit and a jug incorporates a Japanese actor print on the wall. Without doubt this was an actual print, not an approximation, as the same print – which seems to feature actor figures in blue against a red background – appears on the wall in Gauguin's group portrait of *The Schuffenecker Family* (Musée d'Orsay, Paris), painted at the Schuffenecker studio in Paris early the following year. So far it has not proved possible to identify this print, although plausible candidates for its authorship are the artists Kunisada and Kunichika [plate 43].[20] The intensity of the red background indicates a date no earlier than the 1860s, when the aniline inks on which the red was based first began to be imported to Japan from the west. The print's theatrical use of silhouetted figures and background

of red make it one of the immediate prompts for Gauguin's colour use in *Vision of the Sermon*. Emile Bernard claimed that Gauguin borrowed his Jacob and the Angel figures from a Japanese album.[21] The usual source cited for this borrowing is Hokusai, whose lively Manga or comic-strip books were well known to French artists of the day. However the similarity is generic rather than specific.

There were plenty of stimuli to keep artists thinking about Japanese art in 1888. In Paris the best-known purveyor of Japanese wares was Siegfried Bing, whose shop was much frequented by Vincent van Gogh. In addition, Hayashi Tadamasa, a Japanese dealer, had been selling prints since 1883. In the spring of 1887, Van Gogh organised an exhibition of Japanese prints in the café du Tambourin, which Gauguin could well have seen before his departure for Martinique. Vincent painted copies of three of the prints he owned, including Hiroshige's *Plum Estate, Kameido* [plate 44], a famous image in which the startling use of spatial planes, diagonal tree-trunk and red background may itself be of relevance to the composition of *Vision of the Sermon*. Vincent's letters make clear how imaginatively steeped he was in Japanese art; in Provence he felt he had found an equivalence of his somewhat idealised dream of Japan and now sought to perpetuate that country's imagined fraternal society through artistic exchanges. In May 1888 Bing launched an important new publishing venture, the monthly journal *Le Japon artistique*, targeting artists and industry. Its first issue coincided with an exhibition in his shop devoted to his own collection of Japanese wood engravings, one of the first serious attempts to explain in a historical way the different masters, schools and styles.

45 | J.-L. Nicolas (Pellerin, Epinal), *Notre-Dame de Rumengol, Patron Saint of Brittany*, 1858*
Musée départemental breton, Quimper

46 | Amédée Guérard, *Farm Interior* or *Sick Child*, c.1870*
Musée départemental breton, Quimper

47 | Emile Bernard, *Lottery Ticket: Virgin and Child*, inscribed, in reverse, 'Loteri pour un povre', 1891*
Collection R.T., Brest

48 | Louis Anquetin, *Avenue de Clichy*, 1887*
Private Collection, courtesy of Brame Lorenceau, Paris

Although Gauguin was not in Paris to see it, he is likely to have been aware of the discussions surrounding these new developments; Fénéon, for instance, covered both events in *La Revue indépendante*.

Other possible prompts for the stark use of red and simplified style of *Vision of the Sermon* were Breton religious prints [plate 45]. Crudely produced, the sheets were either printed locally, in the Pellerin workshop at Rennes for example, or transported from Epinal and distributed by travelling salesmen for small sums. While they could be found in rural households throughout France, the popularity of religious imagery was greater and more persistent in Brittany than elsewhere.[22] Amédée Guérard's Salon painting *Farm Interior*, c.1870 [plate 46], with its tender scene of a sick child in a traditional Breton carved box bed, is one of several genre paintings documenting the way in which these prints were displayed in Breton homes and the votive uses to which they were put. Most peasant and farming families would have had a collection of images. Emile Bernard's enthusiasm for such popular imagery is well documented. In several instances he imitated their angular forms in his own woodcuts and paintings, although the dating of these is sometimes hard to determine. But his deep absorption in medieval art seems to have burgeoned from 1889 onwards [plate 47]. In 1892, for instance, he contributed woodblock prints to the short-lived journal *Le Bois*, promoting the medium's revival; in 1894 he collaborated with Rémy de Gourmont and Alfred Jarry to produce the periodical *L'Ymagier*, specifically devoted to reviving the traditional art of the woodcut. It seems unlikely that prior to Bernard's arrival in Pont-Aven Gauguin was oblivious to these colourful, simplified, predominantly religious images. While the case for direct influence would be hard to make, the relevance of such prints to Gauguin's conceptualisation of Brittany and its piety and superstition seems clear. Here was a widespread form of local imagery with an explicitly religious content, heightened through the naïvety and directness of drawing and the expressive, dramatic use of primary colours. It was invested with the power to move the emotions of the spectator, to inspire devotion and ward off harm. For the cynical viewer, such popular imagery

played on fears and reinforced superstitions. Its ubiquity was a vivid visual reminder in a largely sceptical and republican country of the thrall in which Breton men and women remained to the Roman Catholic Church.

CLOISONISM

The use of simple outlining and blocked colour in *images d'Epinal*, Japanese prints and stained glass was cited by the critic Edouard Dujardin as a possible template for a new form of advanced painting. This new style, launched by his old friend Louis Anquetin (1861–1932), at last offered a viable alternative to the dead-end of *trompe l'oeil* naturalism. The article was prompted by seeing Anquetin's recent paintings at *Les Vingt* in Brussels.[23] To describe them, Dujardin coined the label 'cloisonism', a term he derived from the applied art of cloisonné enamels where colour is separated into compartments by bands of metal. It seemed to fit Anquetin's new manner of painting in flat tones and firm outlines, a manner he had evolved after a 'vigorous apprenticeship' experimenting with all forms of Impressionism. Dujardin's descriptive analysis, which doubled as a recipe for would-be adherents of the new technique, emphasised the new method's strict separation of drawing and colouring, the former to establish the permanent character of the object represented, the latter to establish the general tonality. Thus, according to Dujardin, in Anquetin's *Avenue de Clichy* [plate 48], two tones sufficed, blue to suggest

evening, red to suggest gas lamps lighting up. In developing his new style, Anquetin, according to Dujardin, had recognised the futility of trying to represent nature in all its trivial details and set out instead with 'a symbolic conception of art'. This marked a major aesthetic shift, parallel to a shift taking place in literature. Anquetin may not have perfected the theory – and indeed in this modern street scene was still treating an essentially naturalistic subject – but he had offered an important step forward.

Although it is uncertain whether Gauguin read Dujardin's article, the ideas it contained would certainly have been discussed that summer. Vincent van Gogh, for instance, on hearing about the article from Theo, took exception to Dujardin's promoting Anquetin over Seurat as leader of the avant-garde.[24] He is likely to have raised the question again in his letters to Bernard or Gauguin, several of which have been lost. In his own painting that summer Van Gogh was emboldened to experiment further with the Japanese manner, to use colour ever more arbitrarily and to contain it within bold outlines so as to heighten its emotional impact. In his series of sunflower paintings, he told Bernard he had achieved effects like 'stained-glass windows in a Gothic church'.[25] Emile Bernard would also have read Dujardin's article, having been closely involved in the development of the cloisonist style the previous year in Paris [plate 57]. Perhaps he felt somewhat sidelined, for the first but by no means the last time, by this critical promotion of an erstwhile colleague.

49 | Paul Gauguin, Letter to Vincent Van Gogh with sketch of *Breton Boys Wrestling*, 24–5 July 1888*
Van Gogh Museum, Amsterdam (Vincent van Gogh Foundation)

50 | Paul Gauguin, *Breton Boys Wrestling*, 1888
Private Collection

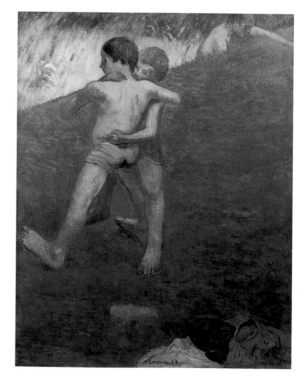

51 | Emile Bernard,
Lane in Brittany, 1888*
Van Gogh Museum, Amsterdam
(Vincent van Gogh Foundation)

52 | Emile Bernard,
*Working Woman
Kneeling*, c.1888*
Collection R.T., Brest

Prior to Bernard's arrival, Gauguin was deploying Japanese mannerisms as a way of abstracting from nature and countering his over-dependence upon Degas. He was convinced that he had been successful, writing to Van Gogh: 'I have just finished a Breton wrestling match which you will like I am sure Two lads blue and vermilion shorts. Another climbing up out of the water to the upper right – green sward – pure Veronese modulating to chrome yellow *without visible brushwork* [*exécution*] like the Japanese *crépons*.' [plates 49, 50].

GAUGUIN AND BERNARD IN PONT-AVEN

This time when Emile Bernard arrived in Pont-Aven, in mid-August 1888, he made an immediate impression. Gauguin told Vincent that he found him intriguing as a personality, and Schuffenecker that he had brought interesting things from Saint-Briac. Bernard was still only twenty, yet his relative inexperience was compensated by a fearlessness, a rebellious spirit, a ready artistic curiosity, a

53 | Emile Bernard, *Portrait of the Artist's Grandmother*, 1887
Van Gogh Museum, Amsterdam (Vincent van Gogh Foundation)

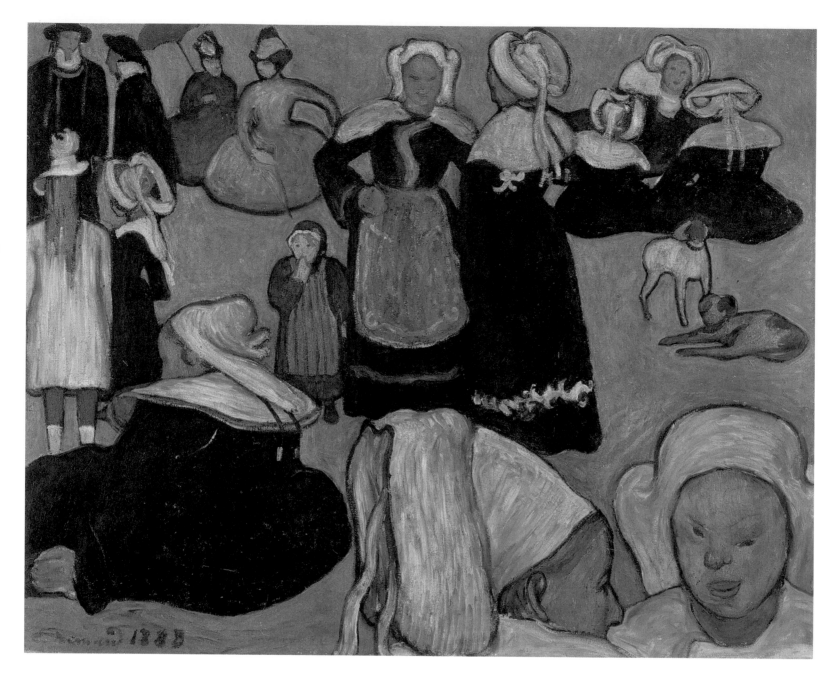

54 | Emile Bernard,
Breton Women in the Meadow /
Pardon at Pont-Aven, 1888*
Private Collection

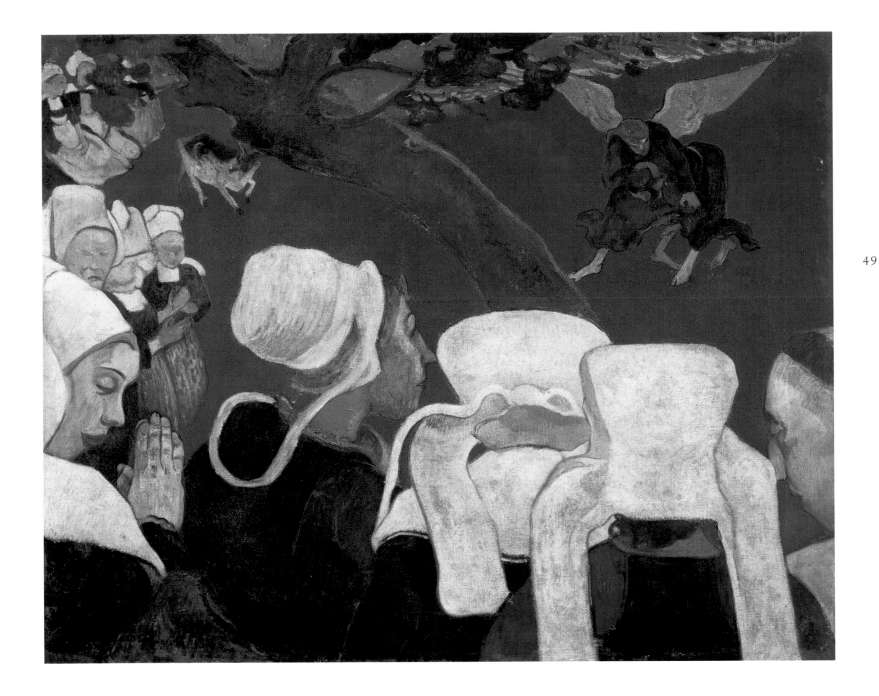

55 | Paul Gauguin,
*Vision of the Sermon: Jacob Wrestling
with the Angel*, 1888*
National Gallery of Scotland, Edinburgh

56 | Charles Laval, *Going to Market, Brittany*, 1888*
Indianapolis Museum of Art, Samuel Josefowitz Collection of the School of Pont-Aven, through the generosity of Lilly Endowment Inc., the Josefowitz Family, Mr and Mrs James M. Cornelius, Mr and Mrs Leonard J. Betley, Lori and Dan Efroymson, and other Friends of the Museum

57 | Emile Bernard, *Breton Woman with Large Coiffe*, 1887*
Musée d'Orsay, Paris (held by the Département des Arts graphiques, Musée du Louvre, Paris)

gift for caricature and an intelligence which allowed him to assimilate ideas quickly. In Paris Bernard had recently painted some still-lifes and portraits in a robust Cézannesque manner. This alternated with a flatter, more cloisonist manner he used for landscapes on the one hand – modern, deliberately unprepossessing suburban views in line with the Neo-Impressionists – and on the other for imaginary subjects. In short Bernard was precociously talented but eclectic and unfocused, veering between seemingly opposed styles and subjects.

The works he brought to Pont-Aven in 1888 presumably included paintings and drawings done on his journey. His quick and amusing studies of Breton women would surely have intrigued Gauguin [plate 52]. Meanwhile he was sending Van Gogh drawings on Breton themes [plate 51], and on the theme of the brothel, an interest Bernard shared with his somewhat older fellow students from the *Atelier Cormon*, Anquetin and Henri de Toulouse-Lautrec. These and the poems that accompanied them reveal a somewhat neurotic attraction towards the lurid and morbid, preoccupations of the decadent poets Bernard admired. Without condemning the drawings themselves, Van Gogh clearly felt unwholesome and disparate influences were sapping Bernard's energies and leading him astray. He urged him to concentrate on portraiture and still life, genres for which he had shown such a strong aptitude. Vincent would surely have mentioned to Gauguin the painting by Bernard he admired above all other, his remarkably strong

Cézannesque portrait of his grandmother [plate 53]. But Bernard's recent efforts in Saint-Briac had been directed towards painting a multi-figure decoration for the wall of the studio in the inn where he stayed. This mural seems to have had a religious theme, which would explain Bernard's preoccupation with the 'mystical' art of the Italian primitives that he and Van Gogh evidently discussed in their correspondence. The decoration no longer exists but a damaged photograph and a sketch traced on to transparent paper survive.[26]

Bernard's other 'asset' was his younger sister Madeleine, a pretty and intelligent girl to whom he was extremely close. Eager to support her talented brother, she had already stayed with him in Saint Briac, enjoying a remarkable freedom for a seventeen-year-old *bourgeoise*. She came to Pont-Aven chaperoned by her mother, whose presence ensured that no impropriety attached to her participating fully in the heady artistic mix. For Bernard's father, by all accounts a fretful parent who only grudgingly gave his wayward son an allowance, it must have been an anxious time. Quite apart from the large foreign contingent staying in the village, Gauguin's circle was entirely made up of male artists such as Charles Laval, Ernest de Chamaillard and Henri Moret, any of whom might have fallen for Madeleine. Laval would indeed in due course ask to marry her. More surprisingly the determinedly hard-hearted Gauguin seems to have been disarmed.

The weather was poor that August, so instead of sea

bathing and open-air excursions Madeleine found herself in the enforced proximity and small rooms of the Pension Gloanec, and on at least two occasions posing for her portrait. Bernard painted her lying in the Bois d'Amour, like a *gisante* on a medieval tomb, and Gauguin painted her looking more coquettish (Musée des Beaux-Arts, Grenoble). With the typical enthusiasm for folklore of an artistic outsider, Madeleine took to wearing Breton costume, presumably on Sundays rather than every day, encouraging the local women not to abandon their distinctive mode of dress. When, shortly after her arrival, Mme Gloanec's birthday was celebrated, Gauguin conspired with Madeleine to circumvent censure of his radical *Still life, Fête Gloanec* [plate 41]. To ensure his painting was hung with the other gifts, he signed it *Madeleine B*, evidently on her suggestion. If the still-life incident brought Gauguin and Madeleine together in a conspiratorial way, she took her assigned role as artist's muse to heart. Indeed, any attraction Gauguin felt towards Madeleine seems to have been reciprocated, to judge from a star-struck letter she wrote her brother on returning to Paris.[27] In this letter she hails Gauguin as the 'greatest artist of the century'. She also refers to the habitual banter between Gauguin's table and that of the other artists at the Pension Gloanec, naming Dauchons, Jourdan and Wigand. Wigand, incidentally, can be identified as the American Otto Wigand (1856–1944), who showed a prosaic painting on a suggestive religious theme at the Salon of 1887 [plate 72].

The renewed enthusiasm for work and lively exchanges of ideas prompted by Bernard's arrival were not lost on Van Gogh, who had encouraged the younger painter to seek out Gauguin. At the practical level, since his brother Theo was now committed to helping Gauguin, it suited him to see the

latter's influence over younger artists increase, even though this risked delaying the outcome he longed to see realised of the shared 'Studio of the South' in Arles with Gauguin at its head. But he became increasingly fearful that Gauguin, whom he idolised as the equivalent of the Renaissance poet Petrarch, would find Arles a backwater compared with the lively hub of intellectual activity in Pont-Aven. He was convinced, nevertheless, that the Impressionists, working together, could bring about a second Renaissance in painting.[28] Thus it was with a mixture of gratification and envy that he monitored the progress of the fraternal community in Pont-Aven, to which he had also made his artistic contribution: Bernard had made an album of the sketches Van Gogh had sent him, and he and Gauguin had studied them together. 'They are enjoying themselves very much', Vincent told Theo, 'painting, arguing and fighting with the worthy Englishmen; he [Gauguin] speaks well of Bernard's work, and Bernard speaks well of Gauguin's'.[29] Wisely, Van Gogh intuited that it was a fragile state of affairs: 'Today while I was working I thought a lot about Bernard', he wrote to Theo in September. 'His letter is steeped in admiration for Gauguin's talent. He says that he thinks him so great an artist that he is almost afraid, and that he finds everything that he does himself poor in comparison with Gauguin. And you know that last winter Bernard was always picking quarrels with Gauguin'.[30] By the end of that summer Gauguin clearly felt his group in Pont-Aven were breaking new ground, and it was perhaps the younger artists who were being the most outrageous: 'Laval and Bernard are tormenting Impressionism to death', he told Schuffenecker [plate 56].[31]

It was in this feverish atmosphere, and perhaps coincident with their discussions about 'painting like children',

58 | Paul Gauguin, Preliminary sketch for *Vision of the Sermon*, 1888
from Walter Sketchbook, Musée du Louvre, Département des Arts Décoratifs, Fonds Orsay, Paris

59 | Paul Gauguin, Sketch of *Vision of the Sermon* accompanying a letter to Vincent van Gogh of 25–7 September 1888*
Van Gogh Museum, Amsterdam (Vincent van Gogh Foundation)

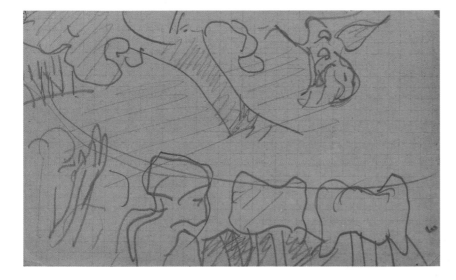

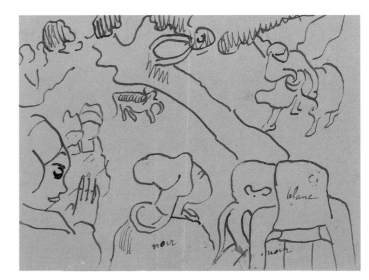

60 | Photograph in profile of Paul Gauguin in 1891 wearing a Breton waistcoat

61 | Paul Gauguin, *Self-portrait: Les Misérables*, 1888
Van Gogh Museum, Amsterdam
(Vincent van Gogh Foundation)

that Bernard painted *Breton Women in the Meadow* [plate 54] and Gauguin painted *Vision of the Sermon* [plate 55], identically sized works on Breton themes, composed with a child-like frontality and simplicity, and painted in a boldly synthetic style.[32] Before examining these paintings in detail, Laval's original foray into the synthetic style deserves consideration. *Going to Market, Brittany* [plate 56] is a daring composition on a non-religious theme in which the Breton figures are seen at close quarters from an oblique angle. The white collar of the woman in the cart has been caught in a gust of wind and raised around her face like a cape. Although Laval's painting is in essence a naturalistic glimpse of an exceptional moment, not unlike a Degas in conception, his drawing and paint handling are daringly crude, abbreviated and comic and he makes bold use of complementary blocks of red and green in the background.

The fascination with children as *subjects* is evident from Gauguin's sketchbooks and his recent painting, *Breton Girls Dancing, Pont-Aven* [plate 64]. It can be seen as consistent with his desire to capture an essential quality of simplistic naïvety, previously overlooked by Brittany's painters. Bernard's drawings have a childlike quality about them too. Did Gauguin urge him to transfer this quality into his paintings? Certainly *Breton Women in the Meadow*, similar in size and colour scheme to Breton Girls Dancing is like a caricatural exaggeration of Gauguin's graceful dance subject. The treatment of the figures, dispersed evenly across the flat yellow-green surface, is deliberately crude. Their shapes, solid black or contained within heavy black outlines, sit on the surface like the lead interstices in stained-glass. Indeed Bernard had been experimenting with stained-glass

effects since the previous year [plate 57]. The large, crudely handled *coiffed* heads are reminiscent of Van Gogh's studies of peasant heads which Bernard had seen and admired in Julien Tanguy's shop; the general air of festivity and narrative disconnection harks back to Seurat's *A Sunday on La Grande Jatte* [plate 7]. The faces are blank or schematic; an exception is the individual to lower right looking out at the spectator, whose small slanted eyes, ample lips and flattened features could indicate a woman with Down's syndrome. Unverified and probably unverifiable, the idea that there was such a known individual in Pont-Aven is intriguing. Gauguin represents a similarly featured woman in his *Breton Calvary* or *Green Christ* [plate 99].[33] Although there is no immediately apparent religious dimension to Bernard's composition, its theme seems to be similar to Boudin's earlier painting, a gathering for a Pardon. This would have been more readily understood once Bernard gave it the title *Pardon at Pont-Aven*.[34]

The exact dating of Bernard's painting has been the subject of debate. Some scholars suggest it was executed in mid-August, in line with the artist's claim that it was prompted by 'a fête in Pont-Aven': this fête, it is pointed out, could have been the Feast of the Assumption on 15 August which coincided with the feast day of Marie-Jeanne Gloanec.[35] Others point to 16 September, presumably because in a more detailed account Bernard asserted that he painted it straight after the Pardon of Pont-Aven, which took place annually on 16 September.[36] Were this the case it leaves a mere ten days in which Gauguin could have started and largely completed *Vision of the Sermon*, assuming his composition followed Bernard's. For one thing is certain:

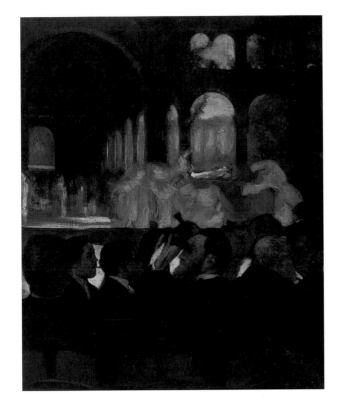

Vision of the Sermon was complete, apart from minor details, by the time Gauguin wrote and sent his sketch of it to Van Gogh in late September [plate 59]. Contrary to certain claims, its dating does not depend upon any Pardon, for Gauguin does not purport to depict a Pardon as such; sermons were delivered at the regular Sunday mass.[37] Maybe Bernard and Gauguin worked on their canvases simultaneously; maybe Gauguin began his painting before seeing Bernard's, and merely adjusted it in response to the latter.[38] A plausible time frame would have Bernard painting his composition in the second half of August, and Gauguin beginning his no later than early September, and

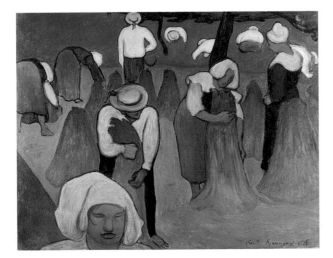

possibly earlier. This accords with the technical observations of Gauguin's paint layers and handling, which suggest some drying time between applications of paint and a certain deliberation on the artist's part.[39] *Vision of the Sermon* would certainly appear to have been worked on over a longer period of time than Bernard's *Breton Women in the Meadow*.

It is an extraordinary fact that in the case of *Vision of the Sermon* there are no surviving studies of the individual figures, indeed none of the considered preparatory work we find in relation to Gauguin's previous figure paintings exists.[40] There is only one preliminary drawing jotted in a sketchbook, a rough compositional idea [plate 58]. Yet the canvas is painted fluently with few hesitations; once it left his studio there is no evidence that Gauguin reworked it, although it may have been relined in his lifetime.

Gauguin described his painting clearly and in some detail for Vincent's benefit, aware that his explanations would be relayed to Theo.

I have just painted a religious picture, very clumsily but it interested me and I like it. I wanted to give it to the church of Pont-Aven. Naturally they don't want it. A group of Breton women are praying, their costumes a very intense black. The bonnets a very luminous yellowy-white. The two bonnets to the right are like monstrous helmets. An apple tree cuts across the canvas, dark purple with its foliage drawn in masses like emerald green clouds with greenish yellow chinks of sunlight. The ground (pure vermilion). In the church it darkens and becomes a browny red.

The angel is dressed in violent ultramarine blue and Jacob in bottle green. The angel's wings pure chrome yellow 1. The angel's hair chrome 2 and the feet flesh orange. I think I have achieved in the figures a great simplicity, rustic and superstitious. The whole thing very severe. The cow under the tree is very small in comparison with reality and rearing up. For me in this picture the landscape and the struggle exist only in the imagination of the people praying owing to the sermon which is why there is contrast between the life-size people and the struggle in its non-natural, disproportionate landscape.[41]

Two curious points, easily overlooked, emerge from this description. First, the painting was conceived by Gauguin from the outset as a religious painting for a church, and yet he wished to evoke the women's 'superstitious' nature. This is not as contradictory as it appears. Contemporary commentators on Brittany – Loti for instance and Adolphe Joanne – noted the many fanciful superstitions that lingered in Brittany, despite its piety. They were a source of conflict with the orthodox Roman Catholic Church and a major curiosity for tourists. Secondly, the description omits all

64 | Paul Gauguin, *Breton Girls Dancing, Pont-Aven*, 1888*

National Gallery of Art, Washington, collection of Mr and Mrs Paul Mellon

mention of a priest. This suggests the figure to the lower right had yet to be added – nor is he present in the sketch. Also absent from the sketch is the frowsty woman scowling at the spectator from centre left. It is scarcely plausible that Gauguin simply forgot to include these figures, even if he made the sketch from memory without reference to the painting, which seems unlikely. The presence of the face to lower right is crucial, not incidental: it serves to close and complete the composition, matching the praying woman on the left rather like donor figures in a Renaissance altarpiece, giving the whole composition a hieratic symmetry.[42] More likely, they had yet to be added. But why in that case would Gauguin have described the painting as finished? One reason may lie in the rhythm of his correspondence with Vincent van Gogh. Their relationship, from one of intense admiration and deference on Vincent's part, more cautious reciprocal sharing of ideas on Gauguin's, had intensified into one of discreet but serious competition. Since May Gauguin had been postponing his standing invitation to join Vincent in Arles, and was acutely conscious of being seen to procrastinate by the Van Gogh brothers. Vincent had written often and at length of the hopes he had of their shared life together in the South, had prepared Gauguin's room in his yellow house with great care and solicitude, was even now painting a series of canvases to decorate it. So

Gauguin needed a justification for his continued prevarication: proof that he was working well and producing an important new work on a specifically Breton theme was just that.

Close analysis of the painting with infrared reflectography confirms the suspicion that the priest figure, if such he is, was one of the trickiest areas to resolve. This is one of the few areas in an otherwise confident composition to reveal changes of mind on the artist's part: the profile we see was painted in over another smaller and possibly female profile (see pp.111–19). This figure's identity as a priest is not universally accepted. It is in any case a discreet identification, signalled solely by the glimpse Gauguin gives us of what could be a partially shaven head. More provocatively, it has been suggested that this *profil perdu* represents Gauguin himself. The low forehead, prominent hooked nose and bulbous eye sockets all speak to this likeness, as a comparison with photographs of Gauguin testifies [plate 60].[43]

The idea of inserting himself into his picture, especially in the guise of priest, raises many questions. Perhaps it evolved in Gauguin's mind after the picture was turned down by a second priest at Nizon, a case of getting his own back at the obtuse clerics who had rejected his offer. It was surely significant that Gauguin was concurrently working

55

65 | Paul Gauguin, Study for
*Breton Girls Dancing / Ronde
Breton*, 1888*
Van Gogh Museum, Amsterdam
(Vincent van Gogh Foundation)

on his *Self-portrait: Les Misérables*, undertaken at Vincent's behest [plate 61]. According to his own explanation, in this strange, complex work Gauguin lent his features to Jean Valjean, the outlaw hero of Victor Hugo's novel, hounded by society, in some sort of expression of artistic solidarity. He explained that doing good (as Jean Valjean, for all his years as a convict, had done in the novel) was the best way the artist had of exacting vengeance on an uncomprehending society. No equivalent explanation of the ambiguous figure in *Vision of the Sermon* survives which leaves the question open to debate. Was Gauguin seeking to stamp a more personal mark on this important, soon-to-be public picture, to present a different, more noble and empowering aspect of the modern artist, a being of spiritual and visionary powers, a conduit for ordinary humanity's dreams and imaginative experience? Certainly, the following year he would go a stage further, identifying himself with the suffering Christ.

Gauguin made two further general references to his 'painting for a church', in letters written about a fortnight after his first letter to Vincent, but this time he did not bother with descriptive detail, knowing his readers were about to see the picture for themselves. To Theo van Gogh he again stressed the point that the picture had been painted with a church setting in mind: 'What works there, in that setting of stained glass, stone etc., doesn't have the same effect in a salon' [plate 82].[44] And to Schuffenecker he stressed that it was style that he felt he had achieved, at last, in this important work: 'This year I have sacrificed everything, execution, colour, for style wishing to make myself undertake something different from what I know how to do.'[45]

In its new-found boldness and flat decorative quality, *Vision of the Sermon* owes something, unquestionably, to the style of Bernard's innovative painting. Both artists make play with the close up, cut-off figures of simplified Breton women, their decorative *coiffes* seen as simple shapes against a unified background. This treatment has a flattening effect which inhibits a spatial reading – despite the rudimentary use of perspective in both compositions. But Gauguin's painting is not altogether flat – there is modelling in the figures and the red ground is variegated. Moreover it has a pondered and sophisticated compositional and iconographic complexity that originates with the preliminary drawing. The women are not scattered in disconnected groups across the surface but united in spirit as spectators, the four in the foreground seen in close-up, the others in rapidly diminishing scale according to their distance from the viewer. The composition's rhythmic coherence and underlying circularity, each figure partially occluded by her neighbour, follows the sketch faithfully [plate 59]. But the curve or upturned

parabola that was emphatically indicated in that sketch – like the rope used to demarcate an arena – has been lost in the process of painting. The extension of the tree trunk and addition of donor-like figures to left and right pull the composition up to the surface and establish a more frieze-like foreground.

Gauguin clearly intended his religious picture to work dramatically and on two levels. Indeed a large part of the painting's impact derives from its theatricality. In all probability Gauguin's composition was partly indebted to the striking intensity of colour contrast that he found in theatre prints by such Japanese masters as Kunichika. Gauguin also absorbed into the composition certain lessons in theatrical composition from his master Degas, as a comparison with Degas's *Ballet from 'Robert le Diable'* [plate 62] demonstrates.[46] As in such compositions by Degas, the attention of the viewer is engaged both by the spectators – or praying women – some of whom are seen from behind, and by what they gaze upon. Where Degas shows ghostly dancers on a raised stage, Gauguin has his spiritual wrestlers silhouetted against an unearthly red, partially hidden from the women by the more naturalistically coloured diagonal tree-trunk. In a similar way, in Degas's fan, *Dancers*, a part of the scenery has the effect of creating a strange dislocation between the viewer's position and the figures in action [plate 34]. In fact only one woman can be said to gaze upon the spiritual wrestling-match, the others, like the priest, having their eyes tight shut. And it is the alert features (possibly modelled on Madeleine Bernard) of this modestly *coiffed* Bretonne, her upturned nose, high cheek-bones, arched brow and single loose curl, that Gauguin treats with the greatest detail and empathy.

The absence of preparatory studies of individual figures is surprising – whether the drawings one might expect to find have been lost or never existed – and marks a break from Gauguin's recent practice. As has been pointed out by earlier authors, a general distinction can nevertheless be made between Gauguin's synthetic practice of drawing as compared with Bernard's cloisonism.[47] Gauguin's forms are built up by applying colour to a drawing previously established with painted outlines on the primed canvas, the large flat areas divided one from another by reserved contours rather than superimposed *cloisons*. This more painstaking method harks back to the practice of his mentor Pissarro. In Bernard's *Breton Women in the Meadow*, and in his even more striking composition *Buckwheat Harvest* [plate 63], drawing seems to take place on top of the painted surface in broad and crude contours applied with the brush.

Whilst he was clearly cultivating simplicity of form with an emphasis on contour, the strength and monumentality of

Gauguin's figures derives from their sound underlying anatomy. Gauguin did not avoid – as Bernard did – difficult but telling details. In the figurative works that precede *Vision of the Sermon*, the caricatural aspect was combined with a remarkable attention to physiognomy and a powerful expressive role was assigned to hands and feet. In the preparatory drawing for *Breton Boys Wrestling* for instance (private collection), which he squared up in the traditional way for transfer, the artist made several attempts at getting the boys' profile and feet as he wanted them. And within his firm but not rigid bounding contours he explored the planes and shadows of their bone structure and musculature. The handhold which is the focal point of Gauguin's composition *Breton Girls Dancing, Pont-Aven* [plate 64] seems not to have been satisfactorily realised in the first preparatory drawing, which groups the girls in a decorative way against a turquoise background [plate 65], so a second drawing to resolve this detail was required.[48] Even so Gauguin had to reduce the scale of the girl's exaggeratedly oversize hand, which originally reached the left edge of the composition. Their faces, and the decorative rhythm established by their white *coiffes* and black bodices, were faithfully transcribed into the final painting.

Hands play a crucial role in *Vision of the Sermon* too, and seem to have been integral to Gauguin's conception of the theme from the outset, if one can interpret the flurry of upward-tending squiggles to lower left in his initial sketch as indications of hands in prayer. The prominent hands of the girl praying in the left foreground, with palms together and fingers outstretched, seem an almost symbolic caricature of prayer. The same gesture is given to the young woman behind her, whose reddish hands stand out, a sign of the raw outside work she presumably had to perform, and contrast with her down-turned, somewhat contorted profile.

A third pair of praying hands holds a rosary. Easily overlooked, the oddity of these gestures becomes more apparent when contrasted with the more natural intertwined handclasp that Millet, for instance, used for his praying peasant woman in *L'Angelus* [plate 66]. The effect conveyed by Gauguin is of naïvety and childishness – with connotations of superstition – as opposed to the reserved and dignified devotion conveyed by Millet's famous image.

BERNARD'S CLAIM FOR PRECEDENCE

The precise dating of the two canvases would be of little account were it not for the fact that Bernard was to claim, some years later, that his painting *Breton Women in the Meadow* had served as the virtual template from which Gauguin had taken all the essentials of *Vision of the Sermon*. In the process of staking his own claim for recognition – legitimately enough, since his pioneering role in the development of pictorial Symbolism had been unfairly overlooked – Bernard's attitude towards Gauguin underwent a complete volte-face. From his near idolisation of an artist of daunting talent in September 1888, in 1891 Bernard embarked on an embittered lifelong mission to reveal his erstwhile hero as an unscrupulous crook. In what might be taken as his most frank version of the sequence of events – frank because it was written for himself and not, apparently, for publication – Bernard wrote that he executed *Breton Women in the Meadow* as a technical demonstration of the advice he had been giving Gauguin about his use of colour, namely, 'the more one divides tone, the more it loses its intensity and becomes grey or dirty'. Whereupon Gauguin wanted to:

demonstrate the same thing for himself and borrowed from me certain colours which I had used, like Prussian blue, which had been banished from the Impressionist palette,

57

66 | Jean-François Millet, *L'Angelus*, 1859 (detail)
Musée du Louvre, Paris

67 | Field of ripe buckwheat near Pont-Aven
Photographed by Alain Le Cloarec, 2004

and which he did not possess. So he executed that canvas of the Vision of the Sermon *which earned him the title of 'creator of symbolism'. Now all he had done was put into practice not the colour theory of which I had spoken to him, but the very style of my* Breton Women in the Meadow, *having first deliberately established a background of red instead of yellow green as mine was. In the foreground he placed the same large figures with their monumental chatelaines' headdresses. He was so pleased with his canvas that he continued to pursue the direction it opened up for him and definitively abandoned the divisionism he had learned from Pissarro.*[49]

It is a somewhat self-serving and implausible scenario in which Bernard describes himself as the tutor advising Gauguin about colour; it certainly seems diametrically opposed to the impression of awed admiration which he had conveyed to Vincent at the time. Bernard's candour is further thrown into doubt by two factors: his later habit of falsifying the dates of his own work and the technical evidence that Gauguin had used Prussian blue on previous occasions.[50] However, to give Bernard the benefit of the doubt, Gauguin may have been temporarily without it on this occasion; certainly Prussian blue is the main constituent of the rich blacks in Gauguin's canvas. This statement is one of the most complete explanations of the grievance

68 | Paul Gauguin and Emile Bernard, *Earthly Paradise*, 1888*
Private Collection

Bernard came to bear Gauguin, which was in essence one of stylistic plagiarism. He first made the accusation publicly in 1895, albeit couched in respectful terms, in an open letter to the art critic of the *Mercure de France*, of which Gauguin was a regular reader.[51] Gauguin declined to reply.[52] Bernard then repeated and elaborated it on numerous occasions after Gauguin's death – in 1903, in 1919, in 1939.[53] As the years went by, as new styles succeeded one another and his own foothold within the history of modern art became more marginalised, his claim became more sweeping.[54] The 1919 version, where he claimed responsibility for Gauguin's 'uncharacteristic' choice of religious subject, was probably the most intemperate. (It is surely significant that this was written after reading the newly published edition of Gauguin's letters from Tahiti to Daniel de Monfreid – letters which exposed, Bernard felt, Gauguin's grossly 'sensual and anti-Christian character'.[55] The letters also contained some disguised, but easily decipherable, unflattering references to Bernard himself.)

Given the complexity of stylistic thinking that had prepared Gauguin for painting *Vision of the Sermon*, Bernard's accusation of out and out plagiarism seems exaggerated. Artists take their ideas where and when they can and Gauguin was certainly apt to pick up his from all sorts of sources, recombining them in creative distillations. Whilst working together, both artists were emboldened to take greater liberties than hitherto, and Bernard in particular produced the best work of his career. The relationship of his daringly cloisonist composition *Buckwheat Harvest* [plate 63], for instance, to Gauguin's *Vision of the Sermon* has never been firmly established. While he would later exhibit it as a pair with *Breton Women in the Meadow*, at no point would Bernard use it as part of his 'case for the prosecution', from which one concludes it followed, and was possibly partly inspired by, Gauguin's *Vision of the Sermon*. On the other hand the subject of Bernard's painting points to a possible prompt in nature for the strikingly non-natural use of red in Gauguin's painting, one that has hitherto been overlooked: fields of ripe buckwheat, just before the crop is harvested, take on a startling red appearance [plate 67]. Sown in early June, buckwheat, used in the preparation of the Breton *galette*, is harvested in late September or early October. In other words, at the time Gauguin was completing *Vision of the Sermon* the crop would have been emphatically scarlet.[56]

During the summer of 1888, working in a collaborative spirit, Gauguin and Bernard sparked each other's creative energies, sharing knowledge, ideas and pictures. Gauguin taught Bernard a number of things, including how to carve in wood. He lent him his tools and they jointly worked on a

69 | Emile Bernard, *Breton Women, Child and Goose* [*Project for a Wood Carving*], *c.1888**
Collection R.T., Brest

70 | Paul Gauguin, *Study for a Bookcase, c.1888*
Private Collection

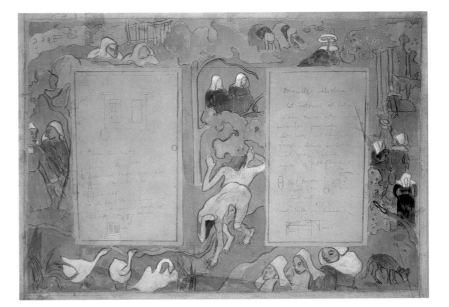

59

Breton sideboard [plate 68].[57] This would seem to be the 'sculpture' Madeleine refers to in the letter she wrote to her brother shortly after leaving Pont-Aven. Drawings by both artists can be loosely related to it [plates 69, 70]. In all likelihood, having agreed the main lines of the decoration – a mixture of Breton and exotic figures, grotesque heads, a cow and geese, unified by a tracery of stylised branches and tree trunks – Gauguin left his young comrade to complete the carving in his absence.[58] The central panels reprise elements taken from *Vision of the Sermon* – two Breton women under a diagonal tree watching a naked wrestling bout. If proof were needed of the creative energy the artists shared, of their shared synthetic style, it is this remarkable piece of furniture signed by them both, where the two artists' hands are virtually impossible to distinguish.

Clearly Bernard brought something important to the Pont-Aven artistic mix, acknowledged by the fact that Gauguin took his *Breton Women in the Meadow* to Arles, where Vincent admired its originality and painted a copy.[59] Its very childlike simplicity had helped Gauguin crystallise and give form to the complex of ideas lying behind *Vision of the Sermon*. But Bernard's claim that Gauguin's artistic direction was transformed by it is untenable. Unlike Bernard, he scarcely ever produced a straightforwardly cloisonist composition – a rare exception being his *Portrait of Mme Roulin* (Saint Louis Art Museum), painted in Arles. His paintings were always a more subtle amalgam of different styles. Yet Gauguin's stylistic progression had been moving consistently towards greater synthesis, towards cultivating the savage and 'primitive'. It was a spasmodic movement and periods of intense stylistic inventiveness

were followed by relatively fallow periods when he reverted to the more impressionistic manner he had evolved under Pissarro's tutelage.[60] But his most effective Tahitian works built on the sound stylistic foundations established in *Vision of the Sermon*, the juxtaposition of simplified, monumental, figures and colourful, non-naturalistic surface patterning.

Gauguin for his part took Bernard's art seriously, gave him great encouragement, urged him to build on his astonishing talent, while not hiding from the younger man what he saw as his faults. 'You are holding all the trump cards', he told him, soon after arriving in Arles.[61] The way had been cleared for him by his elders, now he needed to work and concentrate on strengthening the gifts he had. Sadly for Bernard that was just what he would fail to do. Left to his own devices he fell prey over the next few years to gloomy periods of self-doubt, switching between wildly opposed styles, trying out philosophical and religious ideas, atheist one day, fervent believer the next. He was still, after all, a very young man.

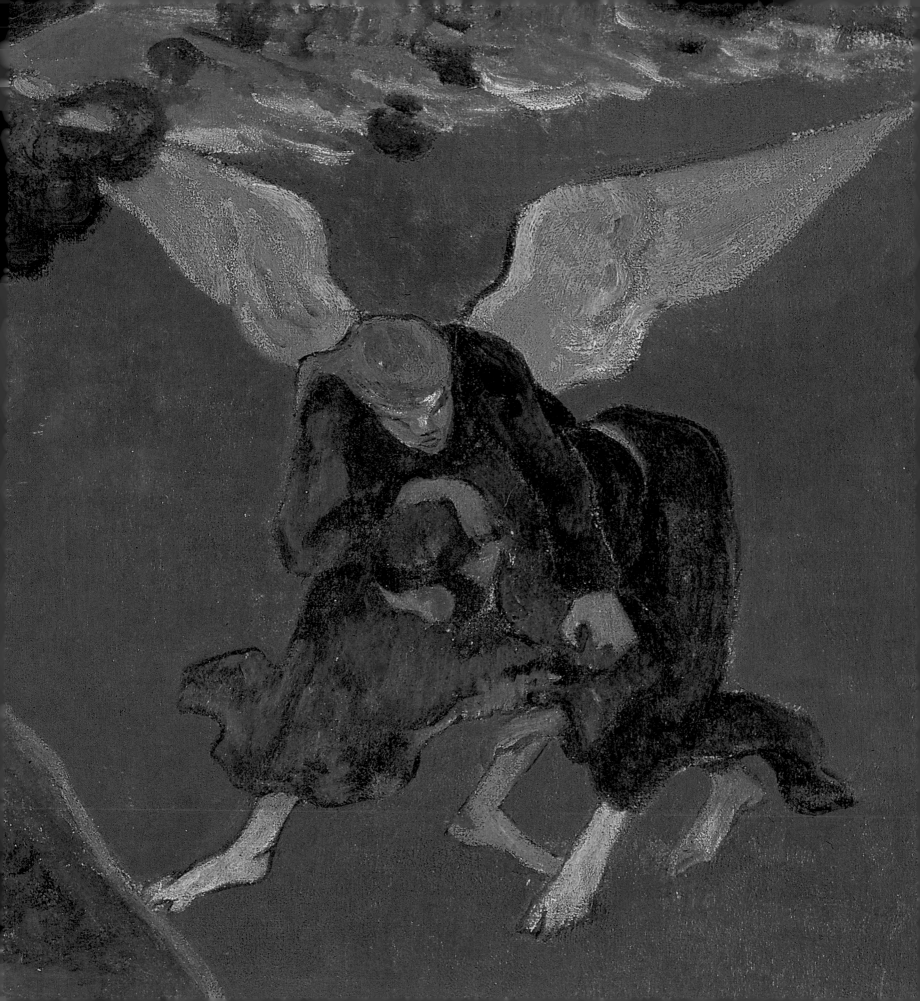

4 The Meaning of *Vision of the Sermon*

In formal terms, despite its apparent simplicity, Gauguin's painting works on two different levels. The same is true of its content, as the two-part title indicates. Painting pious Breton women was by no means unusual in the 1880s. But to paint them in a challenging modern style experiencing a supernatural religious vision was unorthodox to say the least. By doing so, Gauguin raised questions not only about the nature of Breton piety and superstition, but about his own religious standpoint. Gauguin called the painting a religious picture yet, by contrast with the women, he represented the biblical story of Jacob and the Angel on a modest scale, relegated to the upper right section of the canvas. So an analysis of the work's meaning needs to begin with an assessment of the purpose and effect of the dominant presence of the Breton women praying.

The status of the Church and the whole question of faith were highly topical issues in the late 1880s, as Gauguin was perhaps aware. Historians of religious belief in Third Republic France have shown that the relationship between Church and State, fraught since the Revolution, was at this period passing through a crisis.[1] Religion was making its painful progress from a state-sanctioned force to a matter for the individual conscience, as advocated by the most influential liberal theologian and progressive thinker of the day, Ernest Renan. Léon Gambetta's declaration of war in a speech to the Chamber of Deputies in 1877 – 'clericalism? That's the enemy!' – ushered in a period of implacable struggle. Traditional faith was also under attack from materialism, science and evolutionary theories. The general move, particularly in Paris and the large cities, was towards a decrease in religious observance, church attendance and papal authority. One of the prime objectives of the governments of the Third Republic was to modernise and laicise the whole of France, to unify it within a single language and within a secular republican ideology. Yet despite the successes in this direction – as emphasised by a statistical report published by André Lebon and Paul Pelet in 1888 –

based on the 1886 census, to the question 'Is France a religious country?' the answer was unclear: 'Talk with individual Frenchmen of any class, and we shall almost always find (with the exception of the provinces of Brittany, where faith is strongly rooted), a scepticism readily passing into mockery and bordering on indifference, on the subject of religious questions …. Ask a peasant his feelings towards his priest and he will show a certain inveterate distrust of the priestly garb; but the same peasant will be married and buried by the Church, and will have his children baptised and confirmed.'[2] It is useful to bear this equivocal picture in mind when considering Gauguin's own attitude to the Roman Catholic Church.

Faith was indeed strongly rooted in Brittany. Its piety, together with its language, separated this ancient Celtic kingdom from the rest of France. There the Catholic Church and its defendants were feeling particularly embattled. According to Kano's *Les Populations bretonnes*, there was no shortage of zealous young candidates for the priesthood in Brittany, and he contrasted their hellfire-and-damnation attitude with the more stereotypical image of the well-fed, indulgent curé. Yet even the latter – a stock figure of fun amusingly caricatured by Lucien Pissarro in his print *The Curé* (Ashmolean Museum, Oxford) – was reportedly seeing red at the threat to his traditional clerical privileges. This state of *lutte* was vividly mirrored in the columns of religious publications. In *La Semaine religieuse*, for example, established in the Quimper diocese in 1886, one finds the issues of the day laid bare. On the one hand there were the constant attacks coming from science, with the new vogue for hypnotism raising particular alarm among the clergy in 1888; on the other, the erosion of clerical influence in schools and thus over young minds.[3] Yet at the same time, seemingly in direct reaction, one hears of the growing numbers attending Brittany's most spectacular Pardons.[4]

The reality of such conflicts was played out two kilometres from Pont-Aven, in the neighbouring parish of Nizon.

(Although today Pont-Aven has far outgrown Nizon, in the 1880s the two communes had equivalent populations, each numbering around 1400 in 1888.)[5] In the late 1870s and 1880s a series of secularising laws was passed by education minister Jules Ferry, known collectively as 'les lois Ferry', wresting education from the hands of the Catholic church and seeking to establish lay-run primary schools through-out the land. This was a particular challenge in remote areas like Brittany where schools were few and traditionally staffed by members of the religious orders. Additionally, attendance was poor as many farmers relied upon their children's unpaid labour to help with the tending of animals. Interestingly, this was an abuse – merely quaint and picturesque though he makes it appear – to which a

71 | Paul Abram, *Praying at Lacronon (Finistère)*, exhibited at the Salon of 1887
present whereabouts unknown

72 | Otto Wigand, *Thinking over the Pardon*, exhibited at the Salon of 1887
present whereabouts unknown

73 | Richard Hall, *The Vow – Brittany*, exhibited at the Salon of 1888
present whereabouts unknown

74 | 'Svelt', Caricature of the Parisienne at her devotions from *La Vie Parisienne*, 31 March 1888, pp.177–8

number of Gauguin's paintings testify. There was a school in Pont-Aven but, until 1877, none in Nizon. It had taken some fifty years of struggle by the municipal council, stalling successive directives from the Prefect, to get to the point of building and opening a mixed school run by nuns. No sooner had it opened than the new Ferry laws insisted upon single-sex schooling and the laicisation of education – an idea unacceptable to many in the community. Change was implemented gradually, despite resistance by the mayor, aristocratic landowner Cyprien de la Villemarqué, beginning with the arrival of a dedicated *instituteur* for boys in 1886. By the turn of the century a fairly typical status quo was reached whereby boys received a civil, laicised education separately from the girls, who continued to be given a full religious education by nuns in preparation for their future lives as '*bonnes mères de famille*'.[6]

It was generally understood that the female peasantry provided the conduit for religious faith, and a marked divide separated their devoutness from the more sceptical stance of their menfolk. For Kano, the hours women spent at their devotions each Sunday were a welcome respite from their hard labours throughout the rest of the week. The church service offered them a place for mental repose, a chance to dream: 'In the midst of gay turnouts, dressed up a bit oneself, what a delight to let one's reveries be lulled by the bursts of the organ and the deep chant of the priest, one's body stilled in well-earned repose'.[7] 'It's in church', he continued, 'at the hour when the shadows fall from the high vaults, that the soul unbosoms itself in scarcely murmured complaints, in the long invocations of prayer; this is where she [the Bretonne] comes to fortify herself for the hardships and struggles of the next day.'[8] Gauguin, who could have witnessed the phenomenon of female piety every week in Pont-Aven, was far from the only artist to draw attention to the predominance of women among the Breton congregations.

That the role of Nizon's successive mayors, Cyprien and then Cyprien II de la Villemarqué, was predominantly conservative is scarcely surprising given the monarchist leanings of this old aristocratic family. Their family home, the Manoir du Plessis, near the Trémalo chapel, is the most prominent grand house in the vicinity of Pont-Aven. Moreover the family was well known thanks to the celebrity of Cyprien's youngest brother, Théodore Hersart de la Villemarqué (1815–1895), one of the foremost figures in Brittany's cultural revival in the nineteenth century. His book *Le Barzhaz Breizh* was a collection of orally transmitted popular songs and ballads which de la Villemarqué had translated from Breton into French and set down for posterity. First published in 1839 then republished many times, *Le*

Barzhaz Breizh was hugely successful in the mid-century and translated into several languages. It had won de la Villemarqué renown in literary circles in Paris – George Sand being a fan – and membership of the Institut Français. Its importance in the battle to preserve the Breton language was considerable. Although its author was criticised by later folklorists for presenting his materials in a tidied up and bowdlerised form, more recently the book has been reinstated as an authentic collection of folk literature. It ushered in a tide of scholarly studies exploring Brittany's literary and cultural heritage.[9]

We do not know that Gauguin read *Le Barzhaz Breizh*, although in his eagerness for a poetic 'take' on Brittany one might suppose it would have been of interest to him. Certain of its folk tales could well have sown the seeds of some of his more puzzling pictures of village life. Brittany's propensity for religiosity and mysticism finds eloquent expression there, particularly in the author's commentaries. For instance, he opines that the extraordinary authority of the priest in Brittany can be linked to a kind of folk memory of the Druidic religion. Joanne's popular guide book certainly drew upon the legends recorded by de la Villemarqué.

THE SALON AND SPECTATOR CHRISTIANITY

If the success of *Le Barzhaz Breizh* was one aspect of the new ethnographic interest Brittany held in the nineteenth century, another was the extraordinary popularity at the Salon of paintings depicting the region's quaint religious observances. What Robert Rosenblum has called 'spectator Christianity' was a pseudo-genre that flourished in the second half of the nineteenth century.[10] It was characterised by the artist as onlooker treating religious worship as an archaic, sometimes sentimental, spectacle. Found in the work of numerous French artists, it was particularly prevalent among the foreigners who visited Brittany. Thus, rather than attempting to deal with traditional Christian iconography – specific biblical narratives – artists chose to observe congregations in prayer, listening to sermons or attending Pardons [plates 71–3].

It was essentially in contrast to what was happening in the cities that such rural religious observances became the object of fascination and, sometimes, cruel humour. Naturalist novelists, assuming an urban readership, penned merciless exposés of the dimwittedness and persistence of superstition among women in rural communities.[11] Church attendance had fallen off dramatically in Paris. Compared with the sober, serious, reflective and emotional scenes artists witnessed in Brittany, urban congregations presented a very different spectacle, as the caricaturist 'Svelt' was amused to observe [plate 74].

75 | Alphonse Legros,
The Sermon, 1871*
National Gallery of Scotland,
Edinburgh

76 | Théodule Ribot,
At the Sermon, c.1887
Musée d'Orsay, Paris

64

Three French exemplars of naturalism made intriguing contributions to the 'spectator Christianity' genre. Alphonse Legros (1837–1911) specialised in paintings of rural piety. His painting *The Sermon*, 1871 [plate 75] can be linked to earlier and later subjects he painted on similar themes. *The Sermon* was originally a more panoramic outdoor scene. X-ray photographs show that the details of the church interior, bench, chairs, pulpit and preacher have been painted in over an earlier composition involving a greater number of female figures (some of whose white bonnets are just visible to the upper right), probably a procession of mourners at a funeral: a white sheeted coffin is distinctly visible to lower left. Although not necessarily Breton in its geographic location (the women's bonnets are not typical of Brittany and the artist himself came from Dijon, later settling in London), the composition explored the religious genre with a typically sombre palette. Although precise in detail, Legros's figures have a naive stiffness and unified look that recall popular prints.[12]

The theme of a congregation listening to a sermon was tackled rather differently by Théodule Ribot (1823–1891). His small canvas entitled *At the Sermon* [plate 76], dedicated to the dealer Bernheim-Jeune in whose Parisian gallery it was shown in 1887, represents a group of working women dressed uniformly in black, their pale faces and hands looming starkly and dramatically out of the dark background. In this work, influenced by the religious paintings of the Spanish painter Ribera, all the emphasis is on the wide-eyed facial expressions, seemingly attentive to the words of an unseen preacher.[13] This painting's association with Brittany is no more than implicit – yet Ribot made several visits to Brittany in the 1870s, and a variant of this composition, incorporating men as well as children, was entitled *Breton Fishermen Listening to a Sermon* (Metropolitan Museum of Art, New York).

Ribot's composition makes an intriguing comparison with the similarly frontal but more naturalist painting on the theme of Breton piety by Pascal Dagnan-Bouveret (1852–1929), *The Pardon, Brittany* [plate 77]. Despite its considerable size it has a press of figures seen from close quarters, and looks like a fragment cut out of a larger composition. It was in fact a simplified variation of *The Pardon in Brittany*, 1886 (Metropolitan Museum, New York), with which the artist had scored a notable success at the 1887 Salon. Dagnan-Bouveret both invites his spectators to read the picture as a narrative and, through the immediacy of the foreground figure, to feel involved. He has contrived to represent individuals of different ages, sexes and attitudes. Thus the man looks more resolute and less reverential than the women, his neighbour looks down at her prayer book, the elderly woman has a resigned air and the young woman seated in the foreground, with candle and prayer book, is lost in reverie. Critics of the time, mesmerised by the artist's 'truthfulness', devoted long exegeses to his pictures, whose subject matter they interpreted, sympathetically or not, according to their own beliefs. In doing so they betrayed their political positions, as Michael Orwicz has shown.[14] Where conservatives uncritically saw laudable piety, republicans, in tune with governmental anti-clericalism, were liable to see ignorant superstition. Such engagement of the spectator's curiosity relied on the intense naturalism of the faces and attention to physiognomic and psychological detail. No barrier of form got in the way of their reading of the subject. The

pastel study for *The Pardon, Brittany* (National Gallery of Scotland, Edinburgh) gives an insight into how that naturalism was achieved: the composition is established by building up the forms in blocks of tone and there are scarcely any firm lines or contours, edges being only lightly indicated with a pencil. The artist's habitual use of photographs encouraged this near monochrome, tonal mode of seeing.

Dagnan-Bouveret was a formidable rival to Gauguin, and one who enjoyed spectacular success with the public [plate 78]. Trained at the Ecole des Beaux-Arts (a pupil of Jean-Léon Gérôme), he had only recently turned to religious subjects, having initially established a radical reputation as a naturalist artist with up-to-date subjects from daily life.[15] Paintings like *The Pardon, Brittany* commanded high prices and were produced for their commercial ends. They lent themselves to black-and-white reproduction in such general-interest weekly journals as *L'Illustration*. Indeed the picture was bought, together with its reproduction rights – another major source of income for Dagnan-Bouveret – by the Goupil firm (Theo van Gogh's employers). So, in one sense, by painting Breton women listening to a sermon and borrowing the norms of a currently popular pictorial convention, Gauguin was making a calculated bid for popular

appeal. He, too, depicts a devotional scene of women in prayer, wearing the picturesque costumes that for him symbolised their god-fearing medieval mentality; like Dagnan-Bouveret's, his composition has a performative aspect, in that it feels as if it is being enacted for the spectator's benefit. But he borrowed from the convention in order to subvert it, for in Gauguin's opinion there was nothing more stultifying to the imagination than the *trompe l'oeil* naturalism of the Salon painters. His aversion to the commercially astute naturalism practised by the 'tailors in paint' – painters with whom he shared meals at the Pension Gloanec – provided an important spur to his own artistic daring. Whilst working on *Vision of the Sermon* he commented to Schuffenecker, 'Even without religious painting what beautiful thoughts can be evoked with form and colour. How prosaic they are, those *pompiers* [academic naturalist painters] with their materialistic *trompe-l'oeil*.' He countered that prosaicness with an oblique reference to Wagner's *The Flying Dutchman*: 'We alone sail on our phantom vessels with all our fanciful imperfection'.[16] Gauguin's painting recast a conventional, popular subject in a suggestively 'primitive' style of flat non-naturalistic colour and crude decorative forms. And he went further.

65

77 | Pascal Dagnan-Bouveret,
The Pardon, Brittany, 1888*
The Montreal Museum of Fine Arts,
William F. Angus Bequest

78 | Pascal Dagnan-Bouveret,
Breton Women at a Pardon,
1887
Calouste Gulbenkian Museum,
Lisbon

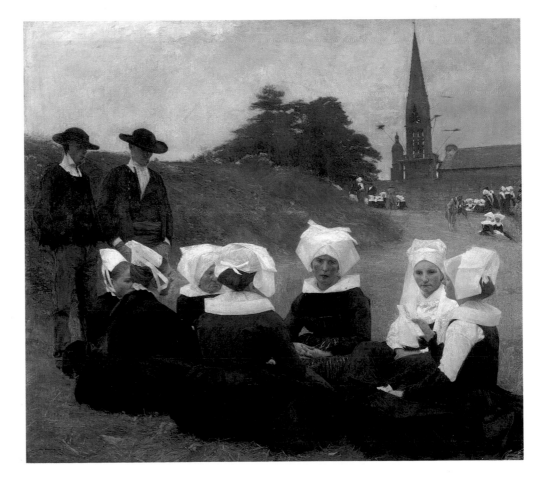

79 | Adolphe Leleux, *Wrestlers in Lower Brittany*, 1864*
Musée national des Arts et Traditions populaires, Paris

80 | Hippolyte Lalaisse, *Wrestling at Rosporden*, 1865*
Musée national des Arts et Traditions populaires, Paris

The advent of the railways to lower Brittany in 1862 brought about a growth in tourism. This in turn increased the popularity, after a period of decline, of the traditional spectacle of wrestling. Lalaisse shows his mostly local spectators grouped in a circle around the wrestlers while stewards keep back the crowds with whips and a frying pan.

81 | Paul Sérusier, *Breton
Wrestling*, c.1893
Musée d'Orsay, Paris
The popularity of the *gouren*
was undiminished by the 1890s.
Sérusier, using a similarly
synthetic style to Gauguin's
Vision of the Sermon, shows his
wrestlers fighting in the
traditional way. They grip one
another by the shirt while one
attempts the *kliked*, a permitted
throw which involved upsetting
the opponent's balance with a
manoeuvre of the toes.

Not content to refer to a sermon through his title – a ser-
mon doubtless delivered with the stirring power for which
Breton priests were renowned – he incorporated its subject
into his composition, and with it, its effects in the minds of
the listeners.

BRETON WRESTLING

At its purely imaginary level – for in his words 'the land-
scape and the struggle exist only in the imagination of the
people praying' – Gauguin's painting owed its inspiration to
its Breton context, as Denise Delouche was the first to
demonstrate.[17] For in Brittany wrestling, or the *gouren* as it
was known in Breton, had considerable relevance and a long
history dating back to pre-Christian times. The *gouren* was
one of the sports practised at the ancient Celtic Tailteann
Games. In its heyday in the sixteenth century, the sport
involved men of all stations – nobility, clergy and peasantry.
Following the Revolution an attempt was made to abolish
the *gouren* and by the early nineteenth century the Church
was beginning to frown on the practice, although for centu-
ries it had formed part of the profane entertainments that
followed a Pardon. Interesting superstitions became attached
to Breton wrestling. Before engaging in combat it was
customary for combatants to make their declaration of fair
play by making the sign of the cross and forswearing the
influence of Satan. The wrestlers wore special clothes – loose
fitting shirts and breeches – and only certain holds were
allowed. The object was to throw one's opponent flat on his
back with both shoulders on the ground. Contestants took
turns to fight the reigning champion, and the main prize was
usually a kid goat, ram or occasionally a heifer, which was
tied, along with lesser prizes, to a tree. Onlookers of both
sexes watched with attention, forming a circle and exerting
their influence on the outcome. They were kept in order by a
number of stewards, armed with whips and a frying pan.[18]

Alphonse Leleux's *Wrestlers in Lower Brittany*, shown at
the Salon of 1864 [plate 79] and Lalaisse's lithograph [plate
80], are valuable documentary records of the local survival
of this tradition [plate 80]. So the idea of making wrestling
the subject of a painting was not original to Gauguin. But as
he sought ways of approaching the true character of Brit-
tany, it was logical that he should alight upon this theme,
which first appeared in his July 1888 painting *Breton Boys
Wrestling* [plate 50]. This canvas should perhaps be seen as a
pendant to the slightly later *Breton Girls Dancing, Pont-
Aven* [plate 64], in that both explore traditional activities
associated with the Pardon. Dancing the *gavotte* was a skill
Breton girls would be keen to master just as boys would
have been encouraged and keen to practise their holds and
try their strength in bouts of wrestling. Indeed at a Pardon

peasant women envision the famous biblical struggle of Jacob and the Angel that the priest has conjured before them but as a bout of the *gouren*, with barefoot wrestlers locked in one of the sport's familiar holds? In this respect Gauguin's biblical wrestlers broke with the conventions for depicting Jacob and the Angel seen in earlier art [plates 88–93].

GAUGUIN AND RELIGION – THE GIFT TO THE CHURCH

There is no simple answer to the question of Gauguin's own religious position. Indeed, in an individual as complex as Gauguin, one would be surprised to find a fixed and unambiguous attitude towards religion. Although he had been raised a Catholic, he was anything but a loyal son of the Church, and passed as impious among the conventionally devout; he was nevertheless a Catholic at heart. For a few years as a teenager he had attended a Jesuit seminary in Orléans, and this experience, he was ready to admit, had inevitably inflected his spiritual life.[21] He had plenty of rude things to say about the Jesuits, claiming that in their care he had discovered, and learned to hate, hypocrisy. However, he judged the Jesuits to be saints compared to the holier-than-thou hypocrites he found among the Calvinists he encountered in Denmark. One of the influences on the Orléans seminary was Bishop Félix Dupanloup (1802–1878), an educational reformer. To judge from certain aspects of the speech given in the presence of Dupanloup by M. Hetsch, to the 1864 cohort of school leavers, the seminary's ethos was relatively progressive and sought to integrate the teaching of science with classical literature, the arts and religion: 'Three centuries of analysis have amassed immense data. A universal synthesis has become necessary.' This synthesis was already 'throwing marvellous clarity on to the accord

dancing often preceded wrestling – the dancers were encouraged to beat down the grass with their clogs to form a suitable wrestling arena – and in Pont-Aven the two activities traditionally took place in the same field above the church.[19]

Breton wrestling offers another layer to the meaning of *Vision of the Sermon*. Allusion to the prize traditionally awarded explains the otherwise puzzling presence of the cow in the upper left of the composition; and the Breton women in this corner, diminutive in scale, seem less like a congregation attentive to a sermon, more like the ring of female spectators at a wrestling bout.[20] One has to admire Gauguin's ingenuity and logic – evoking a supernatural vision by means of this down-to-earth spectacle, confusing the Christian with the pagan. For how else would Breton

82 | Stained glass windows (1875) in the apse of the church of Saint Joseph, Pont-Aven
Photographed by Alain Le Cloarec

83 | Photograph of Nizon's main calvary when still surrounded by its cemetery, *c.*1890
Courtesy Alain Le Cloarec

84 | Photograph of Nizon church, *c.*1890
Courtesy Alain Le Cloarec

between the sciences in general and between each science and faith'. Nevertheless, at the heart of the school's moral teaching was the image of Christ: 'To him belongs, my dear children, all the glory of the good which has been done in your minds and your hearts'.[22] However distanced he felt from the modern day Roman Catholic Church, Gauguin's education gave him a familiarity with the Bible, a susceptibility to Christian symbolism and a preoccupation with the life of the soul that could readily have resurfaced in the special context of Brittany.

What was the motivation behind Gauguin's offer of his first religious painting to a local church? Was it a cynical act, as Bernard clearly believed, or a sincere one? Once again there is no easy answer. It is important to recognise that the offer was not a one-off gesture. Whereas most accounts stress the attempted gift to the medieval church of Nizon – to which there was more than one witness – Gauguin had already offered the painting to the church at Pont-Aven. On this point Gauguin's letter to Vincent van Gogh is clear. Just before he describes the painting's composition he states, 'I wanted to give it to the church of Pont-Aven. Naturally they don't want it.' Rather than discounting this offer as implausible, as some commentators have done on the grounds that the church in Pont-Aven was new, there are grounds for taking it seriously. Consecrated in 1877, the Église Saint Joseph was centrally and conveniently situated, only a few steps from the Pension Gloanec. Not overly ornate, it was built in the vernacular Gothic style. Gauguin's landscape views of Pont-Aven frequently include its delicate steeple. It was still being fitted with its internal fittings and decorations; stained-glass windows, for instance, donated by local parishioners, were installed between 1875 and 1883. In theory, therefore, the rector, Père Madec, might have welcomed a painting by one of the locality's resident artists. (In later years the church acquired a number of them, including a painting by Emile Bernard). Had Vision of the Sermon been accepted by the local church, Gauguin would have had two satisfactions: first, seeing his work, with its simplified, decorative style, in a sympathetic architectural context surrounded by old statues (several of which had been installed from the previous chapel) and brightly coloured stained glass [plate 82]; secondly, Vision of the Sermon would have been on permanent view, playing a part in the life of the village, but at the same time, given the internationalism of Pont-Aven's artistic community, spreading his fame abroad.

As it was, turned down at Pont-Aven, Gauguin tried his chances at the church of Saint Amet in Nizon, of which the rector was Père Orvoen. Dating mostly from the fifteenth century, this church was particularly admired for its re-

markable granite calvary, which stood in the cemetery outside [plate 83]. It was well known to the Pont-Aven artists and would inspire Gauguin's Breton Calvary the following year [plate 99]. The plaque fixed to the plinth records the fact that the calvary was repaired between 1882 and 1886, during the period when M. Milin was rector and M. de la Villemarqué mayor, an indication of the value Brittany was beginning to place on its monumental heritage. In the 1880s, a second calvary (no longer extant) stood at the east end of the church, as seen in a further contemporary photograph [plate 84].

Confusingly we have two witness accounts of this little drama, the first from Bernard,[23] the second a short account given by Paul Sérusier (1864–1927), who was evidently also of the party.[24] Bernard claims that Gauguin's reasons for offering Vision of the Sermon to the church of Nizon were exclusively artistic – 'to see the effect it had among the rustic Romanesque and Gothic forms of granite chapels'. A little posse of artists, including Charles Laval, evidently made the two-kilometre trek uphill on foot, taking turns to carry the picture. In his first published account of the story Bernard got the name of the village wrong, calling it Névez not Nizon, only in subsequent versions altering it to Nizon. It was an understandable mistake to make at the distance of time and space at which he was writing, namely in 1904 from Egypt, but an indication, nevertheless, that Bernard's memory of these events and of the Pont-Aven locality was no longer fresh. (Névez is a village some six kilometres to the south of Pont-Aven, not reached by the route Bernard describes). In other respects, Bernard's account has the ring of truth. On arriving at the church and finding it open, Laval was tall enough to hoist the picture up to the position Gauguin chose for it, above the little entrance door, against a background of bare stone. Bernard himself fetched the rector from the nearby presbytery to inspect the gift. Bernard watched his reaction.

I saw immediately that he would not accept. It was very different of course from the ordinary liturgical furnishings. The first words he uttered were those of a polite refusal. Gauguin raised as an objection the old saints, the ancient church, the harmony that there could between this art … and he seemed to take the wooden statues, the heavy pillars, the strange crossbeams as his witness. So then the priest questioned him about the subject, and declared it not to be a religious interpretation. Perhaps if it had represented the famous struggle in a straightforward way! But these enormous bonnets, the way the backs of these peasant women filled the canvas, and the essential element reduced, in the distance, to such insignificant proportions!! … It was not possible, he would be held accountable, on le blâmerait …[25]

85 | Rembrandt van Rijn,
*The Angel Departing from the Family of Tobias, c.1660**
Hunterian Art Gallery, University of Glasgow

he was seeking to represent superstition and piety, two mutually exclusive concepts.[26] If one takes as its sole *raison d'être* a cynical representation of superstition, of the fantasies to which unintelligent, possibly illiterate Breton women were subject, one might be inclined to agree. As we have seen, *fumisterie* played some sort of a role in its conception. On the other hand, there is a sincerity and veneration about the praying women which belies such a view; the whole image is reminiscent of certain northern European Renaissance paintings. It is these Breton women alone, Gauguin insists, albeit owing to their naivety and simplicity, who are capable of experiencing such a vision. He, as an artist, merely invites his viewers, sceptical onlookers like himself, to imagine what that kind of religious transport might be like. Gauguin the man did not need to be a devout believer – despite Bernard's charge – for Gauguin the artist to make his painting. He could admire and find symbolic expression for the mystery of piety, without sharing these women's faith. Nor did he need to be a devout Christian to make his offer in all sincerity to the church. Nevertheless, one wonders how different the history of late nineteenth-century painting in France might look had the canvas hung in an obscure Breton church to this day.

CHALLENGING THE CONVENTIONS OF RELIGIOUS PAINTING

The painting's rejection did not surprise Gauguin in the least. Apart from their suspicion of the unorthodox nature of the subject matter, the local priests would understandably have been on their guard against the painters in Pont-Aven, known as pranksters. It was probably an ill-judged decision on Gauguin's part to paint a pompous inscription in blue on the white wood frame, 'Gift of Tristan de Moscoso', the name of his noble Peruvian ancestor. In the wake of Bernard, Gauguin's sincerity in making this gift has been called into question by modern historians; some deny it to be a religious painting at all in view of Gauguin's claim that

For Gauguin, taking on a religious subject was a way of pitching his ambitions up to the level of the old masters. (For similar reasons he regularly tackled nude subjects.) After all Rembrandt, Raphael, Delacroix, Giotto, Cranach,

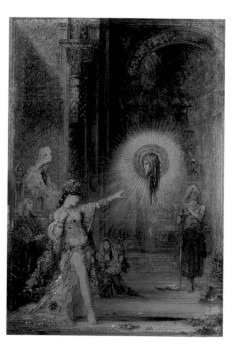

86 | Luc-Olivier Merson,
The Vision, 1872
Musée des Beaux Arts, Lille

87 | Gustave Moreau,
The Apparition, 1876
Musée du Louvre, Département des Arts Décoratifs, Paris

Ingres – names one encounters frequently in his writings – all painted religious subjects. Gauguin made clear that it was with them that he communed, particularly in the last decade of his career, working in isolation in Polynesia. He possessed a remarkable library of reproductions which sustained him in the South Seas. So did he turn to the old masters when planning his first ever composition involving a biblical theme and a vision? Or did he look to his contemporaries?

In Christian iconography many painters depicted visions and there were conventional ways to do so. One was to choose a vertical format, as this helped to convey the physical distinction between earth and heaven; it was also more suited to chapel altarpieces. Another was to separate the figures experiencing the vision from what they see by some pictorial device, for example by surrounding the apparition in a halo or cloudburst of bright light. Rembrandt made spectacular use of this convention in his etching *The Angel Departing from the Family of Tobias* [plate 85]. Among Gauguin's contemporaries, Luc-Oliver Merson (1846–1920) conveyed in *The Vision*, for which he won a prize in the Salon of 1873, the legendary vision of a fourteenth-century nun through dramatic contrasts of light and somewhat histrionic gestures [plate 86]; Gustave Moreau used the halo convention to great effect in his Salon painting on the theme of the beheading of John the Baptist, *The Apparition* [plate 87].

In *Vision of the Sermon* Gauguin discarded almost all of these conventions and ready-made symbols. He made certain concessions to tradition by giving the angel golden wings and applying a few gold highlights to the naturalistically coloured tree-trunk and the woman in profile's features, as though to indicate the glow of celestial light. Mostly to distinguish his peasant women from their supernatural vision he relied upon his invented pictorial devices – the diagonal tree, the sudden change of scale between the 'life-size people and the struggle in its … disproportionate landscape', the 'non-natural' use of red.

As previously shown, popular religious prints and Japanese prints favoured strident red backgrounds. But Gauguin may have had traditional portraiture in mind, the way artists such as Cranach, or indeed Ingres, used red backgrounds to provide a striking foil for soberly dressed sitters; or, more recently, the powerful effect Degas had achieved by making it the background colour in works like *Woman Adjusting her Hat* [plate 3]. Degas would go on experimenting with red and its associative resonance in a number of canvases in the 1890s.[27]

Using red non-naturalistically allowed Gauguin to play on the colour's associative connotations. Symbolic of blood, the expression 'seeing red' to signify anger, red as a sign for danger and red to indicate political radicalism would have been familiar to him. Perhaps he remembered the lines of Baudelaire's poem, *Les Phares*, evoking the powerful musical quality of Delacroix's colour: 'Delacroix, that lake of blood haunted by fallen angels, with a dark fringe of fir-trees, evergreen …'[28] For the poet Adolphe Retté, while it was clear that Gauguin's intention was symbolic, the chance of arriving at an accurate interpretation of his use of red was negligible: 'One cannot imagine all the things that were signified, according to M. Gauguin, by that blazing turf!' He compared its abstruseness to a line of poetry by Mallarmé.[29]

Gauguin tried to make the whole composition of *Vision of the Sermon* express and symbolise its content. So maybe the essential point about his use of that most intense of colours was that it seemed right for the emotional tenor of his picture. Indeed it was in such artistic decisions that the 'sincerity' of Gauguin's art lay, for Maurice Denis (1870–1943) at least. This was where it made a definitive and historic break from the drab and deceitful *trompe l'oeil* of the naturalists. Gauguin's delight in rich, sonorous colours for their own sake was also a deliberate rebuff to the bleached tonalities of the Neo-Impressionists, over-concerned with reproducing the effects of sunlight [plate 94]. As Denis argued in 1890, truth in art consisted in being true to the means of art, simplifying its forms and remembering that it was in essence decorative. Gauguin, by making exaggeration acceptable, by authorising his followers to paint with pure vermilion a tree that had momentarily appeared reddish, had opened the door to poetic lyricism.[30]

THE JACOB THEME IN ART

Vision of the Sermon's secondary or alternative title is of course *Jacob Wrestling with the Angel*, and this biblical struggle, small in scale and decentralised though Gauguin makes it, is the focal point of the composition. The Old Testament patriarch Jacob is the bearded figure in green; the angel the somewhat demonic-looking blond-haired figure in blue. The relevance and possible meaning for the artist of this ancient story, as well as some of the artistic and literary precedents for its interpretation, need to be taken into account.

The story of Jacob's fight with the Angel is told in Genesis, chapter 32, and is one of many escapades involving the Jewish patriarch, one of God's chosen. Jacob's early life involves a series of subterfuges, including the theft of his brother Esau's birthright. Despite his ruses God looks kindly on Jacob, allowing him to prosper, marry and have many children who will eventually head the twelve tribes

88 | Jan Theodoor de Bry, *Jacob with the Angel*, from *Illustrated Bible*, Mainz, 1609
Courtesy of the Warburg Institute, London

89 | Rembrandt van Rijn, *Jacob Wrestling with the Angel*, c.1660
Staatliche Museen Preussischer Kulturbesitz, Berlin

of Israel. Jacob's encounter with the angel occurs on the last stage of his homeward journey, after long years of banishment. In trepidation, about to face his brother Esau, Jacob sends ahead his flocks and retinue as a peace offering. He then finds himself alone by the river Jabbok. A man whose identity is unclear wrestles with him throughout the night. At break of dawn the stranger overpowers Jacob by touching the hollow of his thigh, thereby revealing his divinity. Jacob exhorts his assailant to bless him, and the Angel does so after changing his name, from Jacob to Israel (meaning prince of God). The place of their struggle is named 'Peniel' by Jacob, meaning the Face of God, 'for I have seen God face to face, and my life is preserved'. The maiming of Jacob's thigh gives rise to the Jewish taboo about eating meat from this animal part.

Within the Christian tradition, the story lent itself to a number of different symbolic interpretations. Some saw the angel as the specific Angel Uriel, others as God, or goodness, yet others as Satan or evil against whom Jacob has to prevail.[31] One of the most widespread interpretations saw the encounter not as a struggle between two actual adversaries but as the inner struggle that took place within each Christian soul. Thus Jacob's struggle with the Angel could stand for the image of the life of the Christian, a perpetual struggle in which the believer is sometimes overcome but, like Jacob, in the end survives. Nearer to Gauguin's time, for the Romantics of the early nineteenth century Jacob came

to stand for the artist, the man of genius, engaged in unarmed combat with nature to unlock her secrets. The mysterious Angel symbolising Nature only opened the door of the invisible after a struggle. This interpretation, for Louis Réau, is the one seen in Delacroix's famous mural [plate 90].[32]

Over the centuries artistic interpretations varied widely. Several versions of the story were undertaken by Dutch, Flemish and Italian artists in the seventeenth century. Most tended to set the central theme of wrestling within a wider landscape, which allowed for representation of other parts of the biblical story. In the engraving by Dutch artist Jan Theodoor de Bry (1561–1623) for example [plate 88], the composition contrives to include the flocks that Jacob sent on ahead and the confrontation with the army of Esau. Bartholomeus Breenbergh (1598–1657) set his wrestlers in sharp relief against an expansive plain (Rijksmuseum, Amsterdam). Rembrandt concentrated solely on the two combatants, contrasting a bearded Jacob with an androgynous golden-haired angel, stressing the sensuous physicality of their encounter [plate 89]. Although probably reduced in scale from its original size, this powerful interpretation set a standard for the realist and naturalist artists who would follow.

In the nineteenth century the theme enjoyed a new vogue in the wake of Delacroix's mural decoration for the chapel of the Saints-Anges in the Paris church of

great admirer of Delacroix, there is every likelihood that Gauguin was familiar with his work at Saint-Sulpice, a place of pilgrimage for independently minded artists. His friend Jobbé-Duval had contributed to the church's decorative scheme.[34] Apart from a similarly heightened use of colour, Gauguin's version owes Delacroix no obvious debt; yet he too aspired to see his painting placed in a church setting.

Gustave Doré's *Holy Bible*, published in Tours in the 1860s, included another version of the theme Gauguin is likely to have known. The full-page illustration [plate 91], engraved by Laplante, sets the two figures on a rise in an open landscape. Unlike Delacroix, Doré (1832–1883) at least attempts to make its vegetation look authentic. He gives the angel the upper hand, and Jacob's efforts to resist look futile. Several mid-century academic artists tackled the theme, including Paul Baudry and Luigi Leloir, and tended to stress the physicality of the unarmed struggle, following Italian or Rembrandtesque precedents.[35] While an equally matched physical combat is stressed by Léon Bonnat in his Salon painting of 1876, his dirty-looking nude figures displaying their muscular strength shocked some critics and seemed more in keeping with an *académie* than a religious subject [plate 92]. Gustave Moreau took a more elegant and decorative approach to the theme, contrasting a vainly struggling earthbound Jacob with a serene, impassive angel, characteristically androgynous in appearance.[36] His *Jacob and the Angel*, shown at the Salon of 1878 (Fogg Art Museum, Cambridge, Mass.), one of the largest canvases Moreau ever produced, is an interpretation more consistent with the Christian idea of an inner struggle than with the Romantic idea of the artist wrestling with nature. In the watercolour [plate 93], one of many studies directly related to the oil, Moreau does not let the figures touch one another. Rather he implies a spiritual force emanating from the angel (which Jacob apparently cannot see for he is looking and directing his violence elsewhere) that arrests Jacob's grasping hand and causes him to flounder. Presumably because the gesture as drawn here was difficult to interpret, in the final oil Moreau modified it. Instead he has a more erect, hieratic-looking angel laying a controlling hand on Jacob's right forearm. Evidently the choice of theme had a deep private and political significance for Moreau: his Jacob represented France being arrested by her guardian angel from pursuing her headlong course towards materialism.[37]

THE JACOB THEME IN LITERATURE

As well as the many visual interpretations, Jacob's struggle with the Angel was an image that cropped up regularly in literature. The story of Jacob was one of the best-known

90 | Eugène Delacroix, *Jacob Wrestling with the Angel*, c.1850–6
Saint-Sulpice, Paris
This is the mural commissioned to decorate the Chapelle des Saints-Anges in the Church of Saint-Sulpice, Paris

Saint-Sulpice [plate 90]. Delacroix made active use of the landscape setting – implausible though his majestic trees are as an evocation of the Holy Land – placing the wrestlers to one side and the caravan and flocks to the other. His Jacob, as Baudelaire noted, is somewhat ram-like in the way he makes his headlong lunges at the calm Angel.[33] As his medium he used encaustic, a mixture of oil and wax, to try to combat the conservation problems that had beset other recent mural schemes in Parisian churches. He also calculated his chiaroscuro and heightened colour effects in terms of the natural illumination of the chapel. Since he was a

91 | Gustave Doré, *Jacob Wrestling with the Angel*, engraved by G. Laplante from *Holy Bible*, 1866*
National Library of Scotland, Edinburgh

92 | Léon Bonnat, Study for *The Struggle of Jacob and the Angel*, 1876
Dahesh Museum of Art, New York

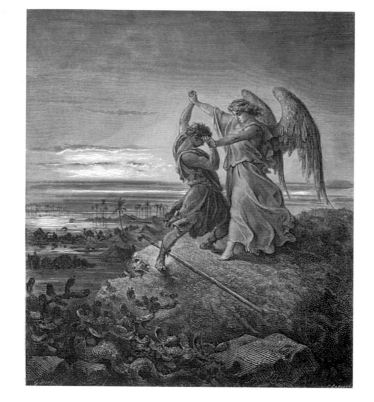

74

Breton mystery plays, traditionally performed out of doors. These were beginning to be set down in print in the nineteenth century, prompted by the Bretons' patriotic desire to prove the ancient origins of the Celtic language. The folklorist Emile Souvestre refers to *Jacob* as one of the four great traditional Breton tragedies.[38] There is no record of Gauguin attending such a play but it is not implausible that he was aware of this oral tradition.

In the literature of the nineteenth century the biblical theme saw a revival similar to that witnessed in painting. Moreover, certain of the writers who used the Jacob story were certainly read by Gauguin. Victor Hugo, for instance, in *Les Contemplations*, 1856, the cycle of personal and metaphysical poems dating from his period of exile, used the image repeatedly.[39] In *Insomnie*, poem XX, it is an image of the perpetually repeated artistic struggle; in poem XXVI, Hugo sees angels as winged envoys of God who bring joy to a few poor hearts '*comme l'ange à Jacob*'; their disappearance, like that of a star at dawn, he likens to the death of a soul, gone from our eyes only to shine more brightly in another realm. In *Les Mages*, poem XXIII, he lists the great artists who were not afraid to engage in the dawn struggle with the divine creator. And in his novel *Les Misérables*, 1862, which Gauguin was reading during the summer of 1888, although there is no longer a specific reference to Jacob, Hugo associates the image of heroic struggle with his

hero Jean Valjean. The spectacle of the goodness of Bishop Bienvenu presents the reformed convict Valjean with his ultimate moral challenge: 'He perceived that the priest's forgiveness was the most formidable assault he had ever sustained … that the battle (*lutte*) was now joined, a momentous and decisive battle between the evil in himself and the goodness in that other man.'[40]

Another pertinent use of the image crops up in *L'Oeuvre*, Emile Zola's novel about a failed artist, which caused passionate discussion in Impressionist circles when it appeared in 1886. The hero Claude Lantier's efforts to paint his masterpiece are likened to the biblical struggle:
One day it would be practically completed, the next scraped clean and a fresh start made. Such is the effort of creation that goes into the work of art! Such was the agonising effort he had to make, the blood and tears it cost him to create living flesh to produce the breath of life! Everlastingly struggling with the Real and being repeatedly conquered like Jacob fighting with the Angel![41]

In their various media and in different ways, artists of the nineteenth century identified their creative and moral struggles with the struggle of Jacob. Was this also true of Gauguin? For Victor Merlhès, Hugo's extended image of Valjean envisioning a moral struggle taking place within his own soul is key to the meaning of *Vision of the Sermon*.[42] Gauguin was unquestionably combative by nature. While

one can only guess at what kind of personal moral struggle he might have been contending with – for instance his sense of reneging on his family responsibilities – in career and artistic terms he clearly felt himself to have embarked upon a *lutte*. Writing to Schuffenecker in late November 1888 he explained that whereas he had hitherto been engaged with '*la petite lutte artistique*', what he soon needed to undertake was '*la grande lutte*', by which he seems to have meant the conquest of public opinion.[43] And in writing a retrospective account of this crucial period in his artistic development, he used the analogy again: 'it was necessary to throw oneself body and soul into the struggle, fight against all the schools, all without distinction, not by denigrating them but by other means, challenging not only the official school but also the Impressionists, the Neo-Impressionists; the old and the new public'.[44]

So on one level *Vision of the Sermon: Jacob Wrestling with the Angel* can be seen as Gauguin's critique of the narrow subject range of Impressionism and of the earthbound, pedestrian approach to religious themes of his Salon contemporaries; on another it is a defiant image symbolising the artist's perpetual struggle, and an ambitious bid for recognition on his own terms. In this remarkable picture Gauguin succeeded in imbuing a deliberately crude and simplified composition with a higher level of sophistication, raising it to a higher plane of meaning. His masterpiece resulted from a slow distillation and a sudden insight: an awareness of widely different traditions of art; a readiness to work with those traditions but cast them in a new, reinvigorated style; an ability to imagine afresh an ancient story through reference to contemporary customs and religious practices.

75

93 | Gustave Moreau, Study for *Jacob Wrestling with the Angel*, c.1878*
Musée Gustave-Moreau, Paris

5 The Public Impact of *Vision of the Sermon*

It was as though the act of painting *Vision of the Sermon* had an empowering effect on Gauguin, radically changing his status vis-à-vis his contemporaries. He clearly considered it the most important work he had produced that summer even though he was by no means able to articulate the reason for its potency. He finally felt able to leave Pont-Aven for Arles on 21 October 1888, confident that he had imposed his ideas and influence. As he prepared to depart, he informed Theo van Gogh that he was sending him a consignment of pictures, specifying that his '*tableau d'église*' would come the following month in the care of Bernard.[1] Bernard, still busy working at his wood carving [plate 68], planned to stay on in Brittany for three more weeks. Once in Arles, having received some funds from Theo, Gauguin sent Bernard the wherewithal to pay his outstanding bills in Pont-Aven and to mail a consignment of pictures to Theo. Bernard seems to have left for Paris with *Vision of the Sermon* around 10 November.[2]

There is no direct documentary evidence of the way *Vision of the Sermon* was received by its first viewers. Emile Schuffenecker made a point of going to see it, but any letter referring to it specifically has been lost. Nevertheless by December he had not only reassured Gauguin that he was on the right track in his newest work but given him exalted, head-turning praise. Gauguin's long reply exudes great confidence. He began by casting himself in the god-like role of Inca, one who dared to return to the sun whence he had come! 'For many I am in the wrong and perhaps all this is in my imagination and yet if I arouse in you the feeling of the beyond [*au-delà*] it is perhaps through this magnetic current of thought whose definite course [*marche absolue*] one cannot know but which one can guess at.'[3] These references of Gauguin's to the beyond and to magnetic currents of thought are important. They recall the aspirations he had for his painting three years before, and indicate an awareness of the latest thinking on hypnosis and other forms of non-verbal, psychological communication.[4]

Such fragments hint that he was now thinking as a 'Symbolist' rather than as an Impressionist, although it would require others to formulate the Symbolist aesthetic.

Degas too, whose opinion Gauguin greatly respected, was enthused by Gauguin's new work from Brittany and interested in buying a landscape. However, he made no specific comment about the departure into religious subject matter.[5] It was Degas who persuaded Octave Maus, the secretary of the Belgian art group *Les Vingt*, to take Gauguin's recent work seriously, for in late November the artist received an invitation from Maus to take part in the next Brussels show, due to open in early 1889.[6] He accepted with alacrity, simultaneously turning down an invitation to show his work in the Paris offices of *La Revue indépendante*. He believed this review, guided by the formidable Fénéon, to be opposed in principle to his new way of working, whereas the Brussels exhibition was a promising new international forum.[7] To show in this progressive arena was of strategic importance, a chance to get his name known, to conquer the public. Having presumably heard Seurat and several Neo-Impressionists would also be showing, it was an opportunity to 'organise a serious exhibition in opposition to the little dot'.[8]

It was thus at the sixth exhibition of *Les Vingt* that *Vision of the Sermon* first went on public show.[9] This independent group of twenty core members had as its advertised platform its openness to all new, progressive tendencies in art – an attitude that extended to music and ideas. From his reading of the art journals Gauguin would have gathered that since showing *A Sunday on La Grande Jatte* in Brussels in 1887 to great acclaim, Seurat had attracted a Belgian following. And this following was likely to be reinforced in 1889 since Seurat was showing again. An important group of work on rural themes was sent by Camille Pissarro, among his Neo-Impressionist colleagues [plate 94]. That year's other French guests were Claude Monet, who exhibited four Antibes canvases, and Gauguin's old friend Bracquemond, who showed a series of etchings after compositions by Gustave Moreau.

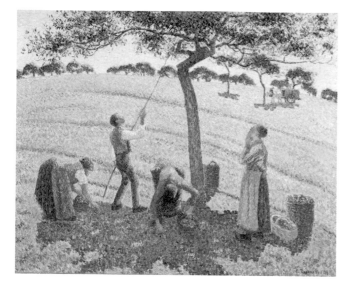

94 | Camille Pissarro,
Apple Picking, 1888
Dallas Museum of Fine Art, Munger Fund

95 | Henry van de Velde,
The Angels' Vigil, 1892–3
Museum Bellerive, Zurich

In planning his own contribution to confront theirs, Gauguin selected a representative but progressive group of twelve recent paintings, two from Martinique, six from Brittany and four from Arles. At the heart of the group was *Vision of the Sermon*. This was the first time Gauguin gave it this title, having considered and rejected *Apparition*, perhaps because it was too closely identified at that time with Moreau's John the Baptist painting.[10] Gauguin suggested a price of 1000 francs. This was considerably more than the 500 francs he wanted for most of the canvases, the painting exhibited as *Breton and Calf* for instance [plate 37]. He pitched *Boys Wrestling* at 800 francs [plate 50]. However, the work to which he attached the highest price, 2500 francs, was his recent Arles painting *Human Anguish* (Ordrupgaard, Charlottenlund), but it would be wrong to infer that Gauguin considered it of so much greater value than *Vision of the Sermon*. Certainly he now regarded it as his 'best painting' of 1888, but the price reflected the cost of its black ebonised frame and was a deliberate deterrent to

96 | Paul Gauguin,
Joys of Brittany, 1889*
Van Gogh Museum, Amsterdam
(Vincent van Gogh Foundation)

would-be buyers, for Schuffenecker had already expressed a wish to acquire it.[11] Taken as a group, these works laid bare Gauguin's recent changes of style, notably his progression from Impressionist brushwork and subject matter to a more synthetic and symbolic conception of art. They were also an indication of his range of preoccupations. Landscape continued to be a strong interest. *Vision of the Sermon* was the only work of a religious nature. *Human Anguish* represented a new interest in symbolic compositions with troubled sexualised themes; painted in Arles, it was conceptually still lodged in Brittany. He would pursue these three key strands through 1889.

The exhibition lasted from 2 February to 3 March. As in 1886 the critical reception of Gauguin's contribution was by no means as favourable as he might have hoped. The predominance of 'scientific' Impressionism, evident even from the exhibition poster whose lettering appeared on a dotted background, was noted by almost all the critics and deplored by one or two.[12] The anonymous reviewer for *Soir* hailed Gauguin as a new name showing 'landscapes and symbolic compositions', but made no distinction between him and other intransigents of the new art, Seurat and Pissarro.[13] Several commented on the Japanese feel of his work, 'a pupil of the school of Yedo' as the reviewer for *La Gazette* put it.[14] Yet, evidently, it was Gauguin's paintings that aroused the greatest passions and the greatest hilarity among the public. 'In front of his row of a dozen canvases … there's an incessant buzz of human stupidity, breaking out, from time to time, into bursts of laughter … people infer from his *Vision of the Sermon* symbolised by the wrestling bout of Jacob and the Angel on a vermilion field that the artist has presumptuously intended to mock the visitors.'[15]

Gauguin sold only one painting and his initial hopes of finding an enlightened audience in Brussels were crushed. It was not until 1891 that he risked putting *Vision of the Sermon* on public show again, and that was in the auction sale he organised to raise money for his trip to Tahiti. But showing the painting in Brussels had not been an entirely negative experience. Maus had linked Gauguin to a growing number of other painters who brought intellectual concerns to their painting. Indeed Belgium had its own distinctly cerebral artists – Félicien Rops, Fernand Khnopff, James Ensor – and it was at *Les Vingt* that Odilon Redon had first found a sympathetic audience. Gauguin would be invited back on future occasions, and would take his cue from their encouragement of the decorative arts to show ceramics and wood carvings as well as paintings. More importantly the ideas his works aroused steadily gained a foothold among the Belgian avant-garde. Whether or not he was aware of the fact, he made one spectacular convert in Henry van de Velde (1863–1957), who became the leading Belgian exponent of Art Nouveau. Originally a

Seurat follower, by 1890–2 Van de Velde was moving away from divisionism, drawing peasant subjects in a linear style similar to Van Gogh's; at the same time he began to pursue an interest in the applied arts, stimulated by the products of the British Arts and Crafts movement, shown regularly in Brussels. When Van de Velde designed his stunning embroidery *The Angels' Vigil*, 1892–3 [plate 95], sewn by a loving aunt and exhibited with *Les Vingt* in 1893, the strong impression he had carried away four years earlier of Gauguin's *Vision of the Sermon* resurfaced.[16] Over two metres wide, the design's sweeping arabesques are more purely decorative than the lines of Gauguin's painting, whose impact had been tempered for Van de Velde by seeing work by other Gauguin followers such as Maurice Denis. But this adaptation to a new medium was consistent with Gauguin's own aptitude for the decorative arts. Its religious theme in a bucolic setting – the sleeping Christ Child watched over by four kneeling praying women – and its symbolic use of saturated colour, particularly reds, owe much to Gauguin.

79

97 | Paul Gauguin,
Breton Women by a Gate, 1889*
Linda and Mel Teetz

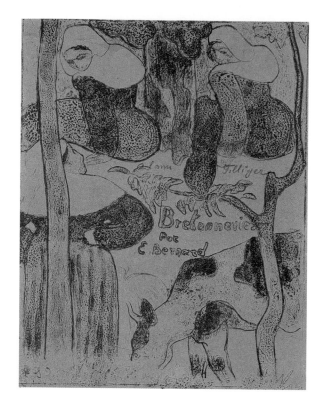

98 | Emile Bernard,
Bretonneries, inscribed
'à l'ami Filliger', 1889*
Musée des beaux-arts, Quimper,
on loan from Musée d'Orsay, Paris

99 | Paul Gauguin, *Breton
Calvary / Green Christ*, 1889*
Musées Royaux des Beaux-Arts de
Belgique, Brussels

Gauguin's major effort in 1888, which he sustained in 1889, was directed towards finding his distinctive voice and creating a mature style. Yet the new direction suggested by *Vision of the Sermon* was not immediately followed through in his own painting. The time he spent in Arles working in close partnership with Vincent van Gogh temporarily threw him off the religious tack. Vincent was uneasy about it, and besides, Gauguin found Arles a thoroughly secular milieu, with classical reminiscences he had insufficient time to explore fully; the dream of the 'Studio of the South' was abruptly curtailed by Van Gogh's breakdown and self-mutilation. Gauguin then spent several months in Paris, exploring new themes – the nude for example – and sampling the extraordinary range of cultural products on offer at the Universal Exhibition. Some of this time was also spent preparing, together with Bernard, zincograph prints intended to help publicise their recent paintings. The locations that inspired Gauguin's prints ranged from Martinique to Brittany and Arles, and the underlying ideas ranged wide also. A few of his Breton images build on the simplification and decorative quality of *Vision of the Sermon* [plate 96]. In *Breton Women by a Gate* [plate 97] Gauguin once again made an unflattering association between the silhouettes of local women in traditional costume and animals; *The Dramas of the Sea* shows three Breton women praying on a cliff edge above rocks and pounding waves, their melancholy piety evoking

the Bretonne's perpetual fear of losing loved ones to the elements. The prints in Bernard's *Bretonneries* album are more restricted and pastoral in theme but perhaps more daring and unified in style. The title page [plate 98] is a particularly successful synthesis of his caricatural drawings, repetitions of ample organic shapes enhancing the decorative design.

Fear of a repetition of the predominantly hostile reactions it had provoked in Brussels, just when he was beginning to find buyers for his less demanding Breton works, was presumably the reason Gauguin decided not to show *Vision of the Sermon* in Paris that May with the *Impressionist and Synthetist Group*. This exhibition was Gauguin's first public demonstration of his new-found leadership role; Gauguin's and Bernard's works dominated the show. Hanging radical paintings in a café inside the Universal Exhibition grounds was a strategic publicity stunt in the tradition of other radical artists' gestures (Courbet had mounted a one-man show at the Universal Exhibition of 1855, Manet in 1867). Theo van Gogh disapproved, seeing it as a vulgar gesture, a way of getting into the Exhibition by the back door. But Gauguin was growing impatient of such circumspection and determined to stir up public recognition by fair means or foul. He was for the same reason keen to seize the opportunity to get his name in print, writing polemical articles on aspects of the Universal Exhibition for the newly launched journal *Le Moderniste*. The journal publicised the show and reproduced his and Bernard's zincographs. Its editor, Gabriel-Albert Aurier (1865–1892), whom Bernard had met in 1887 in Saint-Briac and recently introduced to Gauguin, was a young critic on whom Gauguin would pin enormous hopes.

When he returned to Brittany in June 1889 Gauguin picked up the threads of his exploration of the theme of peasant piety. He painted two important new canvases. *Breton Calvary* or *Green Christ* [plate 99] was inspired by the granite calvary outside the church at Nizon, which he placed, suggestively, in the bleak dune landscape near Le Pouldu, and *Yellow Christ* [plate 100] was inspired by the wooden crucifix in the chapel of Trémalo, just outside Pont-Aven. Although lacking *Vision of the Sermon*'s supernatural dimension, both feature local women pursuing their ritual devotions in an apparently natural, instinctive way. And in both, colour is heightened and the dominant note established by the calvary serves to unify the composition. In *Breton Calvary* a weary peasant woman with rough-hewn features, momentarily relieved of her laden basket, leans back against the granite carving. Her sheep nuzzles her, as though to ensure that she is still alive and not absorbed into this melancholy deposition rendered in stone.

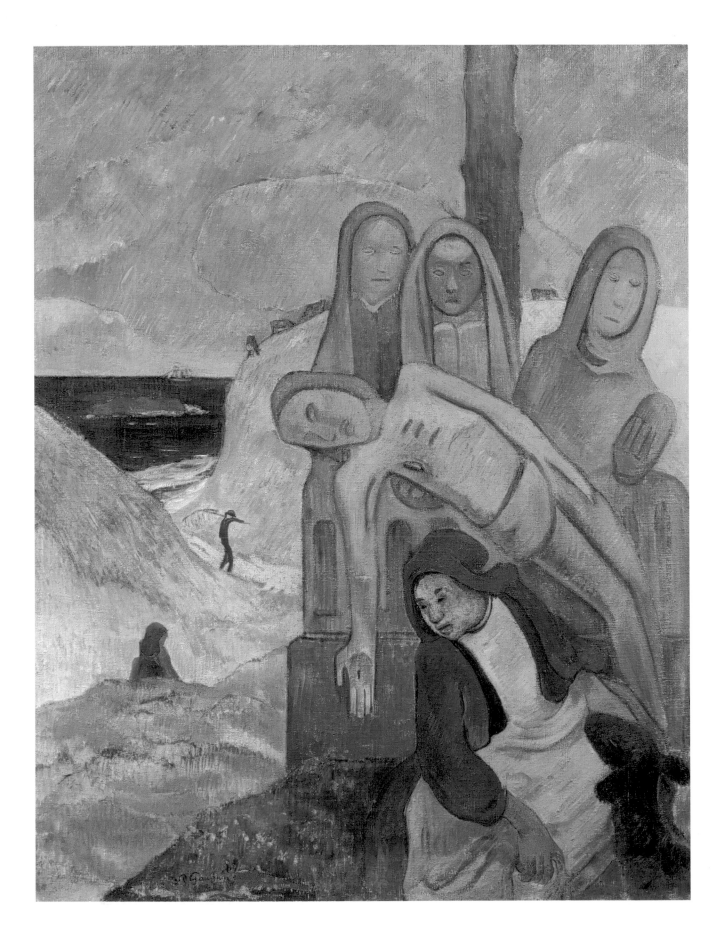

Nature empathises, forming halo-like clouds above the mourners' heads, repeating the downward-tending curves of the stonework. In *Yellow Christ* there is a stronger sense that it is the expressiveness of the carved crucifix that has provoked the women's demure, passive piety. The smooth fresco-like surface has been achieved by Gauguin's flattening the paint layer with irons and wet newspaper to get it to adhere more closely to the canvas surface. Both are vertical compositions in which the primitive religious artefact is embraced by, or absorbed into, nature. This transposition of the carved figures away from their specific church settings into simplified representations of the local landscape was Gauguin's way of generalising the message he was seeking to convey, his way of stressing the indigenous power of Breton religious feeling.

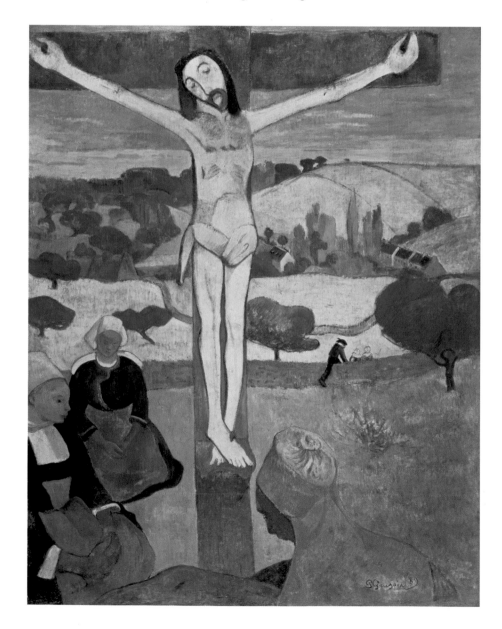

GAUGUIN'S NABI FOLLOWERS

In October 1888, when Gauguin had dispatched *Vision of the Sermon* to Paris, he had also dispatched a new convert to his work and ideas, Paul Sérusier. This intelligent advocate of the cause of 'synthetist' painting was to be of key importance to Gauguin over the next few years. Sérusier was an artist of some standing, he held a position of responsibility at the Académie Julian, one of the key teaching studios in Paris, whose students flocked every summer to Brittany. He had had a success at the 1888 Salon with *Breton Weaver's Workshop* (Musée d'Art et Archéologie, Senlis) and could easily have forged a conventional career by continuing to paint genre subjects in this conscientious naturalist vein. He had been looking into the possibility of renting studio space in Concarneau in the same building as Dagnan-Bouveret.[17] But, already immersed in the study of Neoplatonist philosophy, Sérusier had doubts about naturalism and was intrigued by Gauguin's recent work and the challenge it presented. On approaching Gauguin for advice shortly before his own departure for Paris, he received an impromptu lesson in synthetic painting in the Bois d'Amour – the outcome of which was a small brightly coloured, proto-abstract painting, *Landscape in the Bois d'Amour* [plate 101]. According to the various accounts of this lesson, Gauguin challenged Sérusier to paint frankly and instinctively: if a tree trunk struck him as on the blue side, to paint it blue using the colour straight from the tube, and so on. It was a recipe for casting aside naturalism's slavish observation of nature and local colour for an expressive simplification of the sensations inspired by nature using synthetic form and colour. For Sérusier these few ideas, combined with the Symbolist potential he had seen in Gauguin's latest work, were enough to lay the foundations of a new aesthetic. He spread the message among his close contacts at the Académie Julian, who, over the course of the winter, formed a secret brotherhood, the Nabis (Hebrew and Arabic for prophets), sworn to defend the ideas of true art to which Gauguin's discoveries seemed to point the way. They dubbed Sérusier's painting their *Talisman*. Sérusier worked alongside Gauguin in Brittany during the summers of 1889 and 1890 and through his letters gave his friends Maurice Denis and Paul Ranson (1861–1909) privileged access to Gauguin's thinking, upon which he doubtless had some influence. Gauguin's sense of the artist having a God-given mission coincided with Sérusier's idealised concept of the Nabi group as a religious brotherhood.

The impact of *Vision of the Sermon* is directly discernible in a number of religious paintings produced by these spiritually inclined young artists. Although unorthodox, for the Nabis Gauguin's religious paintings conveyed infinitely

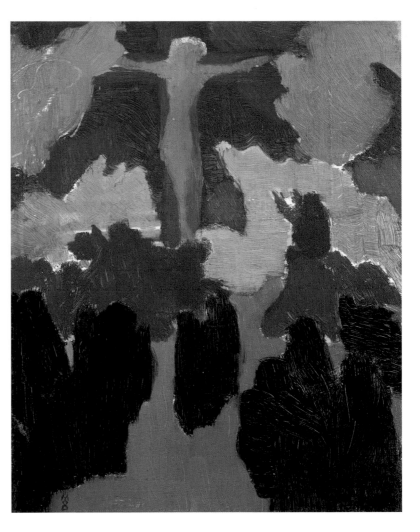

101 | Paul Sérusier,
*Landscape in the Bois
d'Amour / The Talisman*,
1888*
Musée d'Orsay, Paris

102 | Maurice Denis,
*Orange Christ, c.*1890*
Courtesy of Galerie Hopkins-
Custot, Paris

greater sincerity and spirituality than the crude Stations of the Cross produced by the commercial purveyors of religious bric à brac. Denis, an orthodox Catholic, aspired to producing an exalted form of Christian art and was already an admirer of the calm mood and pale harmonies of Fra Angelico and Puvis de Chavannes. He was immediately drawn to the visionary aspects of Gauguin's Breton work. He found through Gauguin's artistic example a way to sanctify his sensual delight in light and colour, movement and gesture, to make the artistic act simultaneously an act of faith.

In 1889–90 Denis painted several small, bright-hued, daringly abstract studies on Catholic themes. *Orange Christ* [plate 102] uses embryonic patches of black, red and green to suggest a procession of pious women approaching a transcendent image of the Crucifixion; the black and red contrasts of *Vision of the Sermon* are used here to convey a powerful feeling of religious ecstasy.[18] In *The Mystical Grape Harvest* c.1890 [plate 103], a painting he gave to Ranson, Denis reintroduces the partial image of Christ

crucified and evokes the sacrament of wine, the red blood of Christ's wounded body merging with the vine's tendrils and the red grapes that the holy women gather beneath him. Denis counters the theme's potential mawkishness by subjecting his composition to a deliberately sinuous decorative treatment, the graceful gestures of the women and the surface pattern of dots combined with a colour harmony of heightened reds, yellows and greens. Red is also used to convey an effect of spirituality by Paul Ranson in *Christ and Buddha* [plate 104], swirling clouds of red suggesting an enigmatic dreamscape which gives way to gold and rank upon rank of praying figures. This syncretic religious image juxtaposes symbols from two of the world's great religions: a green Buddha occupies the foreground – with a second truncated Buddha face looming to upper right – while in the middle ground an image of Christ on the cross appears in a halo of light, similar in its expressive qualities to Gauguin's *Yellow Christ.*[19]

In August 1890 Denis took up the role of propagandist for the aesthetic ideas he and his friends were evolving,

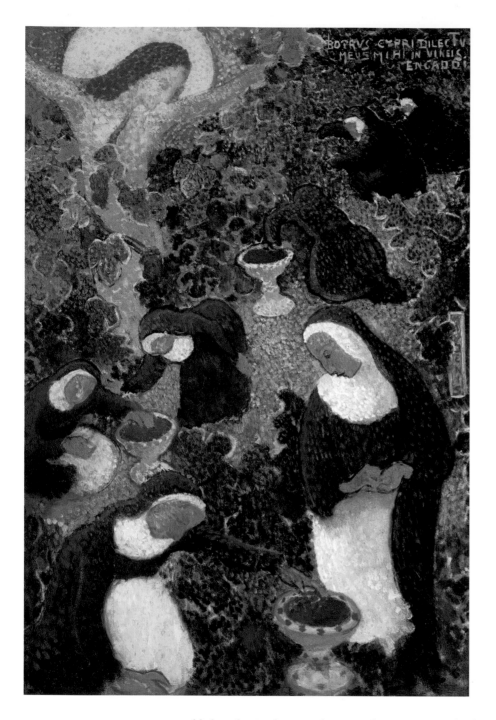

BOTRVS CYPRI DILECTV
MEVS MIHI IN VINEIS
ENGADDI

103 | Maurice Denis,
The Mystical Grape Harvest,
c.1890*
Triton Foundation, The Netherlands

overthrowing the academic precepts to which he and his friends had been subjected, Denis went on to trace Gauguin's artistic lineage – and that of Puvis de Chavannes – back to the great decorative masters of the past, the Egyptians and the Italian primitives. He argued that in each case it was not the artist's choice of subject alone that produced a lofty sincerity of expression but his beautiful and expressive arrangements of line and form.

The flat colour, strong contours and rhythmic forms favoured by Denis from around 1890–3 were distinctly Gauguinesque, as were certain of his choices of subject, such as his interpretation of that melancholy Breton theme *Seaweed-gatherers* [plate 105] and a study of women watching wrestlers at a pardon.[22] And in *Jacob Wrestling with the Angel*, 1893 [plate 106], Denis tackled head on Gauguin's modern interpretation of the biblical subject. Denis's two wrestlers, robed and barefoot like Gauguin's, are similarly placed in a Breton setting, the clearing of a dark forest where the trees are transformed by fiery dawn light. But there are no Breton onlookers, and Denis gave the story a highly idiosyncratic twist: the wingless angel is in fact based on the artist himself, the smaller figure of Jacob on his bride Marthe. Painted on his honeymoon, in Denis's composition the traditional spiritual struggle is a symbolic sublimation of the couple's nightlong marital dance.

The name Nabi was essentially an honour, conferred liberally by Sérusier and Ranson on artists who never attended any of the group's Paris meetings. Gauguin himself was considered a Nabi, but so were artists such as Bernard and a number of new recruits to Gauguin's cause. Through the Nabis and the younger artists, like Armand Seguin, who became his disciples in Pont-Aven, Gauguin found a body of articulate supporters. Even after he had forfeited the support of his close collaborators, Bernard and Schuffenecker, these younger men would trumpet the formal and spiritual message of his work onward to the next generation.

One might criticise Gauguin for surrounding himself with artists of lesser stature, often considerably younger than himself, who had their own ambitions and agenda. With them he had no need to compete. But one senses his unease at becoming the exclusive hero of the young; it was the masters of the Impressionist movement, Degas, Monet and Pissarro, whose opinions still mattered to him the most.

CRITICAL RECOGNITION

The manner in which Gauguin emerged as leader of the Symbolists is fascinating and reveals much about the power of the press in modern society. Crucial to that process was the consecration, in 1891, of *Vision of the Sermon* as

publishing his 'Definition of Neo-Traditionism'. His chief purpose was 'to shout out loud, since people are unable to see it, that the author of … the *Struggle of Jacob* … is quite simply a master'.[20] The radicalism of Gauguin's example inspired Denis's famous modernist dictum, whose influence would have far-reaching consequences in the twentieth century: 'Remember that a painting before being a war-horse, a nude woman or some anecdote or other is essentially a flat surface covered with colours arranged in a certain order'.[21] After pointing out the flaws in naturalism,

Gauguin's masterpiece. It took over two years for the painting to achieve such recognition, but without question this, as Bernard ruefully observed, was the canvas 'that did the most in Paris to ensure Gauguin was considered the creator of symbolism'.[23]

Gauguin's work prior to 1891 had not gone unnoticed by the critics – Huysmans and Fénéon having singled him out for attention – but their commentaries had often been unfavourable, ill-informed or wide of the mark. Much mischief could be done by the written word, as Gauguin was well aware, and he remained scathing in his attacks on

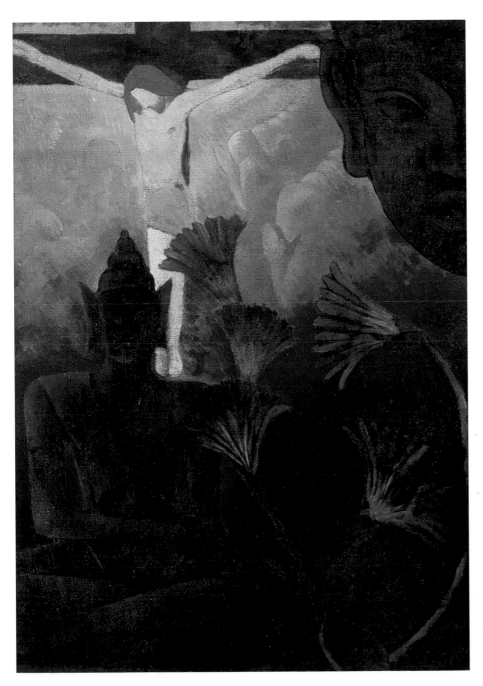

professional and literary art critics to the end of his career, maintaining that artists were their own best apologists. From late 1888 on, his letters to his artist colleagues and his dealer repeatedly demonstrate a need to elucidate the meanings of his more abstruse Symbolist works, whilst retaining an element of mystique. This need grew urgent by late 1889, when he sensed hostility among his old Impressionist colleagues both to the new religious turn his work had taken and to his new style which they judged pretentious and overly derivative. Gauguin suspected the caveats of Degas and Pissarro were influencing Theo's opinion against him.[24] He wrote the dealer a long letter in a tone that was by turns reassuring and pugnacious, defending his career strategy and seeking to explain his recent work. The *Green Christ*, for instance, was intended to express 'Brittany, simple superstition and desolation'.[25]

It was at this crucial juncture that Gauguin decided he needed the support of some sympathetic, articulate critics. For if he sensed he was losing support from the Impressionist camp, he knew his star was rising among the young. Throughout 1890 he pressed Bernard to remind Aurier of his promise to write a supportive article; he badgered Pissarro to put him touch with the critic Mirbeau. By enlisting the support of these two rather different critics, Gauguin was doing his utmost to control his public persona and secure his future reputation.[26] Octave Mirbeau (1848–1917), well-known as a novelist, had recently come to the fore as champion of Monet, Rodin and Pissarro. It was through the joint agency of Pissarro and of Stéphane Mallarmé that Gauguin succeeded in getting his support. Pissarro, looking back on this period, was disgusted: 'If you knew the contemptibleness with which Gauguin behaved to have himself elected (that's the word) man of genius, and how shrewdly. There was nothing to do but facilitate his ascent!'[27] There was some justification for Pissarro's scathing comments, for Gauguin had not disguised the fact that he was using the pens of these educated writers to further his reputation, treating them as his press agents. His purpose was simple – to raise the money to finance his projected trip to Tahiti.

Gauguin made a point of going to visit Mirbeau in the country in order to put his case. He supplied Aurier with some picture notes, and probably talked to him in Paris. About the *Green Christ*, he wrote on a visiting card: 'Calvary of cold stone, taken from the earth – Breton idea, of the sculptor who explains religion through his Breton soul using Breton costumes – local, Breton colour, passive sheep. The whole in a Breton landscape, that's to say Breton poetry, its starting point (colour draws the surroundings into harmony sky, etc., sad to do. Opposed to this – (the

human figure) poverty, [illegible word] of life.'[28] There is no record of his having written similar notes about *Vision of the Sermon*.

The literary climate was favourable to Gauguin's art in 1890. Poets had for some years been questioning the orthodoxy of naturalism in literature, and a new Symbolist movement was gaining ground. Inspirational figures like Verlaine and Mallarmé offered examples of a more suggestive type of poetry in which nuance replaced concrete description; and free verse, which was increasingly replacing the traditional alexandrine, had a liberating effect on the imagination. But in the fine arts there was still a dearth of painters offering an alternative to naturalism. Puvis de Chavannes and Gustave Moreau, in their different ways, represented a will to rise above banal reality. Odilon Redon's potent creations, inspired by literature but distilled from an imagined world of science and dream, were gaining admirers. Now, in Gauguin, experienced writers like Mallarmé, Mirbeau and Jean Dolent and younger writers such as Aurier, Julien Leclerq and Charles Morice, were

confronting an artist who was confidently harnessing Impressionist techniques and brilliant colour to an art drawn from the imagination. Gauguin alluded to this meltdown of styles when writing to thank Mirbeau for his willingness to defend 'the right cause', 'just at the moment when we're seeing a blazing fusion of naturalism, Parnassianism and Symbolism'.[29]

Letters exchanged between Gauguin, Mirbeau and Monet provide an important insight into how Gauguin now saw himself in relation to his erstwhile Impressionist colleagues. Mirbeau, who had taken time out from an extensive article he was writing on Monet to help Gauguin's cause, was urged by the latter to divulge what Monet thought of Gauguin's latest work. Did Monet approve of 'his evolution towards a complication of the idea through simplification of the form'? This brief formulation is the nearest Gauguin ever came to summing up what Symbolism meant in his own work. Mirbeau, who found Gauguin to have 'a sympathetic nature, genuinely tormented by the suffering for his art', replied in the affirmative,

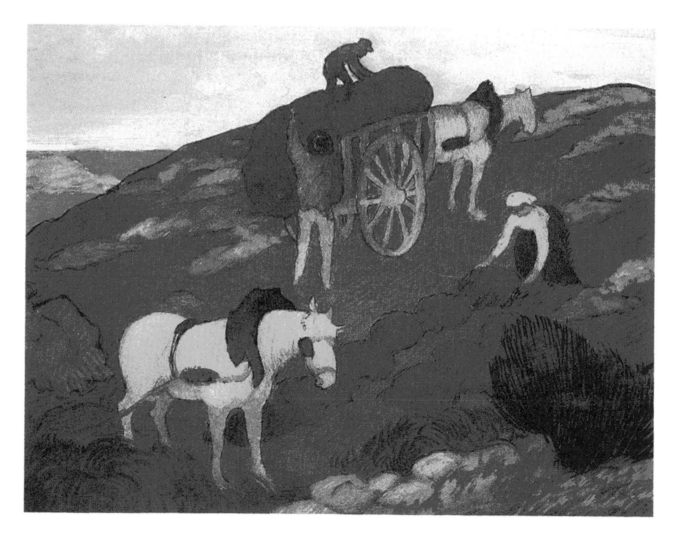

105 | Maurice Denis,
*Seaweed-gatherers, c.1890**
Private Collection

86

that Monet had indeed liked his *Jacob Wrestling with the Angel* a great deal, as well as his pottery. 'I did the right thing', Mirbeau told Monet; 'that gave him much pleasure'.[30] Presumably Monet had expressed some such approval, but Mirbeau had overstepped the mark. His reply is lost but a distinctly nettled Monet appears to have written back setting out in brief his own 'doctrine of art' and the gulf that separated it from Gauguin's overly cerebral Symbolism: his main point seems to have been that an artist could only stimulate thinking by first appealing to the eye. This much is revealed in Mirbeau's hasty reply, backtracking, pacifying Monet, concurring that Gauguin's art was of course 'inferior' in terms of its ability to move the spectator, that it certainly looked 'clamorous, a bit vulgar' next to the 'distinction and discretion' of Monet's *Haystacks* (this was the context in which Mirbeau had had to appraise Gauguin's work at the Boussod & Valadon gallery). Nevertheless, in spite of all its shortcomings, it revealed a 'taste for decorative arrangement which is pleasing'. And he had been particularly taken with one of Gauguin's pots, shaped like female genitalia, 'of a poignant and lofty obscenity'![31]

Mirbeau's fulsome articles, published in *L'Echo de Paris*[32] and on the front page of *Le Figaro*, reached a wide audience and were well timed to publicise Gauguin's auction. Mirbeau dramatised Gauguin's plight as that of an exceptionally talented artist forced into exile by lack of recognition. He seems to have had *Vision of the Sermon* in mind when he wrote: 'Let others laugh before these canvases … some of which have the mystical and distant breadth of a cathedral's stained glass; laughter is more often than not the inability to feel beauty. Before these canvases, I myself sense a thinking brain and a suffering heart, and this moves me.'[33] Mirbeau put his own reputation on the line for Gauguin. For Aurier, bestowing the hotly contested crown of 'Symbolist painter' on Gauguin was a chance to get himself noticed. While Aurier's more pondered and penetrating words, published in the *Mercure de France*, an élite journal, were probably only read in advanced artistic circles, they continue to be cited today.[34] His article was both a promotion of Gauguin as *the* contemporary exemplar of 'symbolism in painting' and an aesthetic prescription for the work of art's essential points. It was to be: 'Ideistic, since its unique ideal will be to express the idea; Symbolist, since it will express the idea through forms; Synthetic, since it will present these forms and signs in a commonly intelligible fashion; Subjective, since the object will never, in the work of art, be considered as an object, but as the sign of an idea perceived by the subject; and, in consequence, Decorative.' Aurier hailed Gauguin as 'the great artist of genius, with the soul of a primitive', the creator of 'troubling,

magisterial and marvelous work'; the leader of a new movement that was trampling on naturalism, surpassing Impressionism, vindicating the artist's right to dream. The only painting Aurier wrote about at length was *Jacob Wrestling with the Angel*, whose subject and paradoxical form set in train his whole argument. He began by evoking it in incantatory terms: 'Far, very far away, on a fabulous hill, where the earth seems to glow bright red, Jacob's biblical struggle with the Angel is taking place'. He justified the spatial oddities by reference to the vision, conjured in simple Breton women's minds; the voice of their village preacher had raised them above their material circumstances, transported them to the supernatural realm.

Several features make one wonder whether Aurier's reading was in part tutored by Gauguin. The stress on fable and childhood may have been Aurier's own take on the painting, but it recalls the discussions Gauguin and Bernard were having in 1888 about children's art. It is doubtful whether Gauguin followed Aurier's more abstruse references to Neoplatonist philosophy. Even artists such as Maurice Denis, who were schooled in philosophy, suspected Aurier's arguments were too theoretical and went over most painters' heads.[35]

Both Mirbeau and Aurier set Gauguin up as an 'isolated genius', not an artist who had worked closely with, been supported by and borrowed extensively from others, Pissarro, Degas and Bernard in particular.[36] Aurier's panegyric sparked forthright and unequivocal disapproval from Pissarro, the artist whose dominant influence it had taken Gauguin so long to shake off. His reaction to *Vision of the Sermon* seems at first to have been merely one of dismay and unease, but, faced with Aurier's lofty claims, it hardened. On 20 April 1891, having annotated the article, Pissarro sent it, together with a long enraged letter, to his son Lucien. He was highly critical of Aurier's hairsplitting reasoning and resented the way in which it tried to drive a wedge between Impressionism and Symbolism, casting the Impressionists in a purely materialist role, incompatible with producing an intelligent art based on ideas.[37] He personally had no particular objection to Gauguin's synthetic style, although it was too heavily dependent on Japanese and other primitive art forms. But as an ardent anarchist and atheist he thoroughly disapproved of Gauguin's abandonment of modern subject matter in favour of an anachronistic religious theme: 'It's a step backwards. Gauguin's no visionary, he's a schemer who has sensed a reaction on the part of the bourgeoisie, in response to the great ideas of solidarity that are burgeoning among the people...! The Symbolists are the same … we must fight them like the plague!'[38] Aurier's article appeared at a time

of reaction and retrenchment in the political and religious climate. These circumstances, too, led Pissarro to see *Vision of the Sermon* not as a quirky aberration on Gauguin's part but as symptomatic of a dangerous emergent trend.[39] He was fearful, looking at the Salon des Indépendants in 1891, of the growing influence Gauguin's mysticism was having among the young.

It is a telling fact that there were many more writers than painters at the farewell banquet for Gauguin held on 23 March 1891; they included Alfred Vallette, editor of the *Mercure de France*, his wife the playwright Rachilde, for whom Gauguin had just drawn a frontispiece, and Mallarmé who presided and pronounced the toast. Notably absent were Schuffenecker and Bernard. Yet for most of 1890, Bernard had been a party to, and included in, Gauguin's plans to set up studio in the tropics. However his attempts to raise money and organise things so that he

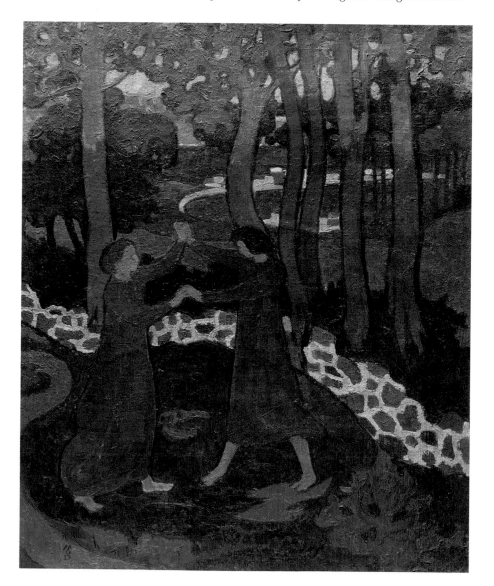

106 | Maurice Denis, *Jacob Wrestling with the Angel*, 1893
Private Collection

could accompany Gauguin had wavered and a growing mistrust had soured their relations. The two had disagreed profoundly about how best to honour their mutual comrade Vincent van Gogh, in the wake of his suicide in July 1890. As the time for departure drew near, recalling certain difficulties that had arisen with Laval, Gauguin himself had grave doubts about the wisdom of fettering himself with another temperamental young companion. Forging his personal reputation and promoting his individual career unquestionably took precedence now over any feelings of responsibility towards others. Whereas his letters of 1888 to 1889 had spoken frequently in terms of joint undertakings, now the pronoun I took over. The death of Theo Van Gogh in January 1891 exacerbated Gauguin's determination to look out for himself. His last letter to Theo, in which he expressed anxiety about not having heard any news, dates from mid-September 1890, that is only a month after his letter of condolence following the death of Vincent who, despite their differences, had been his closest artist friend, and his nearest equal. Soon after this he learned that Theo had lost his reason and was too ill to manage his business affairs. One should not underestimate the desperation this double loss caused Gauguin, although the tone in which he conveyed the news to Bernard sounds callous and self-centred.[40] It may in part explain his rough and ready dealings with others in his circle in the winter months of 1890–1.

The extravagant publicity surrounding Gauguin in February-March 1891 had the desired effect where his art was concerned, resulting in a relatively successful auction sale at the Hôtel Drouot.[41] But it fractured the artist's already friable relationship with Bernard, led to a considerable *froideur* between Bernard and Aurier, gave annoyance to Monet and Pissarro, and was probably the final straw for Schuffenecker, who had endured so much from his overbearing friend.[42] Henceforth the supportive role he had played was taken over by Georges-Daniel de Monfreid. Bernard confronted Gauguin at the sale and broke off relations; his action was backed up by his sister. Although personal misunderstandings had been building up, a series of injustices for which art critics, and not Gauguin, were responsible had compounded the problem. For instance, Jules Antoine had claimed that Bernard was obviously Gauguin's close imitator in his review of their joint exhibition in 1889.[43] And Aurier's *Mercure de France* article, which Bernard could have read before its publication, completely omitted to mention Bernard's close collaboration with Gauguin. As far as Aurier was concerned, it was not with his contemporaries that Gauguin needed to be compared, but with the great masters of the past: 'This

marvellous artist … has attempted to reinstate true art in our society, so ill prepared for such a revolution, the art of Ideas made incarnate in living symbols, the art of men like Giotto, Angelico, Mantegna and da Vinci'.[44]

For artists there is an inevitable, perennial conflict between committing oneself to group efforts and pursuing individual ambition. That conflict created turmoil for Emile Bernard in early 1891, torn as he was between his altruistic desire to promote his friends (for he had urged Aurier to write about Vincent van Gogh as well as Gauguin) and his self-interest. In a letter to Schuffenecker of January 1891, Bernard proposed the formation of an 'Anonymous Society' where all artistic work would be undertaken for the mutual good and presented incognito, with no thought of individual popularity, 'no jealousies, no dishonest plagiarism ….'[45] It was a chimerical ideal that directly translated his feelings of resentment towards Gauguin. But a few months later he backtracked, publishing pioneering articles on Van Gogh and Cézanne, whom he had indeed been one of the first to appreciate, and agreeing to the publication by Schuffenecker of his own profile, all for the series Les Hommes d'aujourd'hui. This article, which never appeared, was largely dictated by Bernard; although many artists were cited as having helped to form his talent, pointedly no mention was made of Gauguin.[46]

Félix Fénéon tried to set the record straight in May 1891, but probably merely succeeded in offending both Gauguin and Bernard: 'Emile Bernard', he wrote, 'who today may be his [Gauguin's] student … appears to have been his initiator'. But Fénéon dismissed the archaic mannered style and religiosity of Bernard's latest paintings. He also mixed praise and condemnation when writing about Gauguin's recent work. While Gauguin had 'unquestionably … enriched the contemporary soul,' his painting had too many obvious borrowings … and the artist had become 'the prey of the literary set'.[47] Even Gauguin's two principal defenders Aurier and Mirbeau could not entirely agree among themselves. In December 1891 they met, seemingly for the first time.[48] Mirbeau took a certain delight in pointing out to Aurier (whom he privately considered an imbecile) that his theories were misguided, that his characterisation of Impressionism and Symbolism was inadequate and insulting to an artist of ideas and integrity like Pissarro – with all of which Aurier apparently concurred. Aurier's subsequent long article on 'Les symbolistes' showed a certain modification of his position but his untimely death the same year left open the question of where his aesthetic thinking was heading.[49]

6 The Legacy of *Vision of the Sermon*

Undoubtedly a fractious and feverish atmosphere surrounded Gauguin's seminal painting in 1891. Thereafter it is possible to follow its legacy in a number of different directions. Its first consequences were for Gauguin's own work. After the concentration of images representing Breton piety in 1889 culminating in his *Christ in the Garden of Olives* [plate 107] this preoccupation receded in Gauguin's oeuvre, although Christian themes cropped up from time to time in Tahiti and on his return to Brittany in 1894. At a purely formal level the angel spawned a number of further angelic images.[1] At a deeper level, the thinking that lay behind *Vision of the Sermon*, both in terms of its 'complication of the idea through simplification of the form' and in terms of its approach to spirituality, proved fruitful. Gauguin was not able to work at this level all the time, and indeed alternated such challenging 'symbolist' works with more straightforward observations of nature. His charming *Landscape with Two Breton Girls* of 1889 [plate 108] is a case in point, combining a certain air of piety with a sensual celebration of landscape. Following the 1891 auction this painting became the property of the Nabi Ker-Xavier Roussel and played an important role for the Nabi group, hung in their respective studios in a place of honour.

But the lessons *Vision of the Sermon* had taught Gauguin about distilling for his art the strangeness and otherness of an unfamiliar place and culture were carried forward to Tahiti. In a small number of his most profound Tahitian works Gauguin took up again what has been called 'the unchanging task of art', the exploration of the 'paradoxical relationship of the Finite to the Infinite'.[2] One sees this 'task' taken on in a suggestive and powerful way in *Manao tupapau* or *Spirit of the Dead Watching* [plate 109], the painting from his first Tahitian voyage by which Gauguin set most personal store. The composition attempts once again to deal with an inaccessible religious feeling, to understand the power of faith, the hold of superstition, on the susceptible 'primitive' mind. Tellingly, as in *Vision of*

the Sermon, the consciousness experiencing the presence of the supernatural is again female, but by showing her naked and at a remove Gauguin stressed her exotic difference from his putative European spectator. The meaning of the painting is left deliberately ambiguous: has the frightened woman conjured up a vision of her innermost fears, or should the brooding figure at the end of her bed be interpreted as a primitive idol? In these post-colonial times, it has become difficult to look dispassionately at Gauguin's artistic purpose in this painting, distracted as we have become with our knowledge of Gauguin's life style, by his exploitation of the model, Teha'amana, his Tahitian mistress. Gauguin himself acknowledged the potential eroticism of viewing, from a position of domination, this vulnerable young girl.[3] But the power of the painting lies in its combination of beautiful colours and forms, in its aspiration to enlarge the viewer's experience, in its communication of a powerful emotion of fear. One needs perhaps to be mindful of the distinction between the biography and the artistic project: 'A man and his "views" are not the same as those of the artist within him who seeks to invade and recreate the mystery of something he feels is forever beyond his reach'.[4]

On his return to Paris in 1893, Gauguin expected to find a hero's welcome. He held an exhibition of his Tahitian work at Durand-Ruel's gallery. He also came into an inheritance from a recently deceased uncle in Orléans. There is a self-important, even triumphalist air about the *Self-portrait with Palette* [frontispiece] which dates from around this time, certain of its details apparently taken from a photograph. Dramatically clad in cloak and astrakhan hat, Gauguin sets his proud, disdainful features against a uniform background of bright vermilion. Given that in recent self-portraits he had pointedly set himself in front of work with which he wanted to identify, the *Yellow Christ* for instance and *Manao tupapau*, one wonders what the significance might be of his bold use of red here. Is it a reminder of the red in *Vision of the Sermon*, a way of

underlining his identity as the artist who had reclaimed the right to dream? He dedicated the canvas to his new friend the Symbolist poet and journalist Charles Morice, with whom he was just then collaborating on *Noa Noa*, an imaginative account of his experiences of Tahiti. It is the isolation of this portrait that is most striking, a proud artist out of kilter with his times. For in Paris, ideas had already moved on. Even his admirer Octave Mirbeau was becoming disillusioned with Symbolism. The fascination of the Dream, the Ideal, had become tarnished by association with the self-promoting proclamations of Sâr Péladan and his newly founded Salon de la Rose+Croix.

Another strand of the legacy of *Vision of the Sermon* is to be found in the art of Gauguin's followers; there one frequently finds generalised recollections of the painting's decorative style, striking use of colour or subject matter. Breton women in white *coiffes* set against red backgrounds appear frequently in works by Sérusier [plate 110] and his pupil Georges Lacombe (1868–1916), usually with a justification in nature – as in Lacombe's striking painting of

Woman Harvesting Buckwheat (whereabouts unknown). Although he would have denounced any notion of perpetuating Gauguin's legacy, Bernard's *Breton Women at a Pardon* [plate 111] is one of several decorative reprises of a theme upon which Gauguin had stamped an indelible mark. But, after this last spell in Pont-Aven, Bernard put Brittany and its increasingly painful associations with Gauguin behind him, travelling to Italy, absorbing himself in the art of the High Renaissance, settling for many years in Egypt. Sérusier and Lacombe on the other hand continued to identify with both Gauguin and Brittany, becoming deeply imbued with the region's traditions and folklore. Sérusier settled in inland Brittany, and Lacombe, whose only meeting with Gauguin seems to have been in Paris, through Sérusier, in spring 1894, regularly stayed with his family at the port of Camaret on the west coast.[5] Gauguin admired Lacombe's independence of spirit and was gratified to have transmitted to him his commitment to the difficult art of woodcarving.

Lacombe's subjects frequently introduce a wry humour

107 | Paul Gauguin, *Christ in the Garden of Olives*, 1889
Norton Museum of Art, West Palm Beach, Florida, gift of Elizabeth C. Norton, 46.5

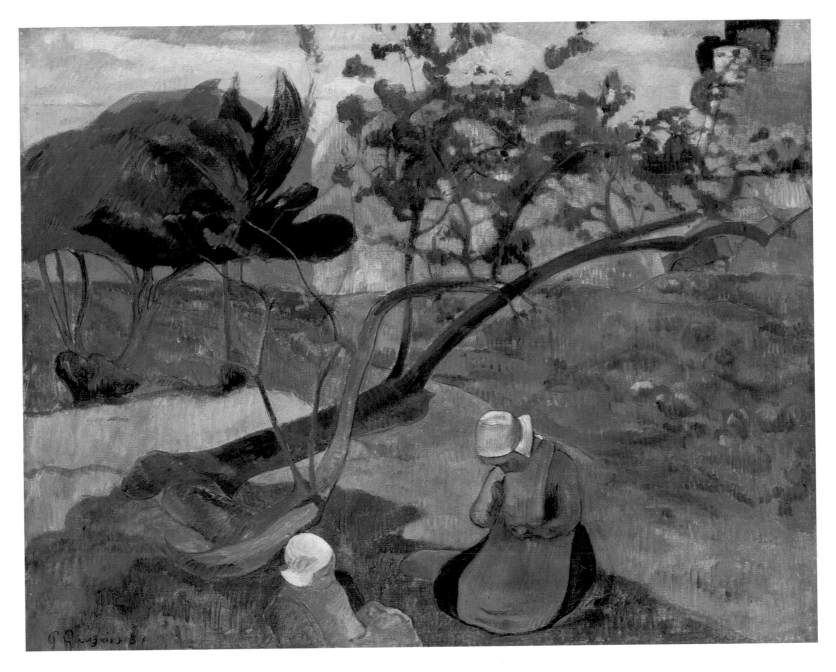

108 | Paul Gauguin, *Landscape with Two Breton Girls*, 1889*
Museum of Fine Arts, Boston, gift of Harry and Mildred Remis and Robert and Ruth Remis

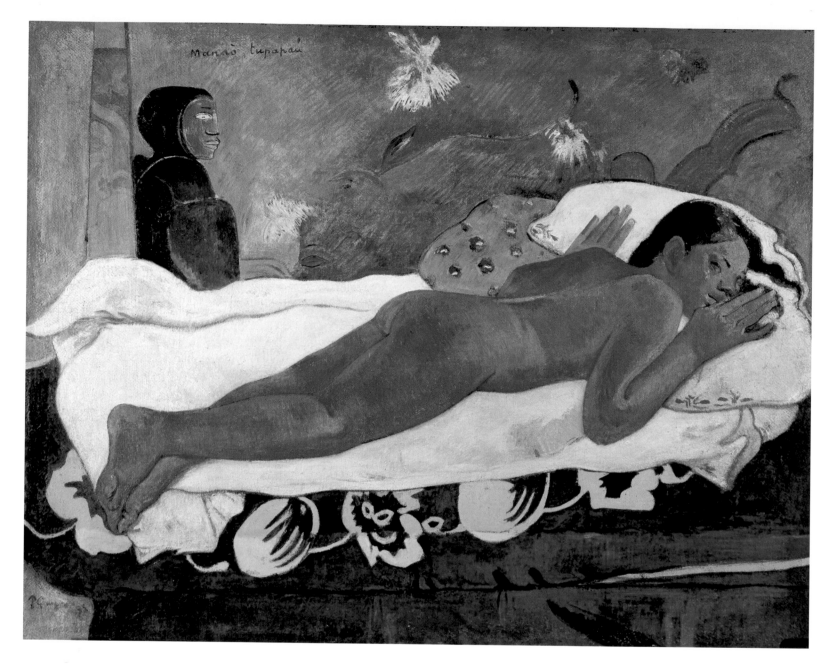

94

109 | Paul Gauguin, *Manao tupapau /*
Spirit of the Dead Watching, 1892*
Albright-Knox Art Gallery, Buffalo,
A. Conger Goodyear collection, 1965

not unlike the *fumisterie* of Gauguin, which can make their interpretation problematic. A case in point is his resolved and considered drawing *The Scuffle* [plate 112], probably a study for a painting or a carved wood relief. Lacombe depicts a fight between two Bretons: both are long-haired, and barefoot, having discarded clogs. One is armed with a knife, the other with a stone. Nearby a nonchalant young Breton woman, presumably the *casus bellum*, stands by holding a flower to her nose. With its mixture of humour and aggression it conforms to other unsentimental, even austere peasant subjects undertaken by Lacombe at this time. Nothing obvious links it to Gauguin. Yet it is a testament to the powerful legacy of Gauguin's image and of his reputation that this drawing has been variously entitled, not by Lacombe as far as we know, *The Struggle between Jacob and the Angel* and *The Battle of Concarneau*. The former title seems unwarranted while the Concarneau title, puzzling given that the setting is hilly and rural and bears no resemblance to that port, alludes to an incident in Brittany involving Gauguin and some of his friends in May 1894. As they strolled on the quayside at Concarneau, Annah, his Javanese mistress, found herself the butt of local lads' taunts and stone throwing. Gauguin defended her and in the ensuing brawl sustained a broken ankle which laid him up for the rest of the summer. While it is plausible that Lacombe heard about this incident and that it sparked his pictorial thinking, one is no more justified in tying the Concarneau incident to this drawing than to his painting of a *Breton Throwing a Stone* (whereabouts unknown), which at least takes place with the sea in the background.

The number of Gauguin's followers, and their international origins, grew exponentially after his departure for Tahiti. In 1893, the notion of an Ecole de Pont-Aven was first mooted, its identity inextricably linked to Gauguin's reputation.[6] Its adherents included numerous Frenchmen, some of whom were Breton in origin, Armand Seguin, Charles Filiger, Emile Jourdan, Maxime Maufra and Henry Moret; two Dutch artists, Jacob Meyer de Haan and Jan Verkade; and two Danes, Jens-Ferdinand Willumsen and Mogens Ballin. Later on Gauguin's circle widened to encompass two British artists, Robert Bevan and Eric Forbes-Robertson; an Irishman, Roderic O'Conor; a Swiss, Cuno Amiet and a Pole, Wladislaw Slewinski (1856–1918).

110 | Paul Sérusier, *Louise / The Breton Servant Woman*, c.1891*
Musée Départmental Maurice Denis, Saint-Germain-en-Laye

111 | Emile Bernard, *Breton Women at a Pardon*, 1892
Dallas Museum of Fine Art, The Art Museum League Fund

112 | Georges Lacombe,
The Scuffle, 1894*
Indianapolis Museum of Art, The
Holliday Collection, 79.259

113 | Armand Seguin,
Breton Peasant Girls at Mass,
1894*
National Museums and Galleries of
Wales, Cardiff

Given the continuing popularity of Pont-Aven as an artistic destination, any number of artists heard at second hand and in passing of Gauguin and his ideas. When he briefly taught in Paris in early 1894, Gauguin's students were Finns, a Pole and a Swede; the following year he invited the playwright August Strindberg to write the preface for the catalogue of his sale, an intriguing continuation of the longstanding Scandinavian links he had maintained through his wife.[7]

Of the many artists who worked at different times in Brittany, who sought out Gauguin or his legacy, only a few responded as directly as Maurice Denis to the radical implications for religious art of Gauguin's *Vision of the Sermon*. However, several underwent a major conversion of style or spiritual belief. Armand Seguin (1869–1903), hitherto a painter of low-life Parisian subjects, was clearly responding to Brittany's charged religious atmosphere when he painted his charming but grave *Breton Peasant Girls at Mass* [plate 113]. Charles Filiger devoted himself almost exclusively to sacred subjects painted in a meticulous archaic style. Jan Verkade (1868–1946) was so affected by the spiritual atmosphere he found in Brittany that he converted there to Catholicism, went on to take holy orders and became a Benedictine monk. Henri Rivière (1864–1951) in his remarkable five-part print *Pardon of Sainte-Anne-la-Palud* (Musée départmental Breton, Quimper), with its Japoniste technique but down-to-earth interpretation, shows no overt awareness of *Vision of the Sermon*. Nevertheless the distance that had been travelled, stylistically, since Boudin's painting of the same subject in 1859 cannot easily be explained without reference to Gauguin. By 1897, Slewinski, principally a painter of the Breton people and landscapes, had adapted the cloisons of Gauguin's synthetic style to his own more naturalistic ends. His impressive painting, *Two Breton Girls with Basket of Apples* [plate 114], with its sloping apple tree and close-up view of two Breton girls in costume, is an intriguing reprise of certain elements of *Vision of the Sermon*'s composition but a robust denial of its Symbolist pretensions.

The Jacob and the Angel theme was taken up in interesting ways by two artists who knew and admired Gauguin, Paul-Emile Colin (1867–1949), a printmaker based in Brittany [plate 115], and Odilon Redon [plate 116]. Colin's woodcut interprets the theme in a simplified, primitivising way that derives clearly from the Breton styles of Gauguin and Bernard.[8] Redon's rather later small painting on wood panel, one of three versions he made of the theme, harks back rather to Gustave Moreau [plate 93]. In both cases the angel stands erect and impassive, and the artist concentrates all the energy into the figure of Jacob. While the setting looks Breton in Colin's woodcut it is characteristically more

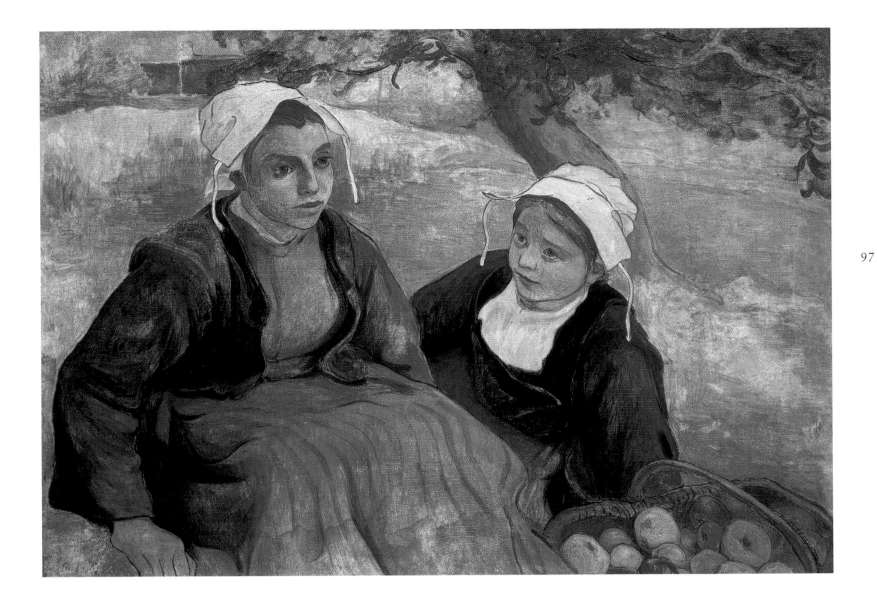

114 | Wladislaw Slewinski, *Two Breton Girls
with Basket of Apples, c.1897**
National Museum in Warsaw

98

115 | Paul-Emile Colin, *Jacob Wrestling with the Angel*, 1896*
Galerie Saphir, Paris

116 | Odilon Redon, *Jacob Wrestling with the Angel*, c.1910*
Musée d'Orsay, Paris, bequest of Mme Arï Redon, 1982

dreamlike and suggestive in Redon's painting, with colour used non-naturalistically and to powerful effect.

Gauguin's bold fusion of simplicity of form, expressive, non-naturalistic colour and spiritual subject matter played their part, as he was confident they would, in freeing the attitudes of the next generation of artists. Without needing to force comparisons, one can say that the formal lessons of *Vision of the Sermon* were absorbed into the thinking not only of the art nouveau master Henry van de Velde, as shown, but of some of the most influential painters of the early twentieth century, Matisse, Picasso and Kandinsky.[9] A painting by Spencer Gore (1878–1914) entitled *Gauguins and Connoisseurs at the Stafford Gallery*, 1911 [plate 119], a fascinating document in its own right, marks a key moment in the transmission of Gauguin's legacy to Great Britain. Gore features Gauguin's painting, already framed in the ornate blue and gilt Baroque frame it hangs in today, alongside his two other major religious canvases, *Christ in the Garden of Olives* and *Manao tupapau*. An indication of the strong impact made by Gauguin's work on the English Camden Town group, of which Gore was a leading member, the painting records the occasion when a number of Gauguins were shown together with some Cézanne landscapes at the Stafford Gallery in Duke Street, St James's, London. Only the previous year Roger Fry had stormed London with his first *Post-Impressionist Exhibition*, stirring the interest of artists and collectors, Michael Sadler among them, in the daring new art now coming across from France. All three paintings were bought by Sadler, and Gore's painting, which also went to Sadler, may have been painted in celebration of their purchase. A number of the gallery visitors are identifiable, including Augustus John in the foreground, Philip Wilson Steer to the far right, and the gallery's manager John Nevill, balding and in spats, in the centre. It has been suggested that through his quirky viewpoint the artist paid discreet homage to the composition of Gauguin's *Vision of the Sermon*: looking down on the exhibition from a mezzanine, he cleverly deploys a parabola-shaped section of balustrade to offset the bold swathe of red carpet.[10]

CONCLUSION

Vision of the Sermon's life as a reproduction had begun by around 1900. First reproduced in black and white by Druet, it was available as a colour postcard as early as 1940 and remains to this day one of the National Gallery of Scotland's best-selling reproductions. Pierre Bonnard (1867–1947), one of the original Nabis exposed to the lessons of the *Talisman* in 1888, kept a colour postcard of the painting pinned to the wall of his studio in the South of France. Bonnard was mindful of the 'magnificent example of Gauguin' to the end of his long career and painted a number of late compositions with predominantly red harmonies.[11] Today, keeping track of the number of reproductions in circulation worldwide is an impossible task. As a striking, boldly coloured two-dimensional image the painting lends itself to use by graphic designers; in recent years it has graced the cover of a book of poetry, a children's colouring book and a set of French stamps.[12]

How is one to explain the continuing appeal of Gauguin's *Vision of the Sermon*? Within art history the painting has occupied a special place, the wrangles with Bernard over originality and primacy making it a *cause célèbre*. It has also provided rich pickings for interpretative theories, dealing as it does with the romance of Brittany, exploiting and perpetuating the myth of the primitive. Both enshrining and upsetting certain clichés, it achieves its Symbolist effects through eclectic borrowing and conscious manipulation of style, with a confidence which, for modern art, helped to close off certain dead-end avenues – notably the pursuit of photographic naturalism – but opened up others, restating the vital fusion of form and meaning. For *Vision of the Sermon* uses form and colour expressively to evoke the presence of the unknown and unknowable within the known world. That it dared in an age of scepticism and science to tackle the big issue of religion, in a highly unorthodox way, was a measure of Gauguin's sense of his greatness. That it continues to provoke questions, about Gauguin's honesty as an artist, about his sincerity as a Catholic, testifies to the painting's own ambiguity. *Vision of the Sermon* is an image that lingers in the mind, crude and caricatural, dignified and reverential. It is a painting that bears its maker's highly personal distinctive mark; an extraordinarily potent distillation of Gauguin's paradoxical, teasing personality.

Following the Vision: From Brittany to Edinburgh

FRANCES FOWLE

In the late summer of 1888, having inherited a small sum of money from his uncle, Theo van Gogh set up a deal with Paul Gauguin. The conditions were extremely reasonable: whereas previously Theo had arranged occasional sales for the artist he now agreed to pay a monthly retainer of 150 francs in return for twelve canvases a year.[1] Accordingly, Gauguin began to send regular consignments of pictures to Paris and on 27 October 1888 he wrote to Theo from Arles regarding his most recent shipment: 'I hope you'll like the pictures from Pont-Aven, the most important one will come with Bernard – Perhaps some are not very finished but I think all the same that they're very carefully thought out and just as I wanted them. Whether they're saleable I don't know.'[2] The pictures were deposited with Boussod & Valadon, the prestigious firm of Paris dealers where Theo was employed as manager of the Modern Paintings section at 19 Boulevard Montmartre. Most were landscapes or Breton figure subjects painted in Gauguin's more conservative 'Impressionist' style.

The pictures evidently met with Theo's approval. Vincent van Gogh wrote to his brother in early November: 'Gauguin is very pleased that you like what he sent from Brittany, and that other people who have seen them like them too'.[3] Indeed, a number of works were sold immediately, including two to the industrialist Jean Baptiste Casimir Dupuis (d.1890), who already owned *The Moulin du Bois d'Amour Bathing Place* (Hiroshima Museum of Art) and who acquired *Breton Women Chatting* (Neue Pinakothek, Munich) that October for 600 francs.[4] Two other Breton pictures were sold to the financier Léon Clapisson (1837–1894)[5] and the poster artist Jules Chéret (1836–1932),[6] making a total of five works sold between October and December for 1,440 francs.[7] The consignment also included *Breton Girls Dancing, Pont-Aven* [plate 64] which Theo asked Gauguin to retouch for a prospective client.[8]

This same group of pictures included *Vision of the Sermon*, referred to as 'the most important one'. Gauguin considered it too precious to travel unaccompanied, so the 'tableau d'église' travelled to Paris in the care of Emile Bernard.[9] Unlike the other Breton pictures it failed to find a buyer, probably because it was an example of Gauguin's revolutionary new 'synthetist' style. It also lacked the charm and sentimentality of a painting such as *Breton Girls Dancing, Pont-Aven*, which sold the following year for 500 francs, after a year of negotiations with three different clients.[10]

Gauguin was commercially minded and made a clear distinction between his more personal, experimental works, such as *Vision of the Sermon*, and the more saleable works. This is exemplified by a brief incident concerning Bernard's mother and sister. The artist entrusted two drawings – studies for *Breton Girls Dancing, Pont-Aven* – to Mme Bernard and Madeleine, intending them to deliver the pictures to Theo van Gogh in Paris. However Mme Bernard wrongly assumed that Gauguin had given them to her and her daughter as a gift. To avoid embarrassment Gauguin asked Emile Bernard to substitute, in place of one of the drawings, a blue-green pot with a bird decoration (now lost), which he wished Madeleine to keep as a memento of their friendship, commenting that it was 'more the expression of myself than the drawing of the little girls'.[11] In the same way, it could be argued that *Vision of the Sermon* was 'more an expression of Gauguin's self' than the pictures that generally appealed to the Paris art market.

The following February Gauguin asked Theo van Gogh to show his new painting in a more challenging context, the sixth exhibition of the avant-garde group *Les Vingt* in Brussels. The artist's preparatory lists of pictures to be included in the exhibition indicate that he still had not settled on a title for his ground-breaking work. After toying with *Apparition* (perhaps a discreet reference to Moreau's painting of the same name) he eventually settled on *Vision du Sermon* and set an optimistic price tag of 1,000 francs.[12]

The picture failed to sell and after the exhibition had ended it was returned to Boussod & Valadon, where it remained on consignment for the next two years.[13]

In February 1891, in order to raise capital for his trip to Tahiti, Gauguin decided to arrange a sale of his pictures, including *Vision of the Sermon*, at the Hôtel Drouot in Paris. The lots were exhibited at the auction house on 22 February 1891 and the sale took place the following day. A preview was held at Boussod & Valadon on 21 February. Even though Gauguin's work at that date fetched much lower prices than, say, Degas, his pictures did not fail to attract public attention and, as the newspapers reported, it was not long before 'crowds formed around these thirty paintings'.[14] The sale was a great success and *Vision après le Sermon*, as it was now catalogued, was sold to Henri Meilheurat des Prureaux for the impressive sum of 900 francs.[15] Indeed, it was the most expensive purchase made at this sale, where the majority of works fetched in the region of 250–350 francs.[16]

The buyer, Henri Meilheurat des Pruraux (1860s–1924), was not a rich Parisian industrialist or financier like Dupuis or Clapisson, but an amateur painter of comfortable means from the Allier in the northern part of the Auvergne.[17] He spent the latter part of his career in Venice, where he established a modest reputation as an artist, but during the 1890s he lived at 49 Boulevard de Montparnasse in Paris. He was a friend of Daniel de Monfried (1856–1929), who evidently introduced him to Gauguin. He was certainly in contact with Gauguin in February 1894, when the latter wrote to

De Monfried (then in Algiers) from Paris, '*Enfin reçu lettre de vous. Que devient Daniel, disait encore dernièrement Meilheurat*'.[18] Meilheurat was very interested in avantgarde art and in addition to *Vision of the Sermon* he owned three other works by Gauguin, none of which has been identified. These were a Breton landscape, *Coteau des Aven* – which he acquired for 160 francs from the later sale of Gauguin's pictures on 18 February 1895[19] and which he lent to the Salon d'automne of 1906 (along with *Vision of the Sermon*) – a *Marine* and a pastel.[20]

Meilheurat must have valued the painting highly to pay so much for it at auction and it was very likely he who acquired the picture's current Baroque-style frame, with its blue marble-effect band – very different from the original white frame that Gauguin had supplied. He may even have bought it when he moved to Italy in the early 1900s, perhaps with a view to exhibiting the picture at the Salon d'automne in 1906. In the end the painting remained in Meilheurat's possession for only another four years. It was sold in February 1910 by Mme Meilherat, presumably the collector's wife, along with the seascape and the pastel, to the Paris dealer Ambroise Vollard for 6,000 francs.

VISION OF THE SERMON IN ENGLAND: THE ROLE OF MICHAEL SADLER

Vollard's acquisition of *Vision of the Sermon* coincided with an awakening interest in the work of the Post-Impressionists in Britain. At Roger Fry's ground-breaking exhibition, *Manet and the Post-Impressionists*, held at the Grafton Galleries in London in 1910, Gauguin was represented by more pictures (thirty-seven) than any other artist.[21] While many of the works on show at this exhibition were dismissed as 'hysterical daubs' and 'sickening aberrations',[22] the British press constructed a comparatively favourable image of Gauguin as a 'savage genius', discussing him in terms of his rejection of Western values and consequent espousal of the primitive.[23]

An important visitor to this exhibition was the educationalist Michael Sadler (1861–1943) [plate 117], soon to become the next owner of *Vision of the Sermon*. As Professor of the History and Administration of Education at Manchester University and later Vice-Chancellor of the University of Leeds, Sadler's commitment to education went hand in hand with an altruistic attitude to art patronage and collecting. Among those pictures at the Grafton Galleries that caught his eye were two works by Gauguin: *Manao tupapau* or *Spirit of the Dead Watching* [plate 109] and the controversial *Christ in the Garden of Olives* [plate 107]. Both pictures were soon absorbed into the Sadler collection.

117 | Mark Gertler, *Portrait of Sir Michael Sadler (1861–1943)*
University of Leeds Art Collections

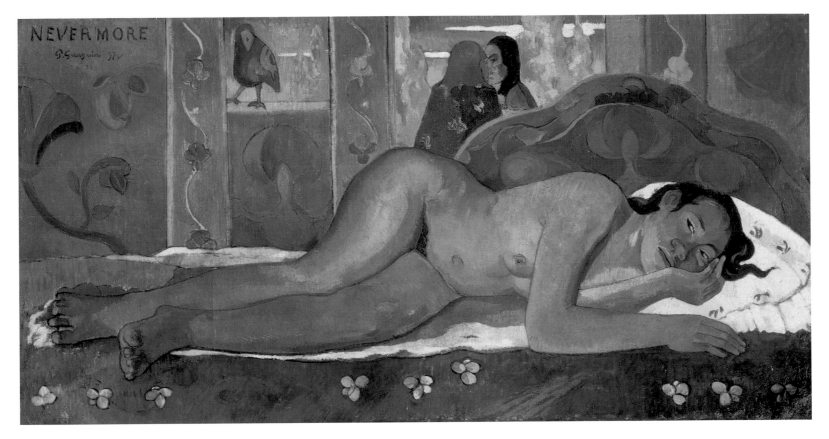

NEVERMORE
P. Gauguin 97

118 | Paul Gauguin,
Nevermore, 1897
The Samuel Courtauld Trust,
Courtauld Institute of Art Gallery,
London

The Irish artist Roderic O'Conor acquired a handful of works by Gauguin during the 1890s,[24] and the English composer Frederick Delius (1862–1934) bought Gauguin's *Nevermore* [plate 118] from Daniel de Montfreid in 1898, but Sadler was the first collector in Britain to invest seriously in this artist. Indeed, his collection included some of Gauguin's most important and best-known works. Of these, as Anna Robins has pointed out, only *Vision of the Sermon* and a watercolour, *Tahitian landscape* (Whitworth Art Gallery, Manchester) remain in British collections.[25]

In 1910 Sadler was a newcomer to the world of collecting and, prior to his visit to Paris and Holland the previous year, knew very little about art. He began collecting on a modest scale in 1892 when he created a fund, into which were paid any extra earnings, for the purchase of English watercolours and items of furniture, but it was not until 1909 that he began collecting in earnest. In that year he visited The Hague and encountered the paintings of Vermeer for the first time. In Amsterdam he was enchanted by the work of the Dutch Orientalist Marius Bauer, who became his first obsession. According to Sadler's son, picture-buying became the antidote to recurring bouts of depression. Sadler himself recalled: 'In those pregnant years my mind was deeply disturbed. I felt that vast changes were pending – war, civil

discord and spiritual bewilderment. I should have gone mad, but for one thing. I happened to get interested in modern painting.'[26]

From 1910 to 1912 Sadler indulged his new passion for art. Paintings became 'a drug to keep depression at bay' and he often spent beyond his means.[27] The son of a Yorkshire general practitioner, Sadler was not well off and this period of indulgence was largely financed by his wife. Mary Sadler's father, Charles Harvey, owned a large linen factory in the West Riding of Yorkshire and had left her 'comfortably off (but no more)'.[28] Her parents were strict Quakers and she, too, was always careful to live within her means. By contrast, Sadler was delightfully impractical and a bohemian at heart – at Oxford he was part of the 'aesthetic' group, who wore their hair long and 'were all for faded greens and yellows and Burne-Jones photographs'[29] – and it often seemed to Mary that her husband's 'demands on her patience and on her capacity to underwrite his commitments to art-dealers … went beyond the reasonable'.[30]

Sadler's main advisors were the London-based Dutch dealer Elbert van Wisselingh and D.S. MacColl of the Tate Gallery. With their guidance, during the course of 1910, he acquired mainly nineteenth-century landscapes by French and Dutch artists, including works by Corot, Daubigny,

119 | Spencer Gore,
*Gauguins and Connoisseurs
at the Stafford Gallery*, 1911
Private Collection

Roger Fry owned an unfinished work by Gauguin, *Tahitians*, c.1891 (Tate), which he included in the Grafton Galleries exhibition, and on 9 January 1911 he delivered a lecture on the Post-Impressionists which Sadler attended. By the autumn Sadler 'was jotting large scale calculations in one of his tiny black notebooks as to the lengths permissible in order to secure a front-rank Cézanne and at least two Gauguins'.[33] Sadler's early enthusiasm for Post-Impressionist art was clearly inspired by Fry, but encouraged by his son, and it was Sadleir who first had the idea of holding an exhibition of Cézanne and Gauguin that November at the Stafford Gallery in London.[34] Above all, both men were anxious to acquire two pictures from Fry's Post-Impressionist exhibition, *Christ in the Garden of Olives* and *Manao tupapau*.

On 27 September 1911 John Nevill, director of the Stafford Gallery, travelled down to Weybridge to discuss the exhibition with Sadler and his son. Sadler guaranteed to underwrite half any losses incurred up to a limit of £50 (if a £100 loss were to be sustained) and Nevill agreed to divide any 'unlikely' profits. Sadler was particularly anxious that the price of each picture should be listed in the catalogue, in order to 'show the visitor what the market value of these pictures already was'.[35] He arranged for Nevill to travel to Paris that weekend to secure certain pictures. The main purpose of the visit was to acquire *Manao tupapau* from the French dealer Eugène Druet at a knock-down price, offering him a maximum of £1400.[36] While in Paris Nevill was also to arrange for Vollard to reserve and send over for inspection (at Sadler's expense) Gauguin's *Christ in the Garden of Olives*. Nevill also suggested a visit to the dealer Bernheim-Jeune and the collector Théodore Duret, both of whom were potential sources of Gauguin's work, and Sadler mentioned Vollard as a source of Cézanne landscapes. However nothing definite was arranged, since Sadler 'felt strongly' that Nevill's taste might not be sufficiently 'discriminating'.

Sadler's negotiations with Druet continued throughout October and he attempted unsuccessfully to secure a number of other works by Gauguin from private collections in France, including *The Yellow Christ* [plate 100], *The White Horse* (Musée d'Orsay, Paris), *Arearea (Joyeusetés I)* (Musée d'Orsay, Paris) or *Pastorales tahitiennes* (State Hermitage Museum, St Petersburg) and *Women at the Seaside* (State Hermitage Museum, St Petersburg).[37] By the end of October Sadler had succeeded in acquiring *Manao tupapau*, *Christ in the Garden of Olives* and Cézanne's *La Maison abandonée*, 1892–4 (Private Collection, USA). All three works were included in the Stafford Gallery exhibition.[38] Vollard sent over three other works by Gauguin for

Daumier, Harpignies, Jongkind, Monticelli and Matthijs Maris. Sadler was also advised by his son Michael, who moved in avant-garde circles and had progressive tastes in art. (He spelled his surname 'Sadleir' in order to avoid confusion with his father.) As a result Sadler graduated swiftly to Sérusier, Cézanne and Gauguin and in almost no time his collection included examples of Klee, Marc, Munter, Van Gogh, Kandinsky and many of the leading English Modernists.

As the artist John Piper later commented, Sadler was a 'creative collector', buying for 'spiritual enrichment', rather than for financial gain.[31] Consequently he was astonishingly swift to make the transition from Barbizon to Modernism. After visiting Fry's exhibition at the Grafton galleries, he became ardent in defending the avant-garde cause against sceptics such as Van Wisselingh, who, in common with the majority of the British public, dismissed Post-Impressionist art as 'blatant and degrading rubbish'.[32]

inclusion in the show: *Vision of the Sermon* (exhibited as *The Struggle of Jacob and the Angel*), an unidentified Breton subject (*Bretons*, catalogued as, *Breton fishermen*) and a picture entitled *La Cueillette*, identified by Robins as *La Cueillette des citrons*.[39]

The exhibition opened on 23 November. It included eight Cézannes and fourteen works by Gauguin, of which Sadler's pictures (including *Vision of the Sermon*) attracted the most critical attention. Michael Sadleir published an article on *Manao tupapau* in the winter edition of the avant-garde publication *Rhythm*. The article was almost certainly written before the Stafford Gallery exhibition had been arranged, since it refers only to the picture's appearance at the Grafton Galleries the previous year. Sadleir described the picture in terms of its colour harmonies – 'a wonderful harmony of rich red purple, golden bronze and blue, with a bold frieze pattern of vivid yellow flowers along the flounce of the couch' – and its literary significance, referring in depth to *Noa Noa*, Gauguin's literary collaboration with Charles Morice. However, he also stressed the

aspect of the picture that was more shocking to the British public, the woman's vulnerability, her primitive nakedness, as she lay face downwards on the bed, 'her eyes fixed in a rigid, unseeing stare'.[40]

The exhibition ran until the end of December and was recorded for posterity by Spencer Gore in his painting of *Gauguin and Connoisseurs at the Stafford Gallery 1911* [plate 119] The picture features *Vision of the Sermon* hanging on the back wall of the gallery, alongside Sadler's most recent purchases, *Manao tupapau* and *Christ in the Garden of Olives*.

During the course of the exhibition Sadler made the decision to add *Vision of the Sermon* to his collection. However, he did not settle his account with Vollard until after the exhibition was over. On 1 February 1912, Vollard wrote angrily to Nevill: 'Considering your exhibition closed a month ago, I am astonished not yet to have received the price of my Gauguin painting "Jacob and the Angel", ie <u>fifteen thousand</u> francs … I am given to understand that Mr. Sadler bought the picture. If you are anxious not to

120 | Paul Gauguin, *Poèmes Barbares* 1896 Courtesy of the Fogg Art Museum, Harvard University Art Museums, bequest from the collection of Maurice Wertheim, class of 1906

121 | Paul Gauguin, *Self-portrait with Idol*, c.1893 Collection of the McNay Art Museum, bequest of Marion Koogler McNay

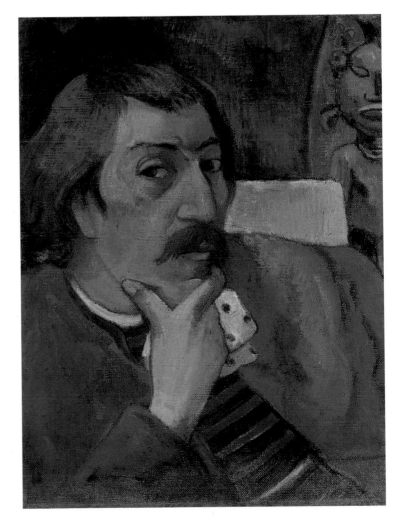

bother him, I can write myself.' Two further letters from Vollard, dated 9 February 1912, return to the same subject, but it was not until 11 March that the French dealer received his money.[41]

In August 1912 Sadler travelled to Cologne with his son to see an exhibition of Post-Impressionist works. He was delighted to come across Gauguin's *Poèmes Barbares*, 1896 [plate 120], the very picture that Fry had used for the poster of *Manet and the Post-Impressionists*, and it was not long before he had added it to his collection, along with a Gauguin self-portrait. This second work was probably the *Self-portrait with Idol* [plate 121] which he lent for exhibition the following autumn.[42] He may also have acquired a pastel of a Tahitian woman around the same date, if not earlier.[43]

Sadler was extremely altruistic in his approach to collecting and was developing the notion (possibly influenced by the Caillebotte gift to the Musée de Luxembourg) of 'buying promising works of this school from young men and holding them until public taste develops'.[44] In addition to Cézanne and Gauguin he was interested in the work of the Nabi artist Paul Sérusier, one of Gauguin's most faithful disciples. He may have acquired Sérusier's *Valley, Grey Weather*, 1907 (University of Leeds Art Collection) as early as 1910, when it was included in Fry's first Post-Impressionist show. He also owned *The Café*, 1907 (University of Leeds Art Collection), which he bought from Druet in September 1911,[45] *L'Imploration*, which he exhibited in Edinburgh in 1913, and *Boys on a River Bank* of 1906 [plate 122], which was also in his collection by 1913.

Unlike most collectors, who acquire art for their own enjoyment, Sadler was always eager to help young artists

and to allow the public access to his collection, and invited numerous influential individuals up to Leeds, including Roger Fry, John Galsworthy, the dealer Percy Moore Turner and the collector Edward Marsh. He even tried to persuade William Marchant of the Goupil Gallery to open up a branch in Leeds, but without success. He became closely involved with the Leeds Arts Club, founded in 1903 by Alfred Orage, and, along with Frank Rutter, the new Director of Leeds City Art Gallery, he used his position to promote Modernist art and to help young artists such as Mark Gertler.

Rutter was appointed Director of the City Art Gallery in 1912 and, with Sadler's support, was responsible for arranging a series of outstanding Modernist exhibitions in Leeds.[46] The first exhibition, in June 1913, was a show of 'Post-Impressionist Pictures and Drawings' to which Sadler lent Gauguin's *Poèmes Barbares* (where it was recorded as cat.no.16) and two watercolours by Wassily Kandinsky.[47] Rutter was then invited by the directors of the Doré galleries in London to stage a similar exhibition of Post-Impressionist and Futurist art. He wrote to Sadler at the beginning of September:

'I have been invited to organise another Post-Impressionist show, in London this October. I don't think it would be fair to ask you to put "Poèmes Barbares" to the strain of another railway journey, but would you help me with other things. I should very much like to borrow your Gauguin's portrait of himself and also the splendid Sérusier (Boys Bathing) which I discovered in a bathroom.'[48]

The Sérusier was *Boys on a River Bank*, now in the National Gallery of Victoria, Melbourne. In the end Sadler lent the Gauguin *Self-portrait with Idol* and two Gauguin

106

122 | Paul Sérusier, *Boys on a River Bank*, 1906 National Gallery of Victoria, Melbourne

123 | Wassily Kandinsky *Composition VII*, 1913 Tretyakov Gallery, Moscow

lithographs – *Mahana no varua ino* and one other, as yet unidentified.[49] The exhibition also included works by Cézanne, Van Gogh, Delaunay, Picasso and Nolde.

Sadler's fascination with Gauguin was equalled only by his love of Kandinsky, whose work he collected from 1912 onwards, after seeing a number of woodcuts recently acquired by his son. He even travelled to Germany to meet Kandinsky and acquired some important examples of his work, including *Composition VII*, his masterpiece of 1913 [plate 123]. Both Sadlers saw Kandinsky as Gauguin's natural disciple, the true heir to the older artist's primitivism, expressed (in Sadleir's words) through 'a technique reminiscent of primitive and savage art'.[50] Indeed, perhaps it was *Vision of the Sermon* itself that explains Sadler's admiration for both artists, since it combined a sense of the spiritual with an emphasis on colour and form.

GAUGUIN IN SCOTLAND

By 1913 Fry's Post-Impressionist exhibitions were beginning to make an impact north of the border and in the summer and autumn of 1913 *The Scots Pictorial* published a series of articles by their art critic 'Ion' on Impressionism, Post-Impressionism, Futurism and Cubism. Such articles draw attention to the very vague definitions that were ascribed to modern art movements at that date. Impressionism was defined as 'a keen-eyed appreciation of light' and comprised artists as diverse as Millet, Whistler and Monticelli. Post-Impressionism was described by 'Ion' in even more nebulous terms as a search for 'the absolute truth of Nature' and included in its canon Monet and Matisse, as well as Van Gogh, Cézanne and Gauguin. The Post-Impressionist, 'Ion' informs us, was a 'philosopher-painter' in search of Truth in art, regardless of aesthetic concerns. Thus Gauguin, always associated with Tahiti, 'found in the life and spirit of the savages something that brought him to his ideas of truth'.[51]

A number of Scots artists were associated with Gauguin and his circle in the late 1880s and 1890s.[52] Eric Forbes-Robertson (1865–1935), for example, lived in Pont-Aven from 1885–7 and was acquainted with Gauguin, Paul Sérusier and Armand Seguin; A.S. Hartrick (1864–1950) lodged with Gauguin at the Pension Gloanec in 1886; and Charles Hodge Mackie (1862–1920) was a close friend of Paul Sérusier, whom he first encountered in Huelgoat in 1892. Gauguin evidently narrowly missed exhibiting at the Glasgow International Exhibition of 1888, since he wrote to his wife Mette in January of that year: 'We are invited to Brussels, probably also to Glascow [sic]. It would therefore be very much in our interest to participate in several exhibitions in '88.'[53] It is not known who could have invited Gauguin to exhibit in Glasgow, but since Hartrick exhibited two works at this exhibition he seems a likely candidate. Another possibility is the Glasgow dealer Alexander Reid (1854–1928), who sent several French pictures to the International Exhibition. Reid was living in Paris in January 1888, working alongside Theo van Gogh at Boussod & Valadon and was almost certainly aware of Gauguin's work.

Despite these early connections with Scottish artists and dealers, there is no evidence that any works by Gauguin appeared in Scotland before 1913. In November of that year the London-based dealer W.B. Paterson and his associate Herbert K. Wood staged an exhibition of 'Impressionist' art at the Grand Hotel, Charing Cross, in Glasgow.[54] The exhibition included an unidentified Tahitian work by Gauguin, described by the art critic for *The Scots Pictorial* as an example of 'the savage Gauguin's "Tahiti", decorative and something deeper than picturesque'.[55]

Also in November the Society of Scottish Artists included pictures by Van Gogh, Gauguin, Cézanne, Sérusier, Matisse, Vlaminck, Fry, Picasso, Russolo and Severini in their annual exhibition at the Royal Scottish Academy in Edinburgh. Some of these works had been borrowed by the artist Stanley Cursiter from Fry's Second Post-Impressionist Exhibition [56] and from the Italian Futurist Exhibition at the Sackville Gallery, London, which had taken place in March 1912. Most, including the Futurist works, had just been shown at the annual exhibition of the Royal Glasgow Institute which closed on 15 November,[57] but the pictures by Cézanne, Van Gogh and Gauguin were lent only to the Edinburgh exhibition. The Paris dealer Bernheim-Jeune sent Van Gogh's *Evening: The End of the Day* (Menard Art Museum, Komaki, catalogued as *L'Homme à la Veste*) and Cézanne's *House Among the Trees* (*Maison dans les arbres*). Almost certainly at Rutter's suggestion, Sadler agreed to send *Manao tupapau*, *Poèmes Barbares* and Sérusier's *l'Imploration*. Rutter himself contributed J.D. Fergusson's *In the Sunlight* (Aberdeen Art Gallery). Possibly as a result of his involvement in the Society of Scottish Artists' exhibition, Michael Sadler was invited to give a public lecture that month at Glasgow School of Art on Cézanne, Gauguin and Van Gogh.

The aim of Sadler's talk was to demonstrate that the art of the Post-Impressionists – especially that of Gauguin – was rooted in tradition and represented a continuity, rather than a rupture with artistic convention. When talking of Gauguin he evoked Conrad and Robert Louis Stevenson, remarking, almost certainly with reference to *Vision of the Sermon*, that 'some of his Breton pictures might be counted among the greatest of modern religious pictures'.[58] The talk was chaired by Sir John Stirling Maxwell, Honorary Presi-

dent of the Society of Scottish Artists and one of the Trustees of the National Gallery of Scotland. Indeed, it may be partly as a result of this network of connections that the National Galleries eventually acquired *Vision of the Sermon* in 1925.

Sadler remained the most significant British collector of Gauguin's work until the major retrospective exhibition organized by the Leicester Galleries in 1924. In the interim a few British collectors had acquired single examples of Gauguin's work. These included, most notably, *C. Maresco Pearce*, who bought *Harvest: Le Pouldu*, 1890 (Tate) in 1912, Lady Cunard, who had acquired the stunning *Nevermore* by 1914,[59] and the Davies sisters in Wales, who bought Seguin's *Breton Peasant Women at Mass* (National Museum of Wales, Cardiff), under the impression it was by Gauguin, in 1916. In the same year the author W. Somerset Maugham installed the stained-glass window, *Woman with Fruit (La Femme au Fruit)*, 1896 in his house at Cap-Ferrat. He later travelled to Tahiti and was inspired by Gauguin's life to write *The Moon and Sixpence*, published in 1919.

However, it was not until after the First World War that the market in Britain for Post-Impressionist art began to pick up, and in 1923 a number of important collectors began focusing on Gauguin. Samuel Courtauld bought *The Haystacks*, 1889 (Courtauld Institute, London) and *Bathers, Tahiti* (Barber Institute, Birmingham) in January 1923 for £1,500.[60] Herbert Coleman acquired *Nevermore*, which was exhibited at Agnews in Manchester in 1923. Mrs Elizabeth

124 | Vincent van Gogh
Olive Trees, 1889
National Gallery of Scotland,
Edinburgh

Russe Workman, the only Scot among this group, acquired two important works: *Martinique Landscape* [plate 6], which she bought from Reid & Lefevre in 1923, and the *Symbolist Self-Portrait* (National Gallery of Art, Washington). Sadler meanwhile had switched his attention to Van Gogh and in 1923 he acquired the *Olive Trees* [plate 124] now in the National Gallery of Scotland and *Still Life with Oleanders* (Metropolitan Museum of Art, New York).[61]

In the same year Samuel Courtauld, the industrialist and art connoisseur, offered a fund of £50,000 to purchase significant examples of modern French painting for the National Gallery in London. Inspired by Courtauld's gift, Sadler contemplated presenting 'a picture or two' to the nation from his own collection. His first idea was to offer Gauguin's *Manao tupapau*, but this was comparable in composition to Courtauld's *Nevermore* and so he suggested that, if Courtauld were to give *Nevermore*, he might offer *Vision of the Sermon* as a companion.[62] In the event the idea was never realised and it was not until 1931 that Sadler fulfilled his aim of gifting a number of pictures to public collections.

In the summer of 1924 Ernest Brown & Phillips at the Leicester Galleries decided to hold a major retrospective of Gauguin's work, to which Sadler, now Master of University College, Oxford, contributed eight works. In addition to five oils in his collection (*Self-portrait with Idol, Manao tupapau, Vision of the Sermon, Christ in the Garden of Olives* and *Poèmes Barbares*) he lent a pastel study for *The Devil's Words (Les Paroles du Diable)*, a drawing after Daumier and a watercolour of a Tahitian coast-scene.

The exhibition also included a series of Gauguin's woodcuts for *Noa Noa*, which were bought by Samuel Courtauld. Running concurrently with the Leicester Galleries exhibition, a separate show of the woodcuts was held in Glasgow at Alex Reid's gallery in West George Street.[63] Gauguin was still regarded with suspicion in some circles and was described by the critic for the *Daily Record* as 'undoubtedly the queerest personality figuring in the history of modern art'.[64] Nevertheless Reid succeeded in selling sets of woodcuts to Glasgow Corporation and the British Museum.[65]

The Leicester Galleries exhibition had the effect of raising Gauguin's profile in Britain, and Sadler soon turned his mind to selling most of the Gauguins in his collection, in order to make way for even more avant-garde purchases of modern French and contemporary English art.[66] The first picture to be sold from his collection of Gauguins was *Vision of the Sermon*. In 1925 he sent the painting to the annual exhibition of the Society of Eight, a group of avant-garde artists who exhibited at the New Gallery in

Shandwick Place, Edinburgh. The Society of Eight's co-founders included Glasgow Boy James Paterson (1854–1932) and Scottish Colourist F.C.B. Cadell (1883–1947), and it was Paterson who acted as intermediary when Sadler offered *Vision of the Sermon* for sale to the National Gallery of Scotland.

Sadler was familiar with the collection at the National Gallery and on a visit in June 1919 he made extensive notes on the paintings. He was particularly taken by the Hals (*Verdonck*), the Tiepolo, the Ruisdael, the Monticellis and the English nineteenth-century landscapes but appears to have disregarded the Boudins, the Bastien-Lepage and the few examples of works by the Barbizon School which comprised the modern French paintings collection at that date. He cannot have failed to note the complete absence of any Impressionist or Post-Impressionist art in the National Gallery's collection and this, combined perhaps with the persuasive influence of individuals such as James Paterson, may have prompted him to offer the picture for sale in January 1925.

On 21 January 1925 the Board of Trustees of the National Gallery of Scotland agreed to buy *Vision of the Sermon* 'at a price not exceeding £1300'.[67] Sadler initially suggested a price of £1200 plus a modest commission of £50 due to the Society of Eight for negotiating the sale. After discussing the matter with the National Gallery's director, James Caw, Paterson persuaded Sadler to lower the price to £1100. Sadler delayed slightly, eventually sending a telegram to Paterson to the effect: 'Regret delay caused by illness – accept £1100 for picture, writing'.[68]

Paterson tried to get the gallery to pay a more generous commission, since commission charged on sales in Society of Eight exhibitions was normally twenty percent. But the Board of Trustees was not happy to relinquish a penny more than necessary on the purchase, despite the importance of the picture. The following day, 28 January 1925, Caw and Paterson had a brief meeting, after which Caw consulted the Chairman of the Board and two of the Trustees. Caw then wrote to Paterson making 'a definite offer of £1150 for the picture',[69] and this was duly accepted.[70] The purchase was announced in *The Scotsman* on 30 January 1925. Although the picture was referred to throughout the Caw-Paterson correspondence as *The Vision After the Sermon*, the press preferred its biblical subtitle, *Jacob Wrestling with the Angel*.

Taken in context, the purchase of *Vision of the Sermon* was a major acquisition for the National Gallery of Scotland. Not only did the gallery own no examples of Post-Impressionism, the Board of Trustees had failed to invest in a single example of Impressionist art, despite the fact that the Scots were among the earliest to invest in Impressionism. They had been offered their first opportunity to acquire an Impressionist picture in March 1911, when they turned down Manet's *The Seamstress*, an enchanting pastel now in the Musée des Beaux Arts in Canada. Between 1911 and 1925 they were offered and turned down works by Degas, Sisley and Cézanne and only succeeded in buying one Manet *Still Life* (NG 1618), which was soon recognized to be a fake – perhaps an indication of the levels of connoisseurship at this date.[71]

Shortly after buying *Vision of the Sermon* the gallery invested in a second major French painting of a similar period, Monet's *Poplars*, 1891–2, which they acquired in March 1925 from the Glasgow art dealer Alexander Reid for £1200.[72] These two outstanding purchases marked a turning point in the gallery's decision-making, at least as far as the French paintings collection was concerned. In 1927 James Caw published a short review of the National Gallery's collection. With regard to the modern French paintings he listed Bastien-Lepage's *Pas Mêche*, Claude Monet's *Poplars* and Gauguin's '*Jacob Wrestling with the Angel*' as the three 'most important and significant' works in the collection.[73] Yet, even though he described *Vision of the Sermon* as 'a pictorial ensemble of singular vitality and interest', Caw betrayed his reservations about the picture by describing Gauguin as 'accomplished … within his limitations' and 'less influential' than his contemporaries.[74]

Caw may have secretly regretted his purchase, but his boldness, Paterson's perseverance and Sadler's altruism have been Scotland's gain. As Sadler predicted, Gauguin's importance as an artist would be appreciated in time and today *Vision of the Sermon* is regarded as one of the most important paintings in the collection of the National Galleries of Scotland.

Sadleir once remarked about his father:

The merest glimmer of an idea for helping the country toward taste and judgement, for enabling the general public to see and appreciate beauty, for smoothing the path of promising young people toward self-expansion and recognition, could set him seeing visions.[75]

And it was largely thanks to Sadler's vision that Edinburgh became the last resting place of one of Gauguin's greatest masterpieces.

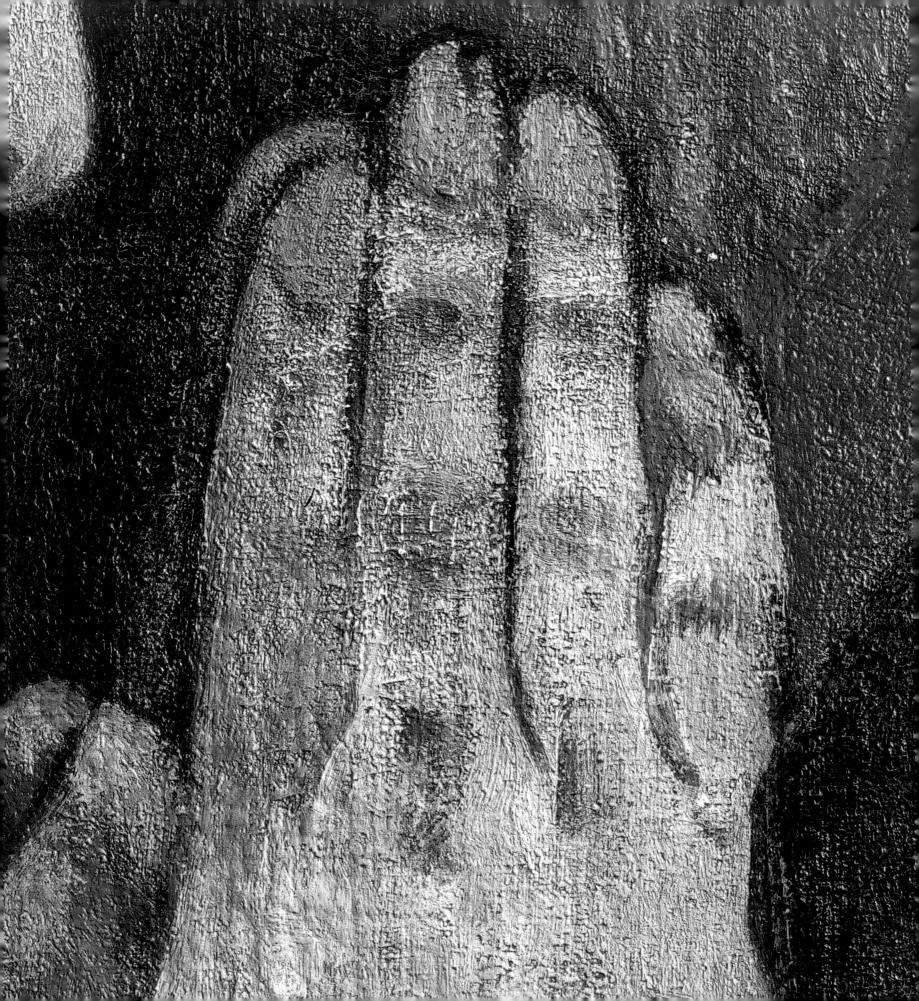

Gauguin's Vision: A Discussion of Materials and Technique

LESLEY STEVENSON

I have just painted a religious picture, very clumsily but it interested me and I like it. I wanted to give it to the church of Pont-Aven. Naturally they don't want it. A group of Breton women are praying, their costumes a very intense black. The bonnets a very luminous yellowy-white. The two bonnets to the right are like monstrous helmets. An apple tree cuts across the canvas, dark purple with its foliage drawn in masses like emerald green clouds with greenish yellow chinks of sunlight. The ground (pure vermilion). In the church it darkens and becomes a browny red.

The angel is dressed in violent ultramarine blue and Jacob in bottle green. The angel's wings pure chrome yellow 1. The angel's hair chrome 2 and the feet flesh orange. I think I have achieved in the figures a great simplicity, rustic and superstitious. The whole thing very severe ... [1]

For the first time since its acquisition by the National Gallery of Scotland in 1925, an opportunity arose with the preparation of the exhibition to undertake a thorough technical investigation of the painting *Vision of the Sermon*.[2] Certain aspects of the materials and techniques employed by the artist in this iconic work have prompted speculation over many years, most notably the paint medium used. The recent publication of a number of detailed technical studies of Gauguin's work has provided an additional incentive to examine *Vision of the Sermon* and a considerable debt is owed by the present study to several of these.[3]

How can information concerning the methods used by an artist contribute to the wider art-historical research surrounding a particular work of art? By understanding the choice of materials made at each step in the painting's development, and the possible factors influencing their selection, it is possible to gain an invaluable insight into the artist's creative process. Such practical details can also help in understanding the present appearance of a work of art, consider how or why it may have changed over time and whether or not this was intended by the artist.

While presenting the results of the examination under-taken of the *Vision of the Sermon*, this essay will assess the artist's technical innovation in September 1888, a pivotal moment in his career. Gauguin is known to have been especially concerned with both the presentation and longevity of his work and for those reasons tentative hypotheses will also be made regarding how the appearance of this painting may have altered since completion.[4]

SUPPORT

Vision of the Sermon is painted on a fine, tabby weave fabric – predominantly bast fibre mixed with raw cotton – with original dimensions conforming approximately to the standard size 30 canvas obtainable commercially at the time.[5]

While availability and economics are likely to have played a part, it is clear that Gauguin regarded the choice of fabric support as fundamental to the painting process. Evidence suggests that experimentation with various painting supports was already well underway in Brittany and continued throughout the artist's career. Gauguin explored the use of a coarser jute fabric while working with Van Gogh in Arles immediately after this period in Pont-Aven, and again during his visits to the South Seas: *Three Tahitians* painted in 1899, and also in the collection of the National Gallery of Scotland, is an example of the use of this coarse jute fabric support.[6] During the 1880s the potential of the support for realising visual effects became increasingly important: exploitation of the intrinsic qualities of the fabric weave was integral to the Impressionists' adoption of broad and visible brushwork, as demonstrated by the highly impressionistic *Martinique Landscape* of 1887 [plate 6].[7] Although the fabric support appears to be more thoroughly concealed beneath the paint layers of *Vision of the Sermon*, the texture of the fabric support is still prevalent. Discrete canvas weave, for example, remains visible in the description of the Breton *coiffes*, suggesting their stiffly-starched tactile surfaces [plate 125].

125 | Detail of the *coiffe* in the centre foreground of the painting where the canvas weave is visible beneath a thin paint layer.

126 | Detail of the upper right corner showing the exposed original tacking margin on the right-hand side and the added filet of wood, which is attached along the top.

127 | Detail of the surface under a raking light from the right-hand side illustrating the flattened and polished character of the paint surface.

112

The original support of *Vision of the Sermon* was lined on to a slightly heavier canvas using an aqueous adhesive some time between completion in 1888 and its display at the Stafford Galleries, London, in 1911. While the transport of canvases from Brittany for sale by a dealer in Paris may have caused problems for many paintings, there is no evidence to suggest that *Vision of the Sermon* was rolled. Indeed, perhaps in recognition of its importance, Emile Bernard is believed to have taken the framed painting to Paris by hand. It is, however, worth noting that the early lining of canvases as a preventive conservation measure was not unusual.[8]

There is no obvious indication on the surface of the painting, such as tears in the support or sign of poor adhesion between ground and paint layers, to signal why such a major structural intervention was undertaken so early in the painting's life. Other aspects of the restoration and the subsequent presentation of the painting may, however, offer an explanation.

Examination suggests that the lining is likely to have been carried out in France. An aqueous glue-paste was the most commonly used adhesive by restorers on the Continent at this time. French newspaper fragments were also noted between the two fabrics when the tacking margins on the right and left sides were examined following removal of the gum paper tape. In addition, two tiny fragments of paper were discovered attached to the surface of the painting and these are presumed to be remnants of the facing paper used during the structural treatment.

Interestingly, the dimensions of the painting were slightly enlarged at this time by two different means: first of all, by partly folding out the original tacking margins on the right and left sides, and secondly, by adding narrow filets of wood to the top and lower edges *after* attachment of the lined painting to a new stretcher [plate 126]. A painting by Spencer Gore of *Vision of the Sermon* [plate 119] on exhibition in London dated 1911 reveals the painting in the elaborate marbled blue and gilded frame in which it is still displayed today. Although the choice of such a frame would be entirely contrary to Gauguin's wishes, it is not implausible that such an invasive structural treatment was carried out simply in order that the canvas could be accommodated in this valuable and conspicuous frame.[10] (It is certainly peculiar that the dimensions of the painting were enlarged by two different means: why was the replacement stretcher not made to the required new dimensions without having to add the wooden filets?)

The paint surface of *Vision of the Sermon* has also altered as a result of the lining process, yet in a less measurable and more disfiguring manner. It is widely acknowledged that excessive levels of heat, pressure and moisture were used in earlier structural treatments and examples of weave interference and 'moated' brushwork proliferate from linings undertaken in the past. 'Weave interference' describes the exaggeration of the grid-like weave pattern of the primary support on the paint surface which occurs as a result of such levels of pressure and heat applied with an iron during the lining process. The painting also has a 'polished' appearance in places, particularly in the flat red background, and the few areas of slightly raised brushwork, for example the angel's wings, have been distinctly flattened [plate 127].

While lining treatments have a near-catastrophic effect on the delicate, descriptive and short brushstrokes of Impressionist paintings, Gauguin may have actually favoured the smooth surface created by the restorer's hot and heavy iron: 'Vincent and I agree on very little, generally and above all in painting … As far as colour is concerned, he accepts the accidents of impasto as in Monticelli and I, I detest the messing with brushwork, etc.'[11] Such was his predilection for a surface devoid of visible brushwork that Gauguin may have – as a restoration measure – ironed his own paintings and those by others in his collection. Indeed, there are two examples of the artist providing written instructions for an ironing method recommended for the consolidation of a flaking paint surface and both emphasise the need for heat and pressure. The iron was usually applied to the reverse but often also to the front of the painting while the surface was protected by a paper facing.[12] In a letter to Van Gogh dated 9 January, 1889, Gauguin writes:

The whole 'Vintage' [Vintage at Arles, Miseres Humaines, *1888, Ordrupgaard Copenhagen] has flakes because of the white [ground layer] which has separated [from the canvas] – I have reattached it completely using a process indicated by the reliner. I mention it to you because it is a very easy thing to do and may be very good for your canvases which need retouching. You stick newspaper on your canvas [the paint surface] with 'flour paste'. Once dry you place your canvas on a smooth board and press down on it hard with a very hot iron. All your flakes of colour will remain, but they will have been flattened and you will have 'a very beautiful' surface. Afterwards you wet your covering of paper well and lift off all the paper.*[13]

It is worth noting that it is impossible to distinguish any flattening of the surface as the result of ironing carried out by the artist from any flattening carried out at a later date, by a restorer's iron.

GROUND APPLICATION

It would appear that Gauguin prepared the fabric support himself: the extremely thin, slightly uneven application, barely filling the interstices of the canvas weave and originally white in colour, does not extend to the edges of the tacking margins. Analysis suggests an absorbent ground layer, that is, one based on chalk (calcium carbonate) bound with an aqueous glue medium.[14] This type of ground was popular with the Impressionists and available commercially pre-prepared on canvas supports as early as 1837. By preferring this type of ground Gauguin follows a well-established contemporary trend, one pioneered by Pissarro and Degas.[15]

The preparatory layer became a preoccupation of the artist and is mentioned frequently in his correspondence.

Structurally important, this layer had a particular resonance for Gauguin as on completion his paintings had to be removed from their stretchers and rolled for transport to his dealer in Paris, making good adhesion of paint to the support essential. However, in light of the artist's regular criticism of the preparation and that fact that this layer was frequently blamed for flaking of the paint, it can be surmised that Gauguin regarded the *aesthetic* function of this priming layer as paramount.

The use of an absorbent ground layer was vital to Gauguin's painting technique. Its favoured characteristics were speed of drying, colour stability and the facility to absorb excess oil from the tube paints – all important factors when striving to create a leanly bound, flat surface using the minimum of pigment.[16] As financial concerns were prevalent throughout Gauguin's life, techniques where economic use is made of materials were generally preferred, although they did not dictate his method.

PREPARATORY LAYERS

Despite Gauguin's projection of himself as an artist working in a spontaneous, primitive manner, free of a rigid system, close scrutiny of the present painting has found this image to be somewhat fanciful. In a letter to the Danish painter Jens Ferdinand Willumsen sent from Pont-Aven in 1890, Gauguin writes:

You know that though others have honoured me by attributing a system to me, I have never had one and could not condemn myself to it if I had. I paint as I please, bright today, dark tomorrow. The artist must be free or he is not an artist. 'But you have a technique?' they say. No, I have not, or rather I have one but it is a vagabond sort of thing, and very elastic. It is a technique that changes constantly, according to the mood I am in, and I use it to express my thought, without bothering as to whether it truthfully expresses nature.[17]

The physical evidence suggests a more methodical, indeed laboured approach to composition, whereby for example, extensive use is made of preparatory sketches (so-called 'documents'). Such sketches could take different forms from swift sketches to full-size studies of individuals.[18]

Unfortunately no full-size preparatory drawings of figures are known for *Vision of the Sermon*, yet the complexity of the scene would seem to demand that they did exist. Instead, we have two curious sketches, each made at different stages of the creative process and both offering their own insight into the genesis of the painting.

A swift 'scribble' in a sketch book appears to represent the artist's preliminary concept. Apparently executed before

113

128 | X-radiograph mosaic of the entire painting.

129 | X-radiograph detail of the lower right corner indicates a compositional alteration to the profile of the figure.

he began the painting, the design is much simplified, omitting both the prancing cow and the figure groups on the left to concentrate on the three central foreground figures, the tree and Jacob wrestling with the angel [plate 58]. Despite the abbreviated forms the rhythmic circular design and the manipulation of scale are already present and were obviously key to the composition from the very outset.[19]

A schematic image incorporated into a letter to Van Gogh [plate 59] was presumably made nearer completion of the painting. It reveals a spare yet precise use of the brown outline that includes the cow and its accurate positioning in respect of the tree and the finished work. The two separate figure groups on the left side are added as are the peculiar elliptical shape of tree branches. Even the distinct shapes of the *coiffes* are described in 'shorthand' while the diagonal division and deeply foreshortened space is firmly established. There are two colour notations, neither of which relates entirely accurately to the pigment choice: the Breton dresses are described as black (*noir*) and the coifs as white (*blanc*). Surprisingly, there is no mention of the stark red non-naturalistic background, and the male figure on the right is conspicuously absent.

The use of preparatory sketches signals a return to the initial step-by-step process familiar to traditional, academic painting practice. As noted by Jirat-Wasiutyenski:
Conceptually, working from memory emphasised memory and imagination in the creative process. Memory would act as a simplifying filter, allowing the artist to concentrate on the essentials in rendering the image. The goal was to arrive at a 'synthesis', and the result was often referred to as an 'abstraction'. These may have been the central aesthetic issues discussed and argued in the winter of 1887–88 by Bernard, Gauguin and van Gogh in Paris.[20]

Gauguin appears to have established the basic outlines of the forms using a dilute Prussian blue paint over the primed canvas.[21] Examination of both the X-radiograph and infrared reflectogram mosaics reveals a confident hand at work with few evident *pentimenti*, or compositional changes. As Prussian blue is transparent in X-radiography and also appears dark in infrared reflectography, black underpainted outlines are clearly visible using both examination techniques [plate 128]. While there are minor adjustments visible, for example at the contour of the nose of the central woman and also where the tree trunk originally stretched across the top left corner, the most significant change relates to the profile of the male figure on the far

right. Although ambiguous, it is possible that initially the collar stood up and the chin was drawn at a sharper angle than the straight line that exists in the final painting. This figure is thought to be a late addition to the composition – it does not feature in either of the aforementioned two schematic sketches – and, although the gender is somewhat unclear, the profile has even been proposed as a self-portrait [plate 129].[22]

The blue outlining appears to have been carried out throughout the painting process as it occurs both below the paint layers as a thin wash with small areas left exposed and on top of painted forms to reinforce contours using a thicker consistency of paint. The thinner under-paint is visible around the profiles of the women and their Breton *coiffes* whereas the more medium-rich outlines applied at a later stage are most clearly evident around the clasped hands in prayer on the left [plate 130].

PAINT LAYERS

Perhaps the most intriguing question regarding the technique of *Vision of the Sermon* has been identification of the paint medium. Despite a lack of confirmed precedents within the artist's oeuvre, various factors have combined in the past to encourage the notion that Gauguin may have incorporated wax into his paint. A thorough examination of the surface was last undertaken in 1985, during which the paint layers' sensitivity to non-polar, 'mild' solvents, the branched, crystallised appearance of the surface in dark passages, and Gauguin's known preference for wax (instead of varnish) as a surface coating, conspired to suggest – understandably – that the paint medium itself contained wax [plate 131].[23]

Analysis of several samples taken from differently pigmented areas was undertaken for this study. No wax was detected in the medium of the paint layers, instead the use of conventional heat-bodied linseed and non-heat-bodied poppyseed and walnut oils was found.[24] There are two important factors to bear in mind in the analysis of paint media of this period. First of all, the widespread use of tube paint in the late nineteenth century resulted in the choice of medium being made by the colourman or paint manufacturer rather than the artist himself. A sample taken for medium analysis from the red background identified two separate paint layers both containing the same pigment – vermilion – but each bound with a different oil. The medium in the slightly darker underlayer consists of a non-heat-bodied walnut oil or a poppyseed oil, whereas the medium in the upper layer consists of a heat-bodied linseed oil.[25] The combination of both types of oil on at least one occasion for the same pigment indicates that, rather than follow a rigid system, Gauguin used whatever was to hand. A second factor to consider when interpreting results is the possibility of adulteration, as this was fairly widespread during the latter half of the nineteenth century.[26]

One of the most striking features of the paint surface in *Vision of the Sermon* is its lean, almost under-bound, matt character. Appreciating how conscious the pursuit of this appearance was is essential to understanding Gauguin's integrated, 'synthesised' approach. Paints supplied in tubes were widely used at this time and, in the past as in the present, each pigment required a different amount of oil (and sometimes a different *type* of oil) to make a workable paint.[27] Although there are few reliable contemporary references to the artist's working method, Gauguin is very likely to have 'blotted' his paint on an absorbent material prior to use in order to remove as much oil as possible, a technique known as *à l'essence*.[28] Other measures undertaken in order to drain the paint layer of excess medium include use of an absorbent ground layer and also the recommendation to 'wash' the paint surface after completion in order to 'degrease' the impasto.[29]

Examination of the pigments used for *Vision of the Sermon* identified a range that compares closely to both published findings of other paintings of this period and a description of the colours used later in life by Gauguin listed by Rotonchamp in his biography of the artist first published in 1906. Lead and zinc white, Prussian blue, ultramarine, vermilion, organic red lake, yellow ochre, chrome yellow, zinc yellow and emerald green were all identified in the Edinburgh painting and all except the zinc yellow were mentioned by the biographer.[30] It is noteworthy that neither black nor brown earth pigments were found, suggesting that Gauguin's choice was determined by a concern for bold and 'clean' colours.

130 | Detail of the praying hands on the left revealing the dark blue outlining of forms, which has been applied at the final stages of execution.

131 | Detail of the lower left corner illustrating the blanched and crystallised appearance of the wax surface coating.

Gauguin's own words in a letter to van Gogh underline the stark clarity and significance of the pigment choice for the painting; 'a very intense black' of the costumes, 'a very luminous yellowy white' of the Breton *coiffes*, 'emerald green clouds' as the foliage of the apple tree, the ground 'pure vermilion', the angel's wings 'pure chrome yellow' and finally the feet, 'flesh orange'. The few cross sections taken demonstrate both the opacity and purity of the colours chosen and a complexity in the pigment combination employed for the 'white' areas [plates 132, 133].

In his investigation of Gauguin's *Portrait of Van Gogh Painting Sunflowers* (1888), (Van Gogh Museum, Amsterdam), painted shortly after *Vision of the Sermon*, Travers Newton cites Pissarro and the Impressionists as key influences in the artist's adoption of a high-keyed palette. His description of technique accords well with analysis of *Vision of the Sermon*, particularly the use of primary colours, absence of glazing between layers, selection of opaque over transparent pigments and use of large areas of solid colour rather than the Impressionists' broken brushwork. [31]

Comparison of *Vision of the Sermon* with *Martinique Landscape* [plate 6] exemplifies the extent to which the former marks a significant departure from the artist's earlier work in more than subject matter and palette. Although both paintings employ the same lean and economical use of paint, the short, diagonal strokes establishing areas of muted, yet broadly naturalistic colour of the earlier landscape manifestly recall the landscapes of Cézanne. In *Vision of the Sermon* paint application techniques appear to

be quite different. A stiff, dry paint is dragged across the surface, filling in rather than constructing individual forms and in doing so reflecting the artist's selection and abstraction from imagination over direct observation and the study of nature.

While great emphasis has been placed on the artist's use of 'flat' areas of unmodulated colour, close examination reveals lively and sophisticated brushwork throughout the composition. Surfaces are expressed in a consciously dynamic manner: for example, the foreground *coiffes* with their unusual shapes, composed of subtle yet complex coloured shadows, appear almost sculptural in their intensity. Far from being harnessed to the description of a familiar reality, Gauguin appears to have used his brush to manipulate both colour and texture to communicate in an entirely new idiom.

Discreet combinations of complementary colours can be found in the latter stages of *Vision of the Sermon* as well as the more obvious and daring initial compositional juxtaposition of the green tree and red background. The orange and green detail at the neckline of the central woman in profile; the yellow stripes on the blue aprons on the left and the red and green detail of the costume at lower right illustrate an intuitive sense of design. Similarly, the addition of differently coloured contours, particularly around the 'monstrous helmets', reveals a concern for balance and a conscious arrangement of tonal contrasts across the surface. Colour is key to the creation of this segmented space and performs a critical role in the symbolism of the scene [plates 134, 135].

132 | A cross-section sample taken from paint loss at the lower edge of the praying hands at the lower left of the painting. Above the vermilion background underlayer (there is no ground layer present), the thicker paint layer for the flesh of the hand is composed of a variety of pigments including lead white, vermilion (mercuric sulphide), geranium lake, zinc yellow (zinc chromate) and emerald green (copper acetoarsenite). Magnification is × 400.

133 | A cross-section sample taken from the upper left edge at the skirt of the kneeling figure, just at the boundary of the *coiffe* of the woman below. | As there is no ground layer present the vermilion underlayer originates from the red background. Above this, there is a lead white containing layer from the *coiffe* below the skirt and finally the upper Prussian blue layer describes the skirt. The wax surface coating with various pigment particles embedded within, is clearly visible along the top of the paint sample. Magnification is × 400.

134 | Detail of the aprons on the left shows where a stiff yellow paint has been dragged over a lighter blue underlayer creating a striped effect.

135 | Detail of the collar of the figure in the foreground showing the juxtaposition of orange and green paint in the final lean brushstrokes.

Throughout the composition there is generally spare use of paint and little overlap of forms except at the interface between colours where the paint has a multi-layer structure. The red background layer is a significant exception to this as, consisting of more than one application of paint, it extends below much of the composition with reserves evidently left only in the upper third of the picture plane for the tree foliage and kneeling figures. Examination indicates that Gauguin reworked parts of this area, for example reinforcing the central diagonal of the tree trunk and also the negative shapes around the dark outlines of the Breton women. Certainly the laboured appearance of this

136 | A cross-section sample taken from the top edge at the foliage of the tree. Above a tiny fragment of ground there are two green paint layers. These are composed of varying mixtures of Prussian blue (iron blue), zinc yellow (zinc chromate), chrome yellow (lead chromate), emerald green (copper acetoarsenite) and vermilion (mercuric sulphide). The wax surface coating with various pigment particles embedded within, is clearly visible along the top of the paint sample. Magnification is × 400.

red field belies the three-week period during which this painting was reputedly executed.

Scant evidence of Gauguin working 'wet-in-wet' was observed; rather it would seem that each layer had properly dried before the next was applied. Some working of different colours simultaneously was, however, noted in the face of the wrestling angel and in the description of the tree. The cross section taken from the top of the foliage reveals subtly different green paints swirled into two denser layers [plate 136].[32]

The only apparent restoration on the surface is located around the typically ragged edges of the original image. This would have been applied to give a more 'finished' appearance to the composition.[33]

SURFACE COATING

Gauguin, preferring a matt aesthetic, was profoundly opposed to the application of a deeply saturating and high-gloss surface coating for his paintings, describing it as 'this dirty disgusting varnish which picture dealers use and which is so common'.[34] His stance was not novel but followed the anti-academic approach championed by the earlier generation of Impressionists. As a non-yellowing alternative and part of his 'primitivising' approach – the return to what he regarded as the more durable art of an earlier age – Gauguin recommended that his finished paintings should be protected by a layer of wax. Connected to his concern for the future condition of his paintings, he was also an early advocate of the use of glass in picture frames as a deterrent against atmospheric pollution. [35]

Clearly visible on the surface, particularly in the darker foreground areas, analysis identified the surface coating on *Vision of the Sermon* as a combination of beeswax and tallow.[36] Beeswax is a material commonly found in a variety of artists' materials as both an extender and an adulterant. Tallow, a hard animal-based fat found in candles, is less frequently encountered: it seems likely that the parsimonious Gauguin added this cheaper component to extend his supply of beeswax.

CHANGES IN APPEARANCE

We can only speculate how the appearance of *Vision of the Sermon* may have altered since its creation. Essentially there are two influences to consider: first, that of the artist's choice of materials, changes that occur naturally as a result of physical and chemical inter-reaction of the constituent elements, including for example external factors such as the effects of environmental fluctuation and light exposure to these materials, and, secondly, subsequent human intervention. Many changes are discreet, not necessarily obvious to

137 | Detail of the figure on the far left under an ultraviolet light. The bright orange fluorescence visible in the hands is indicative of certain organic red lake pigments, in this case possibly geranium lake.

138 | Detail of the wrestling figures under an ultraviolet light. The bright orange fluorescence visible in the feet of both figures and in the wings of the angel is indicative of certain organic red lake pigments, in this case possibly geranium lake.

an untrained eye and most are impossible to quantify.

With regard to the first category, Gauguin appears to have made fairly extensive use of an organic red pigment, estimated in this case to be geranium lake, a colour known to have poor light-fastness.[37] This has been identified in cross-section samples, which were taken and, owing to its characteristic orange fluorescence, is also clearly visible when the painting is examined under an ultra violet light source [plates 137, 138].[38] The pigment appears to be primarily incorporated into the white-containing areas, that is, the description of the faces, hands, *coiffes* and lapels of the Breton costumes, also the feet and hands of the wrestlers and highlights on the angel's wings.

It is difficult to assess the true extent of any fading in these areas, and, as the organic lake represents only one pigment in a mixture of several, we should probably assume that the change is minimal. If we imagine that the afore-mentioned areas would have been a deeper, brighter pink then feasibly the whole would originally have had less tonal contrast between the lighter areas and the mid-tone of the red background. However, regarding the Breton *coiffes*, it is worth heeding Gauguin's description of them being 'a very luminous yellowy-white' which seems generally in keeping with their present appearance.

Judging the effect of Gauguin's early application of wax

to the surface is more straightforward. As part of the natural ageing process this layer has broken down significantly: instead of providing a discrete, uniform (invisible) surface coating there is an uneven, blanched and crystallised charac-ter to the paint surface. As wax degrades and changes from being a smooth to a broken layer, the light falling on the surface scatters. Consequently this phenomenon is particu-larly obvious in the darker painted areas, specifically the deep blue of the foreground costumes and brown tree trunk. This disturbing, somewhat incongruous appearance can bear little relation to the artist's original intention [plate 131].

Unfortunately the deliberately lean nature of the under-lying paint has led to the migration of loose pigment parti-cles into this wax layer. In effect the wax has taken over the role of the missing paint medium, filling voids and becoming, by default, intrinsically bound to the paint layers. Leaving aside questions of the ethics involved, removal or indeed re-saturation of this degraded layer with solvents is therefore not possible without adversely affecting the pigmented layers, i.e. without removing traces of original paint.[39]

Since its acquisition by the National Gallery of Scotland, *Vision of the Sermon* has not received any remedial conser-vation treatment and consequently it is reasonable to assume that, to date, the painting has undergone only a single con-servation campaign. It is fortunate that no attempt appears to

have been made either to remove any surface coating during this time or to apply a varnish layer, as has been the fate of other unvarnished paintings of this period. Many late nineteenth-century French paintings in museum collections across both Europe and the United States have been irrevocably altered by ill-thought-out, yet probably well-intentioned, restoration campaigns. Not only has the delicate impasted brushwork been flattened by the excesses of early lining procedures, but also, and arguably more damaging still, the light pastel colours and matt surfaces have been saturated by uniform, glossy natural resin varnishes. Often the sensitivity of the relatively young paint makes such layers unable to withstand the solvents required to remove the surface coatings. As varnish layers inevitably darken and discolour with age, cleaning is made impossible without risking damage to the original paint.

One unmistakable departure from the appearance of the painting intended by Gauguin is the frame in which *Vision of the Sermon* is seen today. There are several documentary references to the artist's preference for a simple moulding, painted white or stained, and such frames also figure in the background of paintings produced by Gauguin during this period.[40] A reproduction frame based on the artist's description of his preferred style of frame was made in the National Galleries of Scotland's Conservation Department for illustrative purposes only [plate 139].[41] The pared-down design emphasises the stark, compartmentalised space, the artist's vivid use of colour and the rhythmic, circular composition. Without the competition of its relatively extravagant Italian frame (nevertheless now an essential part of the painting's history) *Vision of the Sermon*, like the reproduction frame itself, appears to make an abbreviated, yet concentrated artistic statement.

By 1888 Gauguin had turned increasingly from the study of nature and painting *en plein air* towards a greater reliance on memory and imagination, and in doing so reflected a wide range of influences as well as an independence of spirit. As his subject matter changed – and *Vision of the Sermon* represents Gauguin's first attempt at a religious theme – consequently his methods, if not materials, were adapted to meet this challenge.

Scientific analysis has shown that there is little remarkable about the individual materials employed by the artist. However, it is hoped an insight to the disparate, physical constituents of this painting can contribute to, rather than detract from, our understanding and appreciation of this arresting image. As is often the case, the valuable information gleaned through technical investigation, while answering some important questions, prompts many others. On a variety of levels the enduring complexity of this iconic work defies both adequate description and reduction of its parts to a list of artists' supplies.

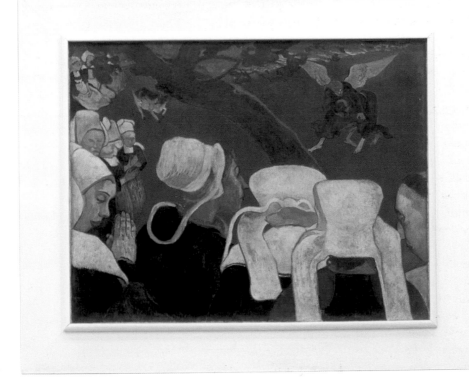

139 | *Vision of the Sermon* framed following the simple design Gauguin favoured at the time.

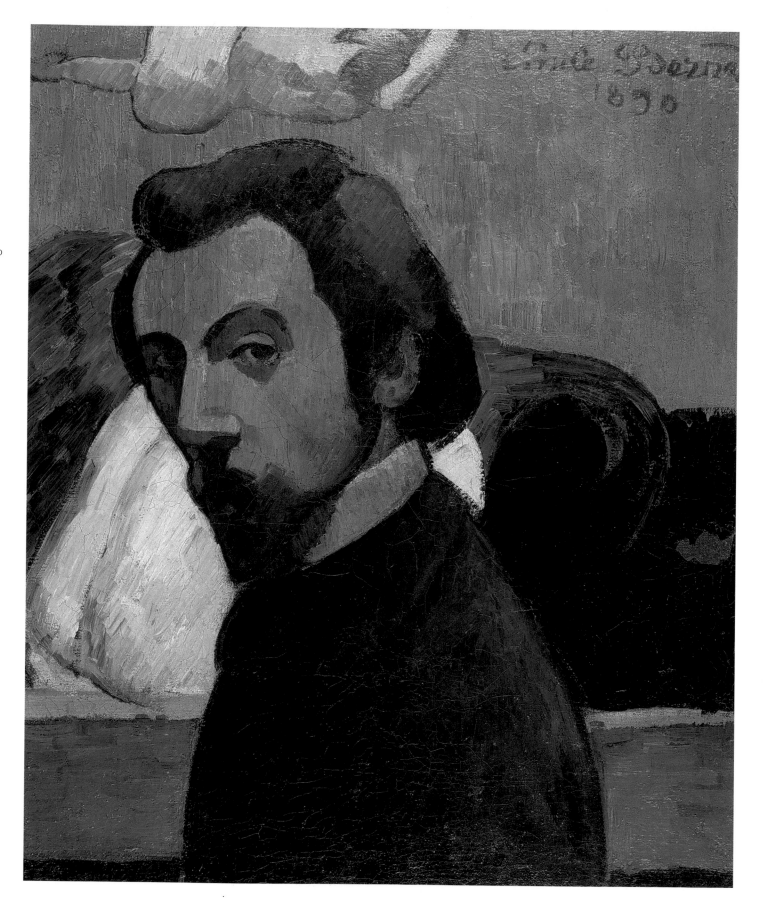

Exhibition Checklist

The checklist is divided into sections that follow the hang of the exhibition, *Gauguin's Vision*. Works illustrated in this book are indicated by a plate number. Dimensions are given in centimetres, height × width

ARTISTS AND BRITTANY

FEMALE COSTUME FROM PONT-AVEN

Comprising artisan's *coiffe* (stiffened white cotton), peasant's mourning *coiffe* (stiffened white cotton), peasant's Sunday or ceremonial *coiffe* (white satin and cotton lace), pleated white collar trimmed with lace, sleeved bodice, black velvet waistcoat, skirt, apron (woven linen and hemp), cross, late nineteenth century.
Musée de Pont-Aven

ARCHIBALD STANDISH HARTRICK
Back of Gauguin's Studio, Pont-Aven, 1886

48 × 61 cm · Oil on canvas
The Samuel Courtauld Trust,
Courtauld Institute of Art Gallery, London
PLATE 15

EUGENE BOUDIN
The Pardon of Sainte-Anne La Palud, 1858

78 × 155 cm · Oil on canvas
Musée Malraux, Le Havre
PLATE 13

PAUL GAUGUIN
Breton Woman Knitting, 1886–8

60 × 41.5 cm · Charcoal, sanguine and pastel on paper
Musée d'Orsay, Paris (held by the Département des Arts graphiques, Musée du Louvre, Paris)

DIOGENE-ULYSSE-NAPOLEON MAILLART
Breton Types and Costumes from Pont-Aven and Douarnenez, c.1870

26.7 × 18 cm · Coloured etching
Musée départemental breton, Quimper

140 | Emile Bernard, *Self-portrait*, 1890*
Musée des Beaux-Arts, Brest

PASCAL DAGNAN-BOUVERET
Study for 'The Pardon, Brittany', 1888
31.2 × 19.8 cm · Pastel on blue-green paper
National Gallery of Scotland, Edinburgh

PASCAL DAGNAN-BOUVERET
The Pardon, Brittany, 1888
123.5 × 68.9 cm · Oil on canvas
The Montreal Museum of Fine Arts, William F. Angus Bequest
PLATE 77

THEODULE RIBOT
*At the Sermon, c.*1887
55.5 × 46.5 cm · Oil on canvas
Musée d'Orsay, Paris, donated by Josse and
Gaston Bernheim-Jeune, 1917
PLATE 76

ALPHONSE LEGROS
The Sermon, 1871
76.2 × 95.9 cm · Oil on canvas
National Gallery of Scotland, Edinburgh
PLATE 75

ADOLPHE LELEUX
Wrestlers in Lower Brittany, 1864
58 × 93 cm · Oil on canvas
Musée national des Arts et Traditions populaires, Paris
PLATE 79

HIPPOLYTE LALAISSE
Wrestling at Rosporden, 1865
25 × 35.3 cm · Lithograph on paper
Musée national des Arts et Traditions populaires, Paris
PLATE 80

PAUL SERUSIER
Breton Weaver's Workshop, 1888
72 × 88 cm · Oil on canvas
Musée d'Art et d'Archéologie, Senlis

VINCENT VAN GOGH
Head of a Peasant Woman, 1885
46.4 × 35.3 cm · Oil on canvas laid on millboard
National Gallery of Scotland, Edinburgh

PAUL GAUGUIN
Two Breton Women; Landscape (recto) and *Two Cows;
A Seated Breton Woman* (verso), 1886
Each sketchbook page 16.4 × 10.8 cm · Various graphic media on paper
National Gallery of Art, Washington,
The Armand Hammer Collection 1991

PAUL GAUGUIN
*A Breton Woman and a Standing Man; Head and Hand of a
Monkey* (recto) and *Breton Boy Tending Geese; Cows and a Figure
Leaning on a Ledge* (verso), 1886
Each sketchbook page 16.4 × 10.8 cm · Various graphic media on paper
National Gallery of Art, Washington,
The Armand Hammer Collection 1991

PAUL GAUGUIN
*Studies of Jugs and Vases; A Man with a Moustache and a Boy
with a Hat* (recto) and *Four Studies of Breton Women; Shapes
and Vases* (verso), 1886
Each sketchbook page 16.4 × 10.8 cm · Various graphic media on paper
National Gallery of Art, Washington,
The Armand Hammer Collection 1991
PLATES 11 & 21

ANONYMOUS
Woman from Pont-Aven, 1850
from the series *France, Musée des Costumes*
27 × 20.4 cm · Coloured steel engraving
Musée départemental breton, Quimper
PLATE 20

FREDERIC SORRIEU
*Souvenir of Lower Brittany, c.*1860
Three plates from a folding souvenir album
Musée départemental breton, Quimper

RANDOLPH CALDECOTT
Pont-Aven, 1880
from Henry Blackburn, *Breton Folk: An Artistic Tour in Brittany*
National Library of Scotland, Edinburgh
PLATE 9

THOMAS & KATHERINE MACQUOID
Costumes and Characteristics of South Brittany, 1879
from *The Magazine of Art,* vol. 2,
National Library of Scotland, Edinburgh

GAUGUIN AND HIS PEERS

CAMILLE PISSARRO
Cow and Landscape, 1885
22.1 × 30 cm · Etching, state II
The Ashmolean Museum, Oxford, Pissarro Family Gift, 1950

CAMILLE PISSARRO
Peasant Woman in a Cabbage Field, c.1885
18.75 × 13.3 cm · Etching
The Ashmolean Museum, Oxford, Pissarro Family Gift, 1950

LUCIEN PISSARRO
Il était une bergère, 1884
song book cover
21.8 × 18.9 cm · Ink and watercolour on paper
The Ashmolean Museum, Oxford, Pissarro Family Gift, 1950

LUCIEN PISSARRO
Il était une bergère, 1884
song book illustration
20.2 × 17.1 cm · Ink and watercolour on paper
The Ashmolean Museum, Oxford, Pissarro Family Gift, 1950

LUCIEN PISSARRO
The Curé, 1885
18.7 × 15.2 cm · Wood engraving and watercolour
The Ashmolean Museum, Oxford. Accepted by HM Government in
lieu of inheritance tax and allocated to the Ashmolean Museum, 2003

RANDOLPH CALDECOTT
The House that Jack Built, London 1878
National Library of Scotland, Edinburgh

RANDOLPH CALDECOTT
The Diverting History of John Gilpin, London 1878
National Library of Scotland, Edinburgh
PLATE 28

EDGAR DEGAS
Woman Adjusting her Hat, 1884
61 × 74 cm · Oil on canvas
Private Collection
PLATE 3

EDGAR DEGAS
The Ballet from 'Robert le Diable', 1871 (dated 1872)
68.5 × 48.2 cm · Oil on canvas
The Metropolitan Museum of Art, New York, H.O. Havemeyer
Collection, Bequest of Mrs H.O. Havemeyer, 1929
PLATE 62

PAUL GAUGUIN
Landscape from Brittany with Breton Women, 1888
91 × 72 cm · Oil on canvas
Ny Carlsberg Glyptotek, Copenhagen
PLATE 35

PAUL GAUGUIN
Breton Woman Seen from Behind, 1886
45.7 × 30 cm · Pastel on paper
Collection Fondation Pierre Gianadda, Martigny, Switzerland
PLATE 36

PAUL GAUGUIN
Breton Girl, 1886
48 × 32 cm · Charcoal and pastel on paper
Glasgow Museums: The Burrell Collection
PLATE 18

PAUL GAUGUIN
Landscape from Pont-Aven, Brittany, 1888
90.5 × 71 cm · Oil on canvas
Ny Carlsberg Glyptotek, Copenhagen
PLATE 37

PAUL GAUGUIN
Comings and Goings, Martinique, 1887
72 × 92 cm · Oil on canvas
Collection Carmen Thyssen-Bornemisza on loan to
Museo Thyssen-Bornemisza, Madrid
PLATE 31

PAUL GAUGUIN
Martinique Landscape, 1887
115.5 × 88.5 cm · Oil on canvas
National Gallery of Scotland, Edinburgh
PLATE 6

PAUL CEZANNE
Mountains, L'Estaque, c.1878
53.3 × 72.4 cm · Oil on canvas
National Museums and Galleries of Wales, Cardiff
PLATE 5

EDGAR DEGAS
Dancers, c.1879
30 × 59.7 cm · Gouache, pastel and essence on silk
Tacoma Art Museum, gift of Mr and Mrs W. Hilding Lindberg
PLATE 34

PAUL GAUGUIN
Landscape from Martinique, 1887
20 × 42 cm · Watercolour and gouache
The Fan Museum, London
PLATE 33

PAUL GAUGUIN
Vase Decorated with Breton Scenes, 1886–7
h. 29.5 cm · Glazed stoneware
Musées Royaux d'Art et d'Histoire, Brussels
PLATE 29

PAUL GAUGUIN
Jardinière with Breton Woman and Sheep, 1886–7
h. 13.5 cm · Unglazed stoneware
Petit Palais, Musée des Beaux-Arts de la Ville de Paris
PLATE 30

AROUND VISION OF THE SERMON

EMILE BERNARD
Breton Woman with Large Coiffe, 1887
20 × 14.8 cm · Pen and black ink, watercolour and China ink
Musée d'Orsay, Paris (held by the Département des Arts graphiques,
Musée du Louvre, Paris)
PLATE 57

EMILE BERNARD
*Costume Study, Woman seen from Behind, c.*1888
22 × 16 cm · Ink on paper
Collection R.T., Brest

EMILE BERNARD
Breton Women Picking Apples, 1888
14.9 × 22.5 cm · Charcoal and watercolour on grey paper
Musée d'Orsay, Paris (held by the Département des Arts graphiques,
Musée du Louvre, Paris)

EMILE BERNARD
*Working Woman, Kneeling, c.*1888
15.5 × 10.5 cm · Pencil on paper
Collection R.T., Brest
PLATE 52

EMILE BERNARD
*Breton Women, Child and Goose
(Project for a Wood Carving), c.*1888
39 × 24.5 cm · Brown ink and wash on paper
Collection R.T., Brest
PLATE 69

ANONYMOUS (PELLERIN, EPINAL)
*The Calvary of Sainte-Anne d'Auray, c.*1852
64 × 42 cm · Handblocked wood engraving
Musée départemental breton, Quimper

AMEDEE GUERARD
*Farm Interior or Sick Child, c.*1870
60 × 92 cm · Oil on canvas
Musée départemental breton, Quimper
PLATE 46

J.-L. NICOLAS (PELLERIN, EPINAL)
Notre-Dame de Rumengol, Patron Saint of Brittany, 1858
64 × 42 cm · Handblocked wood engraving
Musée départemental breton, Quimper
PLATE 45

PAUL GAUGUIN & EMILE BERNARD
Earthly Paradise, 1888
h. 101 × w. 120 × d. 60.5 cm · Pine and oak sideboard
Private Collection
PLATE 68

UTAGAWA HIROSHIGE
Plum Estate, Kameido, 1857
Number thirty from *One Hundred Famous Views of Edo*
36 × 23.5 cm · Woodcut on paper
National Museums of Scotland, Edinburgh
PLATE 44

TOYOHARU KUNICHIKA
*Two Sections of a Theatrical Triptych, c.*1870–80
38 × 52 cm · Woodcut on paper
National Museums of Scotland, Edinburgh
PLATE 43

KATSUSHIKA HOKUSAI
*Wrestlers, c.*1816
Page from the *Manga* album
22 × 13 cm · Woodcut on paper
National Museums of Scotland, Edinburgh

PAUL GAUGUIN
*Letter to Vincent Van Gogh with sketch of 'Breton Boys
Wrestling', 24–5 July* 1888
21 × 13.6 cm · Brown ink on paper
Van Gogh Museum, Amsterdam
(Vincent van Gogh Foundation)
PLATE 49

LOUIS ANQUETIN
Avenue de Clichy, 1887
60.3 × 50.3 cm · Pastel on paper
Private Collection, courtesy of Brame & Lorenceau, Paris
PLATE 48

PAUL GAUGUIN
Study for 'Breton Girls Dancing / Ronde Bretonne', 1888
24 × 41 cm · Pastel and gouache on paper
Van Gogh Museum, Amsterdam
(Vincent van Gogh Foundation)
PLATE 65

PAUL GAUGUIN
Breton Girls Dancing, Pont-Aven, 1888
71.4 × 92.8 cm · Oil on canvas
National Gallery of Art, Washington,
collection of Mr and Mrs Paul Mellon, 1983.1.19
PLATE 64

PAUL GAUGUIN
Vision of the Sermon: Jacob Wrestling with the Angel, 1888
72.2 × 91 cm · Oil on canvas
National Gallery of Scotland, Edinburgh
PLATE 55

PAUL GAUGUIN
Preliminary sketch for 'Vision of the Sermon' with accompanying letter to Vincent Van Gogh, 25–7 September 1888
11.7 × 15.5 cm (sketch) · 18 × 11.5 cm (letter)
Van Gogh Museum, Amsterdam
(Vincent van Gogh Foundation)
PLATE 59

EMILE BERNARD
Breton Women in the Meadow / Pardon at Pont-Aven, 1888
74 × 90 cm · Oil on canvas
Private Collection
PLATE 54

EMILE BERNARD
Lane in Brittany, 1888
30.7 × 20.2 cm · Pen and ink and watercolour on paper
Van Gogh Museum, Amsterdam
(Vincent van Gogh Foundation)
PLATE 51

EMILE BERNARD
Breton Woman in an Orchard, 1888
32 × 19.1 cm · Pen and ink and watercolour on paper
Van Gogh Museum, Amsterdam
(Vincent van Gogh Foundation)

CHARLES LAVAL
Going to Market, Brittany, 1888
37.5 × 46 cm · Oil on canvas
Indianapolis Museum of Art, Samuel Josefowitz Collection of the
School of Pont-Aven, through the generosity of Lilly Endowment Inc.,
the Josefowitz Family, Mr and Mrs James M. Cornelius, Mr and Mrs
Leonard J. Betley, Lori and Dan Efroymson, and other Friends of the
Museum, 1998.178
PLATE 56

PAUL GAUGUIN
Breton Calvary / Green Christ, 1889
92 × 73.5 cm · Oil on canvas
Musées Royaux des Beaux-Arts de Belgique, Brussels
PLATE 99

PIERRE PUVIS DE CHAVANNES
Sainte Geneviève as a Child in Prayer, c.1875–6
136.5 × 77.2 cm · Oil on paper, laid down on canvas
Van Gogh Museum, Amsterdam

THE THEME OF JACOB AND THE ANGEL

ODILON REDON
Jacob Wrestling with the Angel, c.1910
27.3 × 13 cm · Oil on wood
Musée d'Orsay, Paris, bequest of Mme Arï Redon, 1982
PLATE 116

REMBRANDT VAN RIJN
The Angel Departing from the Family of Tobias, c.1660
10.2 × 15.2 cm · Etching
Hunterian Art Gallery, University of Glasgow
PLATE 85

GUSTAVE MOREAU
Study for 'Jacob Wrestling with the Angel', c.1878
18.5 × 10 cm · Watercolour on paper
Musée Gustave-Moreau, Paris
PLATE 93

GUSTAVE DORE
Jacob Wrestling with the Angel, 1866
Engraved by G. Laplante from *Holy Bible*
National Library of Scotland, Edinburgh
PLATE 91

PAUL-EMILE COLIN
Jacob Wrestling with the Angel, 1896
24.2 × 19.4 cm · Woodcut
Galerie Saphir, Paris
PLATE 115

EUGENE DELACROIX
*Jacob Wrestling with the Angel, c.*1850
Study for the Saint-Sulpice mural
57 × 40 cm · Oil on canvas
Österreichische Galerie Belvedere, Vienna
SEE PLATE 90

THE IMPACT AND LEGACY OF
VISION OF THE SERMON

PAUL GAUGUIN
Landscape with Two Breton Girls, 1889
72 × 91.4 cm · Oil on canvas
Museum of Fine Arts, Boston, gift of Harry and Mildred Remis
and Robert and Ruth Remis
PLATE 108

HENRI RIVIERE
The Pardon of Sainte-Anne La Palud, 1892
56.5 × 134.5 cm · Coloured wood engraving
Musée départemental breton, Quimper

MAURICE DENIS
*Seaweed-gatherers, c.*1890
33 × 41 cm · Oil on canvas
Private Collection
PLATE 105

PAUL SERUSIER
Landscape in the Bois d'Amour / The Talisman, 1888
27 × 22 cm · Oil on cardboard
Musée d'Orsay, Paris
PLATE 101

MAURICE DENIS
*Orange Christ, c.*1890
24 × 19 cm · Oil on cardboard
Courtesy of Galerie Hopkins-Custot, Paris
PLATE 102

MAURICE DENIS
*The Mystical Grape Harvest, c.*1890
74 × 51 cm · Oil on canvas mounted on cardboard
Triton Foundation, The Netherlands
PLATE 103

PAUL RANSON
*Christ and Buddha, c.*1890
66.7 × 51.4 cm · Oil on canvas
Triton Foundation, The Netherlands
PLATE 104

ARMAND SEGUIN
Breton Peasant Girls at Mass, 1894
55.1 × 38.4 cm · Oil on canvas
National Museums and Galleries of Wales, Cardiff
PLATE 113

JAN VERKADE
Saint Sebastian, 1892
45 × 22 cm · Gouache on paper
Musée Départemental Maurice Denis,
Saint-Germain-en-Laye

PAUL SERUSIER
*Louise / The Breton Servant Woman, c.*1891
73 × 60 cm · Oil on canvas
Musée Départemental Maurice Denis,
Saint-Germain-en-Laye
PLATE 110

PAUL GAUGUIN
Manao tupapao / Spirit of the Dead Watching, 1892
74 × 95.53 cm · Oil on canvas
Albright-Knox Art Gallery, Buffalo, New York,
A. Conger Goodyear Collection, 1965
PLATE 109

SPENCER GORE
Gauguins and Connoisseurs at the Stafford Gallery, 1911
83.8 × 71.7 cm · Oil on canvas
Private Collection
PLATE 119

PAUL GAUGUIN
Les Cigales et les fourmis – Souvenir de la Martinique, 1889
20 × 26 cm · Hand-tinted zincograph from Volpini Suite
Private Collection USA, courtesy of Ruth Ziegler Fine Arts

PAUL GAUGUIN
Pastorales Martinique (Martinique Pastoral), 1889
21.3 × 26.3 cm · Zincograph from Volpini Suite
Van Gogh Museum, Amsterdam
(Vincent van Gogh Foundation)

PAUL GAUGUIN
Misères humaines (Human Misery), 1889
28.5 × 23 cm · Zincograph from Volpini Suite
Van Gogh Museum, Amsterdam
(Vincent van Gogh Foundation)

PAUL GAUGUIN
Joys of Brittany, 1889
20 × 22.2 cm · Zincograph from Volpini Suite
Van Gogh Museum, Amsterdam
(Vincent van Gogh Foundation)
PLATE 96

PAUL GAUGUIN
Breton Women by a Gate, 1889
16.2 × 21.6 cm · Hand-tinted zincograph from Volpini Suite
Linda and Mel Teetz
PLATE 97

PAUL GAUGUIN
The Dramas of the Sea, Brittany, 1889
16.8 × 20.8 cm · Hand-tinted zincograph from Volpini Suite
Albright-Knox Art Gallery, Buffalo, New York, ACG Trust, 1970

EUGENE DRUET
Framed photograph of 'Vision of the Sermon', c.1900
Musée de Pont-Aven

CAMILLE PISSARRO
Letter to his son Lucien Pissarro
20 April 1891, last two pages
25.1 × 16.2 cm / 18.2 × 15.3 cm
The Ashmolean Museum, Oxford, Pissarro Family Gift, 1950

PAUL GAUGUIN
Self-portraits, c.1889
18 × 12.8 cm · Pen and ink on paper
Collection Waldemar Januszczak

GEORGE LACOMBE
The Scuffle, 1894
33.3 × 27 cm · Black chalk on paper
Indianapolis Museum of Art, The Holliday Collection, 79.259
PLATE 112

PAUL GAUGUIN
Self-portrait with Palette, c.1894
92 × 73 cm · Oil on canvas
Private Collection
ILLUSTRATED OPPOSITE TITLE PAGE

EMILE BERNARD
Self-portrait, 1890
55.5 × 46 cm · Oil on canvas
Musée des Beaux-Arts de Brest
PLATE 140

EMILE BERNARD
Bretonneries, 1889
33 × 25 cm · Title page of album of zincographs
Musée des beaux-arts, Quimper (on loan from Musée d'Orsay, Paris)
PLATE 98

EMILE BERNARD
Breton Women Hanging Washing, 1889
25 × 32 cm · Zincograph
Musée des beaux-arts, Quimper (on loan from Musée d'Orsay, Paris)

EMILE BERNARD
Lottery Ticket: Virgin and Child, 1891
22 × 12.5 cm · Woodcut heightened with watercolour
Inscribed in reverse: 'Loteri pour un Povre'
Collection R.T., Brest
PLATE 47

WLADISLAW SLEWINSKI
Two Breton Girls with Basket of Apples, c.1897
82 × 116 cm · Oil on canvas
National Museum in Warsaw
PLATE 114

Paul Gauguin: A Brief Biography

1848

7 June. Birth of Eugène-Henri-Paul Gauguin in Paris, second child of Pierre-Guillaume-Clovis Gauguin, republican journalist, and Aline Marie Chazal, daughter of radical feminist Flora Tristan (1803–1844).

1849

Clovis Gauguin, out of favour with new Bonapartist régime (Napoléon III), emigrates to Peru but dies during voyage. His widow Aline and her two children, Marie and Paul, settle in Lima home of her maternal great uncle, Don Pio de Moscoso. Gauguin's first years spent in tropical climate, speaking Spanish. He later flaunts this exotic ancestry: 'The Inca according to legend came straight from the sun and that's where I will return.'

1854–65

Returns to France. Attends schools in Orléans and Paris, spending three years at Jesuit seminary in Orléans (1859–62).

1865–8

Serves in merchant marine. Aboard the *Luzitano*, makes two voyages to Rio de Janeiro; aboard the *Chili*, makes a thirteen-month voyage to South America.

1867

Mid-voyage, receives news of mother's death.

1868–71

Re-enlists in navy to fulfil military service. During Franco-Prussian War, serves aboard imperial yacht the *Jérôme-Napoléon*, in Mediterranean and North Sea. Ordinary seaman. *Matelot de 3ième classe.*

1872

Returns to civilian life. Gauguin's guardian, Gustave Arosa, finds him employment as *agent de change* with stock broking firm of P. Bertin. Meets fellow employee, Emile Schuffenecker, also ambitious to become painter.

1873

Marries Mette Sofie Gad, young Danish woman. Between 1874 and 1883 they have five children, four sons and a daughter. Starts painting as recreation on Sundays. Attends evening classes at Atelier Colarossi.

1876

Shows landscape at Paris Salon.

1877

Leaves Bertin firm. Subsequent employers in financial sector include Caperon-Tanays & Thomas, A. Bourdon and A. Thomereau. Moves from central Paris to suburb of Vaugirard, where neighbours include several sculptors.

1878

Arosa holds sale of his sizeable collection of modern art, including several works by Pissarro. Period of successful speculation on Stock Exchange. Gauguin starts collecting on his own account.

1879

Invited by Camille Pissarro to take part in fourth Impressionist exhibition, to which he is already lending from his collection. Goes on to exhibit at fifth, sixth, seventh and eighth Impressionist exhibitions, in 1880, 1881, 1882 and 1886. Buys and sells works by Impressionists and frequents their café, La Nouvelle-Athènes.

1880

Moves to larger property with studio in rue Carcel, Vaugirard, sub-letting from Félix Jobbé-Duval, a Breton painter.

1881

At sixth Impressionist exhibition, *Nude Sewing* (Ny Carlsberg Glyptotek, Copenhagen) singled out for praise by Joris-Karl Huysmans.

1883

Abandons Stock Exchange in order to concentrate on painting full-time.

1884

Moves with family to Rouen, to economise, but in December is obliged to take up residence with Gad relations in Copenhagen. Works as agent for Dillies & Co., tarpaulin manufacturers.

1885

Having fallen out with in-laws returns with son Clovis to Paris. Visits Dieppe. Winter spent in abject poverty, posting bills to earn money.

1886

At eighth Impressionist Exhibition – where Seurat and his new divisionist style are main talking points – disappointed at failure to attract attention. July to October, first stay in Pont-Aven, artists' colony in southern Brittany. Meets Charles Laval and Emile Bernard. Over winter begins ceramic work with Ernest Chaplet. Frequents studios of Edgar Degas and Felix Bracquemond.

1887

First meeting with Vincent van Gogh. With Laval, travels to Panama and spends six months working in Martinique. Theo van Gogh becomes his dealer.

1888

Second stay in Pont-Aven, January to October. Joined there in August by Emile Bernard and Laval. Intense period of collaborative work. Paints *Vision of the Sermon* [plate 55]. Meets Paul Sérusier, gives him lesson in synthetism. Joins Vincent van Gogh in Arles. In late December following quarrel with Gauguin Van Gogh suffers mental breakdown; attacks himself with razor, severing ear.

1889

February, exhibits twelve paintings with *Les Vingt*, Brussels, including *Vision of the Sermon*. From February to April in Pont-Aven. May – June, exhibits work with Bernard, Schuffenecker, Laval and others at café Volpini, within site of Paris Universal Exhibition. On returning to Brittany settles in Le Pouldu; joined there by Sérusier and Jacob Meyer de Haan. Paints *Breton Calvary* [plate 99], *Yellow Christ* [plate 100], *Christ in the Garden of Olives* [plate 107].

1890

Plans trip to tropics with Bernard, considering Tonkin (Vietnam), Madagascar, eventually Tahiti. Returns to Paris at end of year to prepare departure.

1891

February, exhibits with *Les Vingt*. Publicity campaign; prominent newspaper articles by Octave Mirbeau. *Vision of the Sermon* singled out for praise by Gabriel-Albert Aurier, who hails Gauguin as leading exponent of 'Symbolism in Painting'. Auction raises 9985 francs. Bernard breaks off relations. Departs for Tahiti in April, beginning two year period of intense creativity.

1892

Paints *Manao tupapau* [plate 109].

1893

August, returns to France. November, mounts exhibition of Tahitian work at Durand-Ruel gallery. With money from inheritance rents studio in rue Vercingétorix. Wife Mette breaks off relations.

1894

February, visits Belgium to see exhibition of his work at Salon de la Libre Esthétique. May, returns to Pont-Aven. Injures ankle in brawl with sailors at Concarneau over Javanese mistress, Annah. Works on *Noa Noa*, illustrated narration of his experiences in Tahiti, with poet Charles Morice.

1895

Diagnosed as suffering from syphilis, returns permanently to Tahiti, settling in Punaauia.

1897

Learns of death of daughter, Aline. Paints *Where Do We Come From? Who Are We? Where are we Going?* (Museum of Fine Arts, Boston). Attempts suicide. After 1898, increasingly hampered in his movements, abandons painting for satirical journalism.

1901

Moves to Hiva-Oa in Marquesas. Constructs 'Maison du jouir' in Atuona. Resumes work.

1903

Dies, 8 May. Small retrospective exhibition in Paris organised by Ambroise Vollard.

1906

Major retrospective exhibition at Salon d'Automne.

Bibliography

BOOKS AND ARTICLES

AMISHAI-MAISELS 1985
Ziva Amishai-Maisels, *Gauguin's Religious Themes*,
The Hebrew University Ph D, 1969, New York 1985.

AURIER 1891
G.-Albert Aurier, 'Le Symbolisme en peinture – Paul Gauguin',
Mercure de France, March, 1891, pp.155–65, reprinted in Aurier 1995.

AURIER 1995
G.-Albert Aurier, *Textes critiques 1889–1892: De l'impressionnisme
au symbolisme*, Paris 1995.

BAILEY 2001
M. Bailey, 'Memories of Van Gogh and Gauguin: Hartrick's
reminiscences', *Van Gogh Museum Journal*, 2001, pp.96–105.

BAILLY-HERZBERG
Janine Bailly-Herzberg (ed.), *Correspondance de Camille Pissarro*,
vols.1–5, Condé-sur-Noireau, 1980 91.

BERNARD 1895
Emile Bernard, 'Lettre ouverte à Camille Mauclair', *Mercure de
France*, June 1895, pp.332–9.

BERNARD 1903
Emile Bernard, 'Notes sur l'Ecole dite de "Pont-Aven"', *Mercure de
France*, December 1903, pp.675–82.

BERNARD 1904
Emile Bernard, 'Concernant Paul Gauguin', *Nouvelle Revue d'Egypte*,
January 1904.

BERNARD 1919
Emile Bernard, 'Mémoire pour l'histoire du symbolisme pictural de
1890,' *Maintenant*, no.3, 1919.

BERNARD 1939
Emile Bernard, *Souvenirs inédits sur l'artiste peintre Paul Gauguin et
ses compagnons lors de leur séjour à Pont-Aven et au Pouldu*,
Lorient, n.d. [1939].

BERSON 1996
Ruth Berson (ed.), *The New Painting: Impressionism 1874–1886,
Documentation*, vol.1, Reviews, vol.II, Exhibited Works, San Francisco
1996.

BLACKBURN 1880
Henry Blackburn, *Breton Folk*, illustrated by Randiolph Caldecott,
London 1880.

BODELSEN 1959
Merete Bodelsen, 'The Missing Link in Gauguin's Cloisonism,'
Gazette des Beaux-Arts, 6ᵉ sér. vol.LIII, May-June 1959, pp.329–44.

BODELSEN 1964
Merete Bodelsen, *Gauguin's Ceramics, A Study in the Development
of his Art*, London 1964.

BODELSEN 1970
Merete Bodelson, 'Gauguin the Collector', *Burlington Magazine*,
no.810, vol.CXII, September 1970, pp.590–613.

BOUILLON 1993
Jean-Paul Bouillon (ed.), Maurice Denis, *Le Ciel et l'Arcadie, Écrits
sur l'art*, Paris 1993.

BOYLE-TURNER 1985
Caroline Boyle-Turner, 'Sérusier's Talisman', *Gazette des Beaux-Arts*,
6ᵉ période, vol.CV, May-June 1985, pp.191–6.

BOYLE-TURNER 1988
Caroline Boyle-Turner, *Paul Sérusier*, Lausanne 1988.

BULLEN 2003
J.B. Bullen, 'Great British Gauguin. His reception in London in 1910–
11', *Apollo*, October 2003, pp.3–12.

BURHAN 1979
Filiz Burhan, *Visions and Visionaries in Fin-de-Siècle France,
Nineteenth century Psychological Theory, The occult Sciences and the
Formation of the Symbolist Aesthetic in France*, Princeton 1979.

CAHN 2003
Isabelle Cahn, 'An echoing silence: the critical reception of Gauguin in
France, 1903–49', *Van Gogh Museum Journal*, 2003, pp.24–39.

CAILLER 1954
Pierre Cailler (ed.), *Lettres de Paul Gauguin à Emile Bernard,
1888–1891*, including preface by Emile Bernard, 'L'Aventure de ma
vie,' Geneva 1954.

CARIOU 1999
André Cariou, *Les Peintres de Pont-Aven*, Rennes 1999.

CHASSÉ 1921
Charles Chassé, *Gauguin et le Groupe de Pont-Aven*, Paris 1921.

CHASSÉ 1955
Charles Chassé, *Gauguin et son temps*, Paris 1955.

COOPER 1983
Douglas Cooper (ed.), *Paul Gauguin: 45 Lettres à Vincent, Théo et Jo
Van Gogh*, 'S Gravenhague 1983.

DELOUCHE 1977
Denise Delouche, *Peintres de la Bretagne: découverte d'une province*,
Rennes, 1977.

DELOUCHE 1986
Denise Delouche (ed.), *Pont-Aven et ses peintres à propos d'un
centenaire*, Rennes 1986.

DELOUCHE 1996
Denise Delouche, *Gauguin et la Bretagne*, Rennes 1996.

132

DEVLIN 1987
J. Devlin, *The Superstitious Mind: French Peasants and the Supernatural in the Nineteenth Century*, New Haven and London, 1987.

DISTEL 1989
Anne Distel, *Les collectionneurs des impressionistes*, Düdingen 1989.

DORRA 1955
Henry Dorra, 'Gauguin and Emile Bernard', *Gazette des Beaux-Arts*, 6ᵉ période, vol.XLV, April 1955, pp.227–46, 259–60.

DORRA 1980
Henry Dorra, 'Extraits de la correspondance d'Emile Bernard des débuts à la Rose-Croix (1876–1892)', *Gazette des Beaux-Arts*, 6ᵉ période, vol.XCVI, December 1980, pp.235–42.

FRECHES-THORY & TERRASSE 1990
Claire Frèches-Thory and Antoine Terrasse, *Les Nabis*, Paris 1990

GAUGUIN 1930
Lettres de Paul Gauguin à Georges Daniel de Monfreid, précédés d'un hommage par Victor Segalen, Paris 1930.

GEDO 1994
Mary Mathews Gedo, *Looking at Art from the Inside Out: The Psychoiconographic Approach to Modern Art*, Cambridge 1994.

GUERIN 1974
D. Guérin (ed.), *Gauguin, Oviri, écrits d'un sauvage*, Paris 1974.

HALPERIN 1970
Joan U. Halperin (ed.), *Félix Fénéon: Oeuvres plus que complètes*, 2 vols., Paris 1970.

HAMILTON FRASER 1969
Donald Hamilton Fraser, *On Gauguin's 'Vision After the Sermon'*, London 1969.

HARTFORD 2001
Eric M. Zafran (ed.), *Gauguin's Nirvana: Painters at Le Pouldu 1889–90*, Wadsworth Atheneum Museum of Art, Hartford, Connecticut 2001.

HARTRICK 1939
Archibald Standish Hartrick, *A Painter's Pilgrimage*, Cambridge 1939.

HERBAN III 1977
Matthew Herban III, 'The Origin of Paul Gauguin's *Vision after the Sermon: Jacob Struggling with the Angel*', *Art Bulletin*, LIX, September 1977, pp.415–20.

HUYGHE 1952
René Huyghe (ed.), *Le Carnet de Paul Gauguin*, Paris 1952 (facsimile of a sketchbook used between 1888 and 1890, now in the Jerusalem Museum).

JACOBS 1985
Michael Jacobs, *The Good and Simple Life: Artist Colonies in Europe and America*, Oxford 1985.

JIRAT-WASIUTYNSKI 1978
Voytech Jirat-Wasiutynski, Letter to the Editor, re. Matthew Herban III's article, *Art Bulletin*, 1978, vol.LX, no.2, pp.397–8, and Herban response, ibid., p.398.

JIRAT-WASIUTYNSKI & NEWTON 2000
Voytech Jirat-Wasiutynski and H. Travers Newton Jr., *Technique and Meaning in the Paintings of Paul Gauguin*, Cambridge 2000.

JOANNE 1877
Adolphe Joanne, *Itinéraire général de la France – Bretagne*, Paris 1877.

JOLY-SEGALEN 1950
Annie Joly-Segalen (ed.), *Lettres de Gauguin à Daniel de Monfreid*, Paris 1950.

KANO 1886
Yves Kano, *Les Populations bretonnes*, first published 1886, re-edition, 2000.

KEARNS 1989
James Kearns, *Symbolist Landscapes: the Place of Painting in the Poetry and Criticism of Mallarmé and his Circle*, London 1989.

KERDRAON 2004
Maël Yann Kerdraon, *Gouren: Traditions de lutte en Bretagne*, Morlaix 2004.

LOTI 1883
Pierre Loti, *Mon frère Yves*, Paris 1883.

LÜBBREN 2001
Nina Lübbren, *Rural artists' colonies in Europe 1870–1910*, Manchester 2001.

MALINGUE 1946
Maurice Malingue (ed.), *Lettres de Gauguin à sa femme et à ses amis*, Paris 1946.

MCMILLAN 2003
J. McMillan, '"Priest hits girl": on the front line in the "war of the two Frances"', in *Culture Wars: Secular-Catholic Conflict in Nineteenth-Century Europe*, C. Clark and W. Kaiser (eds.), Cambridge 2003, pp.77–101.

MERLHES 1984
Victor Merlhès (ed.), *Correspondance de Paul Gauguin*, vol.1 (1873–88), Paris 1984.

MERLHES 1989
Victor Merlhès, *Paul Gauguin et Vincent van Gogh, 1887–1888, Lettres retrouvées Souces Ignorées*, Taravoa, Tahiti 1989.

MERLHES 1994
Victor Merlhès (ed.), Gauguin, *Racontars de rapin*, fac-similé du manuscrit, Taravoa, Tahiti 1994.

MERLHES 1995
Victor Merlhès, *De Bretagne en Polynésie : Paul Gauguin Pages Inédites*, Taravoa, Tahiti 1995.

MICHEL & NIVET 1990 A
P. Michel et J-F. Nivet (eds.), *Octave Mirbeau: Correspondance avec Claude Monet*, Tusson, 1990.

MICHEL & NIVET 1990 B
P. Michel et J-F. Nivet (eds.), *Octave Mirbeau: Correspondance avec Camille Pissarro*, Tusson, 1990.

ORTON & POLLOCK 1980
Fred Orton and Griselda Pollock, 'Les Données bretonnantes: la Prairie de Représentation,' *Art History*, September 1980, pp.314–44.

PARIS 1991
Musée d'Orsay/Ecole du Louvre, *Gauguin, Actes du colloque Gauguin, Musée d'Orsay, 11–13 janvier 1989*, Paris 1991.

PHOENIX 1982
David Sellin, *Americans in Normandy and Brittany 1860–1910*, Phoenix Art Museum, Arizona 1982

POLLOCK 1992
Griselda Pollock, *Avant-Garde Gambits 1888–1893: Gender and the Colour of Art History*, London 1992.

PRATHER & STUCKEY 1987
M. Prather and C. Stuckey (eds.), *Gauguin: A Retrospective*, New York 1987. This volume contains translations of many of the original reviews of Gauguin's work and of some of his own writings.

QUEINEC 1983
Bertrand Quéinec, *Pont-Aven 1800–1914*, Bannalec 1983.

QUEINEC 1993
Bertrand Quéinec, *Nizon: Histoire d'une Paroisse Rurale*, 2 vols., Bannalec 1993.

RAPETTI 2002
Rodolphe Rapetti, 'Invention de Symbolisme: Paul Gauguin, Emile Bernard, G.-Albert Aurier', in Christa Lichtenstern (ed.) *Symbole in der Kunst*, Röhrig Universitätsverlag, St. Ingbert 2002.

RAPETTI 2004
Rodolphe Rapetti, 'L'Inquiétude cézannienne : Emile Bernard et Cézanne au début du xxe siècle', *Revue de l'Art*, no. 144, 2004, pp.35–50.

REWALD 1978
John Rewald, *Post-Impressionism: from Van Gogh to Gauguin*, (first published 1956) London 1978.

REWALD 1986
John Rewald, 'Theo van Gogh as art dealer', *Studies in Post-Impressionism*, London 1986, pp.7–116.

ROSKILL 1970
Mark Roskill, *Van Gogh, Gauguin and the Impressionist Circle*, London 1970.

ROTONCHAMP 1925
Jean de Rotonchamp, *Paul Gauguin, 1848–1903*, (first published 1906) Paris 1925.

SADLEIR 1949
Michael Sadleir, *Michael Ernest Sadler (1861–1943), a memoir by his son*, London 1949.

SILVERMAN 2000
Debora Silverman, *Van Gogh and Gauguin: The Search for Sacred Art*, New York 2000.

SIMPSON 1999
Juliet Simpson, *Aurier, Symbolism and the Visual Arts*, Bern 1999.

THOMSON 1982
Belinda Thomson, 'Camille Pissarro and Symbolism: Some Thoughts Prompted by the Recent Discovery of an Annotated Article', *Burlington Magazine*, no.946, vol.cxxiv, January 1982, pp.14–23.

THOMSON 1987
Belinda Thomson, *Gauguin*, London, 1987, 2000.

THOMSON 1993
Belinda Thomson (ed.), *Gauguin by Himself*, Boston and London, 1993, 1998.

THOMSON 2004
Richard Thomson, *The Troubled Republic: Visual Culture and Social Debate in France, 1889–1900*, New Haven and London 2004.

VAN GOGH 1958
Vincent van Gogh, *Complete Letters*, 3 vols., New York and London 1958.

WILDENSTEIN 1964
Georges Wildenstein and R. Cogniat, *Paul Gauguin: 1, Catalogue*, Paris 1964.

WILDENSTEIN 2001
Daniel Wildenstein, *Gauguin: Premier itinéraire d'un sauvage, Catalogue de l'oeuvre peint (1873–1888)*, 2 vols., Paris and Milan 2001.

WILDENSTEIN 2002
Daniel Wildenstein, *Gauguin: A savage in the Making, Catalogue raisonné of the Paintings (1873–1888)*, 2 vols., Paris and Milan 2002.

YONNET & CARIOU 1993
Daniel Yonnet and André Cariou, *Le Finistère des Peintres*, Rennes 1993, 1999.

EXHIBITION CATALOGUES

PARIS 1949
Gauguin: Exposition du Centenaire, Orangerie des Tuileries, Paris 1949.

EDINBURGH 1955
Gauguin, An Exhibition of Paintings, Engravings and Sculpture, Royal Scottish Academy, Edinburgh 1955.

LONDON 1966
Gauguin and the Pont-Aven Group, The Tate Gallery, London 1966.

LONDON 1979
Post-Impressionism: Cross Currents in European Painting, Royal Academy of Art, London 1979.

TORONTO 1981
Bogomila Welsh-Ovcharov, *Vincent van Gogh and the Birth of Cloisonnism*, Toronto, The Art Gallery of Ontario; Van Gogh Museum, Amsterdam, 1981.

NEW YORK 1984
Kirk Varnedoe, 'Gauguin' in *Primitivism in Modern Art*, Museum of Modern Art, New York 1984.

SAINT GERMAIN-EN-LAYE 1985
Le Chemin de Gauguin: genèse et rayonnement, Musée du Prieuré, Saint-Germain-en-Laye 1985.

WASHINGTON / CHICAGO / PARIS 1988
F. Cachin *et al.*, *The Art of Paul Gauguin*, National Gallery of Art, Washington; Art Institute of Chicago; Grand Palais, Paris 1988–9.

LONDON 1989
Gauguin and the School of Pont-Aven, Prints and Paintings, Royal Academy of Arts, London 1989.

PONT-AVEN 1989
Seguin, Musée de Pont-Aven, 1989.

MANNHEIM / AMSTERDAM 1990
Mary Anne Stevens, Fred Leeman *et al.*, *Emile Bernard 1868–1941: A Pioneer of Modern Art*, Städtische Kunsthalle, Mannheim; Van Gogh Museum, Amsterdam 1990.

QUIMPER 1992
L'Imagerie populaire bretonne, Musée départemental breton, Quimper 1992.

ZURICH / PARIS 1993
C. Frèches-Thory and V. Perucchi-Petri, *Nabis, 1888–1900*, Zurich Kunsthaus and Galeries nationales des Grand Palais, Paris 1993–4

LIÈGE 1994
Françoise Dumont *et al.*, *Gauguin: Les XX et la Libre Esthétique*, Musée d'Art moderne et d'Art contemporain de la ville de Liège 1994–5.

SAN DIEGO 1994
Ronald Pickvance, *Gauguin and the School of Pont-Aven*, a touring exhibition coordinated by San Diego Museum of Art 1994.

LONDON 1997
Anna Gruetzner Robins, *Modern Art in Britain 1910–1914*, Barbican Art Gallery, London 1997.

MARTIGNY 1998
Ronald Pickvance, *Gauguin*, Fondation Pierre Gianadda, Martigny 1998.

AMSTERDAM 2000
C. Stolwijk and R. Thomson, *Theo van Gogh 1857–1891. Art dealer, collector and brother of Vincent*, Van Gogh Museum, Amsterdam 2000.

CHICAGO/AMSTERDAM 2001
Douglas Druick and Peter Kort Zegers, *Van Gogh and Gauguin: The Studio of the South*, Art Institute of Chicago and Van Gogh Museum, Amsterdam, 2001–2.

SAINT LOUIS 2001
Cornelia Homburg, *Vincent van Gogh and the Painters of the Petit Boulevard*, Saint Louis Art Museum, 2001.

NEW YORK 2002
The Lure of the Exotic: Gauguin in New York Collections, The Metropolitan Museum of Art, New York 2002.

NEW YORK / DAHESH 2002
G.P. Weisberg, *Against the Modern: Dagnan-Bouveret and the Transformation of the Academic Tradition*, Dahesh Museum of Art, New York, 2002.

PARIS / QUIMPER 2003
Andre Cariou, *L'Aventure de Pont-Aven et Gauguin*, Musée du Luxembourg, Paris; Musée des Beaux-Arts de Quimper 2003.

PONT-AVEN 2003
Catherine Puget & Denise Delouche, *Kenavo Monsieur Gauguin*, Musée de Pont-Aven 2003.

PONT-AVEN 2004
Julian Campbell, *Peintres britanniques en Bretagne 1818–1939*, Musée de Pont-Aven 2004.

MADRID 2004
Guillermo Solana, *Gauguin and the Origins of Symbolism*, Museo Thyssen-Bornemisza, Madrid 2004–5.

Notes and References

PAGES 13–15

1 Aurier 1891.
2 Hamilton Fraser 1969, p.4.
3 Exh. cat. *Art Nouveau 1890–1914.* ed. Paul Greenhalgh, Victoria and Albert Museum, London, 2000, p.75.
4 The reproduction advertised the exhibition *Gauguin and the Origins of Symbolism*. See Madrid 2004.
5 'Le peintre farouche de la Lutte de Jacob avec l'Ange', Rotonchamp 1925, p.177. For details of its sale and ownership history see the essay in this volume by Frances Fowle.
6 Rotonchamp 1925, p.88.
7 See Robert Herbert, *Seurat and the Making of the 'Grande Jatte'*, exh. cat., Chicago, 2004.
8 The sale was held at the Hôtel Drouot on 23 February 1891. See Paris 1949, pp.95–6.
9 Gauguin to Vincent, dated 25–27 September 1888; Merlhès 1984, p.230.
10 Gauguin to Theo, dated to 6 or 7 October; Merlhès 1984, p.247.
11 The list, sent to Octave Maus, secretary of *Les Vingt*, dated December 1888, is in the Archives de l'Art contemporain de Belgique, 5225, Musées Royaux des Beaux-Arts, Brussels.
12 The listing in which he calls it *Apparition* appears in a sketchbook used between 1888–1890. See Huyghe 1952.
13 This manuscript is in the Bibliothèque du Louvre, R.F. Ms. 310.
14 Rewald 1986, p.57. This list could have been sent to Theo van Gogh as a statement of account; alternatively Gauguin may have been asked by the Boussod & Valadon firm to draw it up in October or November 1890, after Theo became too ill to manage his business affairs, since an appended note refers back to earlier arrangements made with Van Gogh and monies he had privately advanced to Gauguin. In this case the list's intended recipient was probably Maurice Joyant, Theo van Gogh's successor.
15 See letter from Mallarmé to Octave Mirbeau, 23 Feb. 1891, in H. Mondor and J-P. Richard (ed.), Stéphane Mallarmé *Correspondance*, vol.IV, Paris 1973, p.201. See also Aurier 1891.
16 Catalogue, Salon d'Automne, 1906, no. 209, *Fuite de Jacob et de l'Ange*, reproduced in R. Cucchi, *Gauguin à la Martinique*, Vaduz-Liechtenstein 1979, p.72.

1 · PAGES 17–23

1 On 26 February 1882 Renoir expressed his refusal to exhibit alongside Pissarro, Gauguin and Guillaumin in a letter to his dealer Paul Durand-Ruel: 'The public doesn't like anything smelling of politics and I have no wish at my age to be a revolutionary. To stay with the Israelite Pissarro is tantamount to revolution.': L. Venturi, *Les Archives de l'Impressionnisme*, I, p.122.
2 Huysmans praised the originality and vehement realism of Gauguin's nude, comparing it to Rembrandt, but felt his landscapes were still mere echoes of those of Pissarro. See Huysmans, *L'Art moderne*, Paris 1883, cited in Berson 1996, vol.I, pp.351–52.
3 Gauguin to Pissarro, August 1882; Merlhès 1984, p.33.
4 Gauguin to Schuffenecker, June 1888; Merlhès 1984, p.181.
5 This stylistic affinity was first pointed out in Roskill 1970, pp.43–5.
6 Although Pissarro and Degas were on good terms in 1880 when both experimented with printmaking, there was no love lost between them and they moved in very different social circles.
7 Armand Silvestre, *La Vie moderne*, 24 April 1880, p.262 ; Berson 1996, vol.I, p.307.
8 Letter to Pissarro, mid-May 1884; Merlhès 1984, p.63.
9 *The Vase of Peonies* was probably painted in Copenhagen as Gauguin dedicated it to his Danish brother-in-law Theodore Gad.
10 Gauguin to Pissarro, 25–9 July 1883; Merlhès 1984, p.51. Full details of Gauguin's picture-buying are given in Bodelson 1970.
11 Letter to Lucien, 31 October 1883; Bailly-Herzberg 2003, I, p.245.
12 Draft of a letter from Gauguin to an unknown Scandinavian recipient, possibly Fritz Thaolow, dated late 1884, quoted in Wildenstein 2001, I, pp.xxx, xxxi.
13 This point is argued persuasively in Burhan 1979, p.66.
14 'La vue seule produit une impulsion instantanée.' His *Notes synthétiques*, drafted in 1885, are in the Hammer sketchbook, National Gallery of Art, Washington D.C.; extracts cited in Guérin 1974, pp.22–6; translated in Prather and Stuckey 1987, pp.59–61.
15 Letter to Mette, 29 December 1885; Merlhès 1984, p.120.
16 Félix Bracquemond, 'Du Dessin et de la Couleur', in *Écrits sur l'art*, Dijon 2002.
17 A full range of the criticism devoted to the eighth Impressionist exhibition can be found in Berson 1996, vol.I, pp.427–74.
18 O. Maus, 'Les Vingtistes parisiens', *L'Art moderne de Bruxelles*, 27 June 1886, pp.201–4. See Berson 1996, vol.I, pp.462–4.
19 J.K. Huysmans, 'Les Indépendants', *Revue indépendante*, no. 6, April 1887, pp.51–57.
20 Letter to Mette, February 1888; Merlhès 1984, p.170. The author raises the possible connection between Gauguin's preoccupation with his two-sided personality and the recent publication of Stevenson's *Dr Jekyll and Mr Hyde* in 'A Frenchman and a Scot in the South Seas: Paul Gauguin and Robert Louis Stevenson', *Van Gogh Museum Journal*, 2003, p.62.
21 Letter from Theo van Gogh to Vincent, 22 December 1889; Van Gogh 1958, III, p.559.
22 For Fénéon's publication of this document in 1887 and subsequent admission it was a fake see Halpern 1970, I, pp.81, 281–2.
23 As a gesture of support, Bracquemond bought a Dieppe landscape from the 1886 Impressionist show. Gauguin went on to paint a view in Sèvres, probably of the Bracquemonds' home, which he dedicated to Mme Bracquemond, herself an accomplished painter; Wildenstein 2001, cat. 195 and 214.

2 · PAGES 25–37

1 Letter to Mette, 19 August 1885; Merlhès 1984, p.111.
2 In both 1885 and 1888 Pont-Aven's population was recorded as 1388 (in parish records in the Archives épiscopal, Quimper). When the register was updated in 1889 the new census showed a population growth to 1516. Each summer the resident population was augmented by around a hundred artists.
3 Cariou 1999, p.27. See also Delouche 1977.
4 For a valuable study of this phenomenon see Lübbren 2001. See also Jacobs 1985.
5 Blackburn 1880, p.130.

6 Verbal communication from Catherine Puget, curator of the Musée de Pont-Aven.

7 Gauguin to Mette, *c.* 25 July 1886; Merlhès 1984, p.133.

8 Henri Cochin in his 'Réflexions sur le Salon de 1888' in *Les Lettres et les Arts*, III, 1 July, 1888, p.99.

9 See Cahn 2003.

10 See footnote 3 above.

11 Guy de Maupassant, 'Au Salon', *Le XIXième Siècle*, 10 May 1886, reprinted in Guy de Maupassant, *Chroniques 3*, Paris 1983, p.254.

12 Hartrick 1939. The consensus of opinion used to be that Hartrick's memoirs, written in a chatty style long after the events he described, were not to be relied upon. Having recently uncovered earlier drafts of the book, Bailey argues that Hartrick is in fact a valuable witness. See Bailey 2001.

13 This is the term Pissarro used at this time to distinguish Seurat's group from the old Impressionists.

14 I am grateful to Fernande Rivet-Daoudal for clarifying these points, and for permission to reproduce an old photograph of the school she attended as a girl.

15 The French word *oie* was used to connote a silly woman, just as in the English expression 'a silly goose'. '*C'est une oie, se dit d'une personne très sotte*': Littré, *Dictionnaire de la langue française*, 1883.

16 Claire Frèches-Thory notes the inscription and suggests Newman may have been an American painter, in Washington/Chicago/Paris 1989, cat. 20, p.92. Quéinec (1983) throws a little more light on Newman, naming him as a friend of Ernest Cutler and James Clunie, who died in 1886. I am grateful to Anne Cowe for this reference and for finding Newman's painting at the 1887 Salon.

17 E. Bernard, 'L'Aventure de ma vie', published posthumously in Cailler 1954, p.13. Gauguin's disdain was probably for the Neo-Impressionist manner Bernard was then experimenting with.

18 Cited in Malingue 1946, p.94, fn. 1.

19 Delouche (1996, p.22) suggests a different sequence of events, seeing the watercolour as a copy of the figure in the painting and dating it, because of the friendly dedication to Bernard, to 1888.

20 Hartrick, 1939, p.33.

21 This curious example dating from Gauguin's first series of ceramic work was published by M. Bodelsen in 'Gauguin Studies', *Burlington Magazine*, April 1967, p.218. Bodelsen reads the shape as a tree.

22 For Theo's visit to Gauguin see Rotonchamp 1925, p.42. For a survey of Theo's role as an art dealer see also Amsterdam 2000.

23 For a recent, highly detailed analysis of their complex relationship see Chicago/Amsterdam 2001.

24 F. Fénéon, 'Vitrines des marchands de tableaux', *La Revue Indépendante*, January 1888, in Halperin 1970, I, p.91.

25 My understanding of the word *grièche* was honed in conversation with Joan Halperin and Anne Distel in September 2004.

26 For a close analysis of Gauguin's changing methods see Jirat-Wasiutyenski and Newton 2000.

27 In a letter to Schuffenecker of 22 December 1888, Gauguin seems to use both meanings of the word when he writes: '*Expliquer en peinture n'est pas la même chose que décrire. C'est pourquoi je préfère une couleur suggestive des formes, et dans la composition la parabole, que le roman peint …*' ; Merlhès 1989, p.241. And later, when explaining his use of veiled meanings, Gauguin evoked the parable of the sower: letter to Morice, July 1901; Malingue 1946, p.302.

28 Laval's letter, written from Martinique, is dated 9 December 1887; see Merlhès 1989, pp.51–4.

29 Rotonchamp 1925, p.177.

30 Letter to Bernard, end October / early November 1888; Merlhès 1984, letter 176, p.270.

31 For instance Bernard's claim that as well as providing for Gauguin the radical cloisonist style of his painting, he had first awakened Gauguin's interest in religious subjects: E. Bernard, 'Mémoire pour l'histoire du symbolisme pictural de 1890', in *Maintenant*, 1919. This claim will be discussed in more detail in Chapter 4.

3 · PAGES 39–59

1 Letter to Mette of *c.* 22 January 1888; Merlhès 1984, p.169.

2 '*Vous êtes parisianiste. Et à moi la campagne. J'aime la Bretagne: j'y trouve le sauvage le primitif. Quand mes sabots résonnent sur ce sol de granit j'entends le ton sourd mat et puissant que je cherche en peinture. Tout celà est bien triste dirait le marsouin, mais à chaque peintre son caractère.*' This letter is published in full with a facsimile of the original manuscript in Merlhès 1989, pp.61–3. C.A.C. Favre was a friend from his sea-faring days.

3 '*C'est d'un triste abstrait et le triste c'est ma corde vous savez*': letter to Schuffenecker of 10 June 1889; Merlhès 1995, p.30. Gauguin was clearly priming his friend to say the right thing when showing Gauguin's work, much of which he still housed, to potential clients. Gauguin wrote in similar vein to his dealer Theo van Gogh.

4 Although Gauguin was described by Fénéon as the initiator of 'Impressionism with literary tendencies' in *Le Chat noir*, 19 September 1891 (Halperin, p.200], the same critic, only months before, charged Gauguin with having had no interest in literature prior to his time in Brittany: 'M. Gauguin returned from there … all in a pseudo-literary (*littératurière*) fervour, he who until then, with the most paradoxical obstinacy, had known nothing of bookshops and ideas generally': 'M. Gauguin', *Le Chat noir*, 23 May, 1891 (Halperin, p.192).

5 '*cependant que quelques-uns des symbolistes ne l'admettent, Gauguin est surtout un peintre de sensations qui, toutes émanent de souvenirs et d'assimilations littéraires ou qui, toutes, correspondent en notre esprit, à certaines réminiscences littéraires. C'est presque – et je ne trouve d'autre mot pour exprimer ma pensée – un peintre philosophe, tristement ironique …*': A. Seguin in *Union Agricole et Maritime*, 11 October 1891 (see Seguin 1989, p.61).

6 *Mon frère Yves*, 1883, *Pêcheur d'Islande*, 1886, and *Le Livre de la Pitié et de la Mort*, 1891. Gauguin's indebtedness to Loti's *Mon frère Yves* is discussed in Amishai-Maisels 1985 and Chicago/Amsterdam 2001, p.96.

7 An indication of the popularity of Loti's books is the fact that a fashionable Parisian periodical could run a spoof of *Mon frère Yves* and expect its readership to get the joke: 'Son frère Yves à Paris' by KLAK, *La Vie Parisienne*, 25 February 1888, p.106.

8 Octave Mirbeau, *Le Calvaire*, Paris 1886. This was Mirbeau's first novel and an immediate success. Mirbeau was already well known to the Impressionists and supported them through his art criticism. Lucien Pissarro, who had already illustrated a short story by the author, hoped to get the job of illustrating *Le Calvaire* but Mirbeau was not in favour.

9 See Joanne 1877; Kano 1886.

10 '*Une connaissance superficielle, si détaillée et minutieuse qu'elle soit, ne saurait suffire. Une photographie n'apprendrait rien. Il faut ici l'œuvre du peintre, qui dégage les traits caractéristiques pour les mettre en lumière, laissant à dessein les autres dans l'ombre. C'est cette œuvre que je voudrais accomplir.*

La Bretagne a un charme intime et étrange qu'on ne saurait comprendre si on ne l'a senti, éprouvé. Elle a surtout le don de parler à l'âme et de lui ouvrir de larges issues sur l'infini': Kano 1886, p.2.

11 For evidence that Brittany was far more advanced agriculturally and economically than the writers and artists supposed see Orton and Pollock 1980.

12 Gauguin, *Bretonne de trois-quarts à gauche*, 1886, private collection, reproduced in Wildenstein 2001, vol.II, p.301. Degas, *Danseuse rajustant son chausson*, oil and sepia on pink paper, private collection, identified in Berson 1996, vol.II, p.35.

13 Letter to Emile Schuffenecker, 14 August 1888; Merlhès 1984, p.210. For the translation see Thomson 1993, p.89.

14 Yvonne Thirion makes a convincing comparison between *The Wave* and a triptych by Hiroshige, in 'L'Influence de l'estampe Japonaise', in *Gauguin, Sa vie, Son oeuvre, documents inédits*, Paris 1958, pp.95–114.

15 Dario Gamboni discusses the head-like profile – possibly a self-portrait – that appears in the water. See his *Potential Images*, London 2002, pp.87–88. One can also detect in the large rock to the left the shape of a cow's muzzle, prefigured in a drawing in the Hammer sketchbook (National Gallery of Art, Washington, ref. 1991.217.51 ab).

16 This composition, painted on two horizontal pieces of wood, appears to represent a number of comestible treats – a *galette bretonne*, pears and

other fruits, and what could be pastries or a pile of orange flowers or tangerines perhaps wrapped in waxed paper – arranged artfully on a circular red lacquer table. It is signed to lower right *Madeleine B.*

17 '*J'adorais le rouge; où trouver un vermillon parfait?*' See 'Natures mortes' in *Essais d'Art Libre*, January 1894.

18 Rotonchamp 1925, pp.56–7.

19 See O. Shigeru, 'Edo *Ukiyo-e* Prints in Works of European Artists', *Daruma*, issue 41, Winter 2004, pp.12–24.

20 Although it is not identical, a diptych print of the right period, type and colouring by Kunichika is reproduced in Wildenstein, *Catalogue raisonné*, II, p.361. Another close match, unfortunately only reproduced in black and white, is the untitled actor print by Kumisada Utagawa (1786–1864) reproduced in G.M. Sugana, *L'Opera completa di Gauguin*, 1972, cat. 119, p.93. I am grateful to Geneviève Lacambre and Professor Oikawa Shigeru for their assistance in trying to resolve this tantalising question.

21 Bernard 1903, p.680.

22 See Quimper 1992.

23 E. Dujardin, 'Aux xx et aux Indépendants. Le Cloisonisme', *Revue indépendante*, n.s. VI, no. 17, March 1888, pp.487–92.

24 Van Gogh 1958, vol.2, Vincent to Theo, T 500, *c.* 5 June 1888, p.590. The tentative datings for these undated letters, unless otherwise stated, follow the carefully considered suggestions of Jan Hulsker in *Vincent van Gogh: A Guide to his Work and Letters*, Amsterdam 1993.

25 Van Gogh 1958, vol.3, Vincent to Bernard, *c.* 18 August 1888, B 15, p.511.

26 The traced drawing showing *The Adoration of the Shepherds* is in the Van Gogh Museum and was discussed by Fred Leeman in the paper he presented at the conference held in Amsterdam, 7–9 March 2002 on 'Bernard, Van Gogh and Gauguin'.

27 This letter was mistakenly dated September 1889 when first published. See Dorra 1980, p.235. Its contents suggest it was sent shortly after Madeleine and her mother left Pont-Aven in 1888. Madeleine asks after the artists remaining in Pont-Aven, including M. Gauguin ('est-il parti, ou va-t-il bientôt partir?'), M. Laval, and '*les*

illustres Dauchons, Jourdan, Wigand, etc.' She refers enthusiastically to Bernard's work – including his new interest, sculpture. She expresses unbounded admiration for Gauguin whose photograph she has just received. She plans to put it in a special embroidered 'Impressionist' frame and, when asked who it is, to tell people: 'the greatest artist of the century'. It was probably in response to this misplaced teenage adulation that Gauguin decided to write Madeleine a letter on 15–20 October (see Merlhès, 1984, pp.256–7), which was intercepted and misinterpreted by her father. He forbade both his children from having any further dealings with Gauguin. Yet when read in the context of Madeleine's letter, Gauguin's seems innocent, as Emile believed it to be. Reading between the lines, Gauguin is urging this young woman on the verge of independent adulthood not to idolise the likes of him, indeed not to raise an altar to anything but her own intellect and honour.

28 Letter from Vincent to Gauguin, 3 October 1888, in Merlhès 1989, pp.107–111.

29 Van Gogh 1958, vol.3, Vincent to Theo, *c.* 21 Aug. 1888, letter 526, pp.18–19. Vincent had sent Bernard fifteen pen-and-ink drawings in exchange for a number of drawings Bernard had sent, and would continue to send, to him.

30 Van Gogh 1958, vol.3, Vincent to Theo, 18 September 1888, letter 539, p.43.

31 Letter of 12 September 1888 to Emile Schuffenecker in Merlhès 1989, pp.87–8.

32 See Van Gogh 1958, vol.3, Vincent to Theo, tentative date *c.* 24 August 1888, letter 527, p.20, for reference to 'painting like children'.

33 Gauguin conjured the image of a similar figure ogling fruit in *Les Fruits* (NW 312) and in his imagined Breton '*pauvresse*', around whom the drama of his Arles painting *Misères humaines* is played out (NW 317).

34 It is not clear where the title *Breton Women in the Meadow* came from. First shown as *Les Bretonnes* at the Volpini exhibition in 1889, Bernard showed the painting at the Salon des Independents in 1892 as *Pardon à Pont-Aven*, a title the present owner feels to be more appropriate to its spirit. However, it should be noted that this change of title occurred after his

quarrel with Gauguin, when Bernard was seeking to underline his picture's priority in terms of form *and* content over the older artist.

35 See MaryAnne Stevens, Mannheim 1990, p.143. The same possibility is raised by B. Welsh-Ovcharov, see Toronto 1981, pp.300–1.

36 Wildenstein 2001, II, p.495.

37 The argument that the mysterious elements of *Vision of the Sermon*'s composition suggest Gauguin's having attended the specific Pardon of Saint Nicodemus, at some considerable distance from Pont-Aven, is unconvincing. See Herban III 1977.

38 Druick and Zegers state 'Gauguin began work on *Vision of the Sermon* upon Bernard's arrival'. See Amsterdam 2001, p.134.

39 See essay by Lesley Stevenson.

40 One should not discount the possibility that some preparatory work relating to *Vision of the Sermon* has been lost. Gauguin was apt to play down his need for preparatory work, falsely claiming later in life that he had completed *Where do we come from?* (1897, Boston Museum of Fine Arts) in a single session.

41 Gauguin to Vincent van Gogh, *c.* 25–7 September 1888; Merlhès 1984, pp.230–2.

42 The interpretation of this absence as a deliberate suppression, on Gauguin's part, of an aspect of his composition that Vincent might have found offensive or overly autobiographical seems hard to sustain. See Gedo 1994, p.72. For the suggestion that Gauguin added the figures after drawing his sketch for Van Gogh see Amishai-Maisels 1985, p.31, and Rapetti 2002, pp.140–1.

43 This likeness was first pointed out in Amishai-Maisels 1985.

44 Gauguin to Theo van Gogh, 7 or 8 October 1888; Merlhès 1984, p.247–8.

45 Gauguin to Schuffenecker, 8 October 1888; Merlhès 1984, p.249.

46 The parallel with Degas was first suggested in Roskill 1970, p.105.

47 See Charles de Couessin, 'Le Synthétisme de Paul Gauguin, hypothèses' in Paris 1991, pp.81–97. For the argument that Bernard may have imitated elements of Gauguin's practice, including drawing on to unprimed canvas, when executing *Breton Women in the Meadow*, see Jirat-Wasiutyenski and Newton 2000, p.103.

48 *Deux petites Bretonnes*, private collection, Photo archives Wildenstein Institute, reproduced Wildenstein 2001, II, p.414.

49 Emile Bernard in 'L'Aventure de ma vie', Cailler 1954, pp.26–7.

50 For evidence that Gauguin used Prussian blue in paintings of 1879 and 1886 see Jirat-Wasiutynski and Newton 2000, pp.40, 76, 102–3.

51 Bernard 1895.

52 The accusation preyed on Gauguin's mind nevertheless. He ironised about his 'debts' to Bernard and Sérusier in letters to de Monfreid, and near the end of his life, his comments about writers' and painters' litigious obsession with their originality undoubtedly relate to his difficulties with Bernard: '*Cette manie qu'ont les hommes de lettres d'aller se chamailler devant les tribunaux pour l'idée première? Et cette manie se communique aux peintres qui soignent leur originalité comme les femmes leur beauté …. Non, mille fois non l'artiste ne naît pas tout d'une pièce. Qu'il apporte un nouveau maillon à la chaîne commencée c'est déjà beaucoup …. Les idées sont comme les rêves un assemblage plus ou moins formé de choses ou pensées entrevues : sait-on bien d'où elles viennent?*' from *Racontars de rapin*, written in 1902. See Merlhès 1994. For evidence that Gauguin drafted a refutation of Bernard's accusation see Dorra 1955.

53 Bernard 1903; Bernard 1919; Bernard 1939.

54 For a recent analysis of Bernard's art and art criticism see Rapetti 2004.

55 Paul Gauguin, *Lettres à G.-D. de Monfreid, précédées d'un hommage par Victor Segalen*, Paris 1919.

56 A red field of ripe buckwheat makes a dramatic background for the nude in Gauguin's last important Breton composition before his departure for Tahiti, *The Loss of Virginity*, 1890–1, The Chrysler Museum, Norfolk, Virginia.

57 Dorra (1955) quotes a previously unpublished document left among Gauguin's papers which was presumably intended as a refutation of Bernard's accusation. In it he refers to the lessons he gave Bernard in wood carving, a skill which Bernard went on to exercise in a series of pieces of furniture.

58 In her letter to her brother, redated by the author to October 1888, Madeleine

Bernard asked, '*Travailles-tu toujours avec acharnement à la sculpture? Es-tu content de ton travail ?*' See Dorra 1980, p.235.

59 In taking the canvas to the South, Gauguin was not appropriating it for himself – it was later returned to Bernard – but responding to Vincent's requests to see Bernard's latest Breton work. Van Gogh's watercolour copy is in the Civic Gallery of Modern Art, Milan.

60 Denise Delouche underlines the irregularity of Gauguin's stylistic 'advances' in her recent article 'Bretagne et Martinique, Deux étapes capitales pour Gauguin', *ArMen*, no. 143, Nov/Dec 2004, pp.54–61.

61 Letter to Bernard of c. 9–12 November 1888; Merlhès 1984, p.274.

4 · PAGES 61–75

1 See McMillan 2003 and Thomson 2004, chap. 3.

2 A. Lebon and P.Pelet, *France As It Is*, Paris 1888, p.123. The authors, professors at the Ecole des Sciences Politiques in Paris, saw it as their mission to present a modernising picture of France.

3 An alarmist article on hypnotism – digest of a longer article by Dom Benoît from the *Revue du monde catholique* – appeared in *La Semaine religieuse*, no. 43, 26 October 1888, p.719.

4 According to *La Semaine religieuse*, over 100,000 took part in the pilgrimage to the Crowning of Notre-Dame de Folgoet in northern Brittany in September 1888.

5 In 1885 Nizon's population was recorded as 1389, but this figure was amended to 1460 in 1889 when a new census was taken. Pont-Aven's went from 1388 in 1885 to 1516 in 1889.

6 See Quéinec 1993.

7 '*Au milieu des gaies toilettes, soi-même un peu parée, on jouit à laisser bercer sa rêverie par les éclats de l'orgue et le chant grave du prêtre, le corps dans une quiétude bien gagnée.*': Kano 1886, p.117.

8 '*C'est dans l'église, à l'heure où l'ombre s'abat des hautes voûtes, que l'âme s'épanche en des plaintes à peine murmurées, dans les longues invocations de la prière; c'est là qu'elle vient se retremper pour les douleurs et les luttes du lendemain*': Kano 1886, p.126.

9 See essay by Per Denez, 'Le Barzhaz Breizh et la Renaissance bretonne', in Théodore de la Villemarqué, *Le Barzhaz Breizh*, Spézat 2003.

10 R. Rosenblum uses this category to describe paintings depicting rural faith by such realists as Legros, Ribot, Bonvin and Dagnan-Bouveret in *Paintings in the Musée d'Orsay*, New York 1989, p.132.

11 In Flaubert's short story *Un Coeur simple* (1877), the simple-minded heroine Félicité confuses a stuffed parrot with the holy ghost. Maupassant's short story *Les Sabots*, one of his *Contes de la bécasse* (1883), begins with a sardonic description of a rural sermon delivered by an old *curé* to a herd-like congregation of white-bonneted peasant women.

12 Baudelaire, whose art criticism was undoubtedly read by Gauguin, greatly admired Legros's earlier painting of village piety, *L'Angelus*, exhibited at the Salon of 1859.

13 See entry on the painting by D. Lobstein, in *Des Amitiés Modernes : De Rodin à Matisse : Carolus-Duran et la société nationale des beaux-arts, 1890–1905*, exh. cat., Paris, 2003, p.48.

14 See M. Orwicz, 'La Bretagne pieuse à travers le discours de la critique', in *Arts de l'Ouest Bretagne. Images et mythes*, Rennes 1987.

15 See for instance his *Wedding at the Photographer's*, 1878–9, Musée des Beaux-Arts, Lyons, and *The Vaccination*, 1882, present whereabouts unknown. repr. New York/Dahesh 2002, p.65.

16 Gauguin to Emile Schuffenecker, 12 September 1888; Merlhès 1989, p.87–9. Merlhès interprets Gauguin's phrase '*tailleurs en peinture*' as a criticism both of the naturalists' confected studio methods and of their laborious work on costumes. Gauguin's puzzling phrase '*à défaut de peinture religieuse*' is probably a reference to earlier exchanges; while acknowledging what he was painting at the time, it shows an awareness that neither Schuffenecker – nor indeed Van Gogh – felt comfortable with the religious genre.

17 See D. Delouche, 'Gauguin et le thème de la lutte', in Paris 1991, pp.157–71.

18 For a recent informative account of this subject see Kerdraon 2004.

19 Adolphe Jean Lachaud's twentieth-century woodcut entitled *Lutte bretonne* shows wrestling taking place in the same field as the dancing in Gauguin's painting. I am grateful to Catherine Puget of the Musée de Pont-Aven for pointing this out.

20 The important role of such onlookers, some of whom climbed into the trees, is described by de la Villemarqué in his Introduction to *Le Barzhaz Breizh*, Spézet 2003, pp.95–7.

21 For a detailed study of the influence of Gauguin's religious education see Silverman 2000.

22 '*Trois siècles d'analyse ont amassé des matériaux immenses. Une synthèse universelle est devenue nécessaire et se prépare. Déjà elle jette des clartés merveilleuses sur l'accord des sciences en général, et de toute science avec la foi.*' '*C'est donc à Lui, mes chers enfants, qu'appartient toute la gloire du bien qui s'est fait dans vos esprits et vos coeurs. C'est Lui qui doit être le véritable triomphateur en ce jour*': *Discours prononcé à la distribution solennelle des prix du Petit-Séminaire d'Orléans par M. Hetsch*, Orléans 1864, pp.7–8.

23 See Bernard 1904, pp.9–10. Bernard later returned to the story in 1939.

24 Sérusier's meeting with Gauguin, to whom he was introduced by Bernard, can be dated to around 15 October 1888, when he was due to leave for Paris in time for the start of the new academic term. According to most accounts he left immediately after the lesson from Gauguin in the Bois d'Amour which resulted in the *Talisman*. Gauguin left for Arles on 21 October. Sérusier's brief account of the walk to Nizon is first recounted in Chassé 1921, p.25, 66–67. It is difficult to understand why, if he was of the party, this is the only mention of the fact, and why Bernard insists that there were just three of them, Gauguin, himself and Laval. An unexplained fragment purporting to be by Sérusier and giving a longer account of events is reprinted in Paul Sérusier, *ABC de la peinture, suivi de fragments de letters …*, La Rochelle, 1995, p.65–6. However the wording is identical to that found in Bernard 1939.

25 Bernard 1904. Although several of the wooden statues that adorned the church in Gauguin's time are still in situ (*St Michel terrassant le dragon; St Amet; Notre-Dame de Nizon*), as is a sixteenth-century painting *Descent from the Cross*, it is hard to say precisely where Gauguin might have wished to place his picture since the church has been completely rebuilt since his day. Perhaps he tried it above the west entrance or the south-facing door, reached through a Gothic porch.

26 Orton and Pollock 1980, pp.338–9. Part of their argument is that Gauguin later referred to it as 'quasi-religious' in a letter to Daniel de Monfreid, 7 November 1891. See Joly-Ségalen 1950, p.52. However Gauguin's letter is ambiguous and he could be referring to other paintings of a somewhat religious character bought by painters at his auction.

27 Richard Kendall has suggested that Degas's new interest in the expressive and emotional use of colour around 1890 may have been a response to exchanges of ideas with Gauguin (conversation with the author, 28 November 2004).

28 '*Delacroix, lac de sang, hanté des mauvais anges, Ombragé par un bois de sapins toujours vert …*' translation by Francis Scarfe in *Baudelaire*, Harmondsworth 1964, p.162.

29 See A. Retté, essay on 'Le Décadent', 1897. '*M. Gauguin, ayant l'intention de représenter la lutte de Jacob et de l'Ange, enduisit de rouge vif le gazon de la plaine où se passait le combat. On ne peut se figurer tout ce que signifiait, selon M. Gauguin, ce gazon flamboyant ! De même, qui saura jamais tous les symboles qu'évoque à M. Mallarmé ce vers absolument dépourvu de sens : Trompette tout haut d'or pâmé sur les vélins ?*'

30 M. Denis, 'L'Influence de Paul Gauguin', *L'Occident*, no. 23, October 1903, pp.160–4, republished in Bouillon 1993, pp.73–80.

31 In a twelfth century bas-relief of the Jacob theme at Modena Cathedral, the angel is represented as a demon.

32 See Louis Réau, *Iconographie de la Bible, Ancien Testament*, Paris 1956–7, II, pp.150–2.

33 Baudelaire, whose aesthetic philosophy coincided in many particulars with Gauguin's, consistently championed the art of Delacroix. His article praising the Saint-Sulpice murals, for which Delacroix thanked him, appeared in 1861.

34 I am grateful to Richard Thomson for pointing out this coincidence.

35 P. Baudry, *La Lutte de Jacob et de l'ange*, 1853, Musée d'Art et d'Archéologie, La Roche-sur-Yon; L. Leloir, *La Lutte de Jacob avec l'Ange*, 1865, Musée d'Art, Clermont-Ferrand.

36 Gauguin admired Moreau but with reservations. He criticised him for being too dependent on literary inspiration, too much of an illustrator who overburdened his compositions with too much surface detail. By contrast he admired Odilon Redon's ability to conjure up dream images in a way that convinced one of their logical reality. He explored his views on Moreau and Redon in a draft response to Huysmans' *Certains*, published in 1889; cited in Guérin 1974, p.61.

37 Quoted from *Assembleur de Rêves*, p.125. See also Geneviève Lacambre, exh. cat., *Gustave Moreau e l'Italia*, Rome, 1996.

38 E. Souvestre, *Les Derniers Bretons*, Paris 1866, pp.233–6.

39 I am grateful to Guillermo Solana for this reference.

40 '*Il sentait indistinctement que le pardon de ce prêtre était le plus grand assaut et la plus formidable attaque dont il eût encore été ébranlé … que la lutte, une lutte colossale et définitive, était engagée entre sa méchanceté à lui et la bonté de cet homme*'; translation by Norman Denny, *Les Misérables*, Harmondsworth 1982, p.116.

41 Emile Zola, *L'Oeuvre*, Paris 1886; quoted from T. Walton's translation, *The Masterpiece*, Ann Arbor 1968, p.248. The possible relevance of this passage for Gauguin was first pointed out in Chicago/Amsterdam 2002, p.137.

42 See Merlhès 1989, pp.92–6.

43 Letter to Schuffenecker, *c.* 23 November 1888, in Merlhès 1984, pp.290–1.

44 '*Il fallait pour celà se livrer corps et âme à la lutte lutter contre toutes les écoles (toutes sans distinction) non point en les dénigrant mais par autre chose, affronter non seulement l'officiel mais encore les impressionistes, les néo-impressionistes; l'ancien et le nouveau public*': Gauguin in *Racontars de rapin*. 1902, See Merlhès 1994, ms. p.26.

5 · PAGES 77–89

1 Letter to Theo, *c.* 7 October 1888; Merlhès 1984, p.247.

2 See letters to Bernard of *c.* 4 November and *c.* 9–12 November 1888; Merlhès 1984, pp.269 and 274. For further details of this consignment see the essay in this volume by Frances Fowle.

3 For the full text of this letter from Gauguin to Schuffenecker of 22 December 1888 see Merlhès 1989, pp.238–43.

4 For the relevance to the Symbolist aesthetic of contemporary theories about hypnosis and Charcot and Bernheim's experiments into second sight, mesmerism, magnetism and other psychic phenomena see Burhan 1979, pp.39, 316.

5 In his letter to Bernard of *c.* 9–12 November 1888 Gauguin expresses immense satisfaction at the reception of his 'Pont-Aven studies' in Paris, especially from Degas. However *Vision of the Sermon* would not yet have arrived in Paris for in this letter he assumes Bernard is about to leave Pont-Aven; Merlhès 1984, p.274. In late 1889, Degas seems to have expressed caveats about Gauguin's pursuit of religious themes.

6 Maus would make Degas's enthusiasm clear at the end of his review of *Les Vingt*: 'Not one of them [Gauguin's paintings] has been understood by the public which is a guarantee [of their quality]. They are all praised by Degas, which must greatly console the painter for the ironic echo of the reviews reaching his ears; *Aucune n'a été comprise du public ce qui est une gurantie. Toutes sont louées par Degas, ce qui doit singulièrement consoler le peintre des appréciations dont l'écho ironique lui sonne aux oreilles*': *La Cravache parisienne*, no. 410, 2 March 1889, p.1, cited in Liège 1994, p.16.

7 Letter to Octave Maus, dated last week of November; Merlhès 1984, p.291.

8 Letter to Schuffenecker, *c.* 23 November 1888; Merlhès 1984, p.290.

9 For a comprehensive account of Gauguin's various contributions to the Brussels exhibitions see Liège 1994.

10 In the list of pictures for the Brussels exhibition which he drew up in a sketchbook whilst in Arles Gauguin refers to the painting as *Apparition*. See Huyghe 1952, pp.72-3.

11 Letter from Gauguin to Schuffenecker, 22 December 1888; Merlhès 1989, pp.238–43.

12 The reviewer for *L'Indépendance belge*, 10 February 1889, laments the fact that such diverse and talented painters as Van Rysselberghe, Toorop and Van de Velde have voluntarily straitjacketed themselves in this method, and renounced the variety of touch that formed one of the attractions of the Flemish school.

13 Unidentified reviewer in *Soir*, 31 January 1889.

14 *La Gazette*, 2 February 1889; Liège 1994, p.16.

15 O. Maus, '*C'est devant la douzaine de toiles qu'il aligne … l'incessant bourdonnement de la bêtise humaine montant, parfois, jusqu'aux éclats de rire …. l'on infère d'une Vision du Sermon symbolisée par le combat de Jacob et de l'Ange luttant sur un pré vermillon que l'artiste a voulu se moquer outrecuidamment des visiteurs*': see footnote 6 above.

16 The affinity is noted in the exh. cat. *Henry van de Velde*, Antwerp and Otterlo, 1987–88, pp.174–5.

17 This possibility is raised in a letter of 1 October 1888 to Sérusier from his mother: unpublished document, Getty Archives no. 860131.

18 *Christ Orange* is a study for a slightly larger painting, *Offrande au Calvaire* (32 × 23.5 cm, private collection), in which the forms are more firmly outlined.

19 Gilles Genty has interestingly suggested that Ranson's syncretic ideas about religion may have been stimulated by the displays exploring eastern religions at the 1889 Universal Exhibition. See *Paul Élie Ranson*, exh. cat., Musée départemental Maurice Denis 'Le Prieuré', Saint-Germain-en-Laye, 1997, p.52. The same was true of Gauguin, who bought photographs at the exhibition of Javanese Buddhist temples.

20 Letter from Denis to Sérusier, dated erroneously 1891, in fact 1890, in Sérusier, *A.B.C.de la peinture*, 1950, p.49.

21 This oft-quoted proposition constitutes the opening of Denis's '*Définition du néo-traditionnisme*', published in *Art et critique* over two consecutive issues, on 23 and 30 August 1890.

22 Maurice Denis, *Bretonnes dans un pré*, *c.* 1894, oil on canvas, 38 × 46.5 cm. Present whereabouts unknown.

23 Bernard 1904, pp.9–10.

24 Had Gauguin gathered something of the reticence Theo was now expressing about his recent work? For instance Theo wrote to Vincent shortly after receiving a consignment of pictures that included *Green Christ* and perhaps *Landscape with Two Breton Girls*: '…there are many more reminiscences of the Japanese, the Egyptians, etc. As far as I am concerned I prefer to see a Breton woman typical of the region to a Breton woman with the gestures of a Japanese woman': Letter from Theo to Vincent, 22 October 1889, Van Gogh 1958, vol.3 T 19, p.555.

25 Letter from Gauguin to Theo, 20 or 21 November 1889. See Cooper 1983, pp.163–4.

26 The effectiveness of Gauguin's press campaign is analysed in Kearns 1989, p.3.

27 Letter from Camille to Lucien Pissarro, 13 May 1891, in Bailly-Herzberg 1988, vol.3, p.81.

28 Cited in Amishai-Maisels 1985, pp.39–40.

29 Letter of 10 February 1891, in P.Michel (ed.), *Lettres de Gauguin à Mirbeau*, Rheims 1992, pp.17–18. The Parnassians were a generation of French poets who had reacted in mid-century against Romanticism; their watchwords were impersonality, formal perfection and the idea of art for art's sake.

30 Letter from Mirbeau to Claude Monet of 22 January 1891; Michel and Nivet 1990a, pp.114–16.

31 Letter from Mirbeau to Monet of *c.* 10 February 1891; Michel and Nivet 1990a, p.118.

32 Mirbeau's article for *L'Echo de Paris*, which appeared on 16 February 1891, was reused a week later by Gauguin as the preface of his sale catalogue. It is translated in Prather and Stuckey 1987, pp.136–47.

33 Octave Mirbeau, 'Paul Gauguin', in *Le Figaro*, 18 February 1891, as translated in Prather and Stuckey 1987, pp.147–50.

34 Aurier 1891, translated in Prather and Stuckey 1987, pp.150–6.

35 M. Denis in a footnote to 'De Gauguin et de Van Gogh au Classicisme', *L'Occident*, May 1909, reprinted in Bouillon 1993, pp.155–74.

36 This strategy consciously recalled Verlaine's earlier sequence of articles, begun in 1883, promoting 'Les Poètes

maudits'. Aurier's article entitled 'Les Isolés – Van Gogh' appeared in January 1890 in the first issue of the revived journal *Mercure de France*. Van Gogh objected to being thus isolated from his contemporaries, insisting upon his debts to others. For the argument that this anti-Tainean idea of the artist's isolation from his age (in the sense that he transcends it through art) was central to Aurier's aesthetic see Simpson 1999, pp.118–21.

37 For a fuller discussion of Pissarro's objections to Aurier's article see Thomson 1982.

38 Letter from Camille to Lucien Pissarro dated 20 April 1891, in Bailly-Herzberg 1988, vol.3, p.66.

39 It is no coincidence, given the vehemence of Pissarro's reaction, that the first moves in a *rapprochement* between Church and State – the start of the Catholic *Ralliement* – had just been indicated by a speech given in November 1890 by Cardinal Lavigerie. See Thomson 2004, pp.117–20.

40 Letter from Gauguin to Bernard of October 1890 : '*Le coup de folie de Van Gogh est un sale coup pour moi*': Malingue 1946, p.233.

41 This took place on 23 February 1891. For further details see the essay by Frances Fowle.

42 For Schuffenecker's tortuous letter of 7 February 1891 telling Gauguin he is no longer welcome as a guest, although he is prepared to continue harbouring Gauguin's works, see Rewald 1978, pp.432–3.

43 Jules Antoine, 'Impressionnistes et Synthétistes' in *Art et Critique*, no. 24, 9 November 1889, p.370.

44 G.-Albert Aurier, 'Monticelli: Gauguin' in *La Revue indépendante*, March 1891, p.422.

45 Letter from E. Bernard to Schuffenecker from Couilly, 19 January 1891 (not 1892), published by J.-J. Luthi as '7 lettres d'Emile Bernard à Schuffenecker' in Delouche 1986, pp.168–9.

46 E. Bernard, 'Paul Cézanne', *Les Hommes d'aujourd'hui*, vol.8, no. 387, 1890; 'Vincent van Gogh', *Les Hommes d'aujourd'hui*, vol.8, no. 390, 1890. Schuffenecker's article on Bernard for the same series remained unpublished. See Mannheim 1990, Appendix A, pp.376–7.

47 F. Fénéon, 'M. Gauguin', *Le Chat noir*, 23 May 1891, reprinted in Halperin 1970, vol.2, pp.192–3, translated in Prather and Stuckey 1987, pp.157–8.

48 Letter from Mirbeau to Camille Pissarro of 16 December 1891, Michel and Nivet 1990b, pp.77–9.

49 A. Aurier, 'Les Symbolistes', in *Revue encyclopédique*, 1 April 1892, pp.475–87, reprinted in Aurier 1995, pp.95–110.

6 · PAGES 91–9

1 In 1889 Gauguin introduced an angelic messenger into his painting of *Joan of Arc* (Private Collection), part of the frescoed decoration of the inn at Le Pouldu. In 1891 he painted a Tahitian version of the Angelic Salutation, *Ia Orana Maria* (Metropolitan Museum of Art, New York).

2 Hamilton Fraser 1969. Although dated, this essay still has merit, throwing the net wide where Gauguin's pictorial and literary sources of inspiration are concerned. But there are chronological errors, and arguably the importance of esotericism and of Bernard's intellectual impact upon Gauguin is overplayed, that of Van Gogh underestimated.

3 See Pollock 1992. For a charged reading of this painting see Mario Vargas Llosa's biographical novel *The Way to Paradise*, London 2003.

4 E. Parry Janis, reviewing R. Thomson, *Degas: The Nudes*, in *Burlington Magazine*, April 1990, p.280.

5 Lacombe appears in a group photograph posed in Gauguin's studio, together with Annah the Javanese, Gauguin's mistress at the time.

6 The first person to coin this label – somewhat misleading since it never denoted more than a loosely connected set of ideas and precepts – seems to have been the painter Maxime Maufra, the assumed author of an anonymous letter entitled 'Gauguin et L'École de Pont-Aven,' published in *Essais d'Art Libre*, November 1893, pp.164–8. A more recent attempt to establish a school was made in 1939 when *The Pont-Aven School of Painting* was founded by British painters Willliam Scott and Geoffrey Nelson but its chances of survival were scuppered by the Second World War. Today the spirit of artistic experiment engendered in the 1880s is carried forward by the American-run Pont-Aven School of Contemporary Art, established in 1993 by Caroline Boyle-Turner.

7 See M. Supinen, 'Gauguin's Fiji Academy', *Burlington Magazine*, April 1990, no.1045, vol.CXXXII, pp.269–71.

8 I am grateful to Philippe Le Stum for drawing my attention to this image.

9 Gauguin's confident used of untextured fields of flat colour was one point of departure for Henri Matisse in works such as *The Red Studio*, 1912 (Museum of Modern Art, New York).

10 See London 1997, pp.52–3. For further details about Sadler's purchases and growing interest in Gauguin, see the essay in this volume by F. Fowle.

11 Bonnard's words in an interview with Raymond Cogniat, cited by A. Terrasse, in *Bonnard*, Paris 1988, p.15. See p.303 of the same publication for a colour photograph of the artist's studio taken by Alexander Liberman a few months after Bonnard's death in 1947. I am grateful to Antoine Terrasse for this clarification.

12 A detail showing the two wrestlers – whose spiritual struggle was appropriate to the themes of the poems – appeared as the cover of Geoffrey Hill, *Collected Poems*, Harmondsworth, 1985. I am grateful to Rupert Thomson for this reference. The image is used on the cover of a colouring book, *Ça s'est passé à Pont-Aven*, published by the Musée de Pont-Aven in 2000. The French post office reproduced the painting as a stamp to mark the centenary of the artist's death in 2003.

FOWLE · PAGES 101–9

1 J. Rewald, 'Theo Van Gogh, Goupil and the Impressionists', *Gazette des Beaux-Arts*, 1973, pp.30–1. This article is reproduced in Rewald 1986, pp.7–116.

2 '*Je compte que vous serez content des tableaux de Pont-Aven, le plus important viendra avec Bernard – Peut-être quelques-uns sont bien exécutés mais je crois cependant qu'ils sont très réfléchis et voulus tels – Quant à dire qu'ils sont vendables je ne sais …*'; Merlhès 1984, no.175, p.266.

3 Van Gogh 1958, vol.3, Letter 559, p.99.

4 Dupuis acquired W237 on 22 October 1888. He also bought W282 in November 1888 and W227 in December 1888. The references are to Wildenstein 2002.

5 For information on Clapisson see Distel 1989, p.167.

6 R. Thomson, 'Theo van Gogh: an honest broker', in Amsterdam 2000, p.137.

7 Rewald 1973, p.33.

8 Mentioned in a letter dated 13 November 1888 from Theo van Gogh to Gauguin. See M. Bodelsen, 'An Unpublished Letter by Theo van Gogh', *Burlington Magazine*, June 1957, p.200.

9 Letter from Gauguin to Theo van Gogh, written at Pont-Aven on 7 or 8 October 1888; Merlhès 1984, no. 167, p.247.

10 These included the writer Félicien Champsaur, who offered to buy it for a low price in exchange for a promotional article. It eventually sold to Montandon, a stockbroker friend of Gauguin. See Wildenstein 2002, vol.II, p.415.

11 '*Plus l'expression de moi-même que le dessin des petites filles*': letter to Emile Bernard, written in the third or fourth week in November 1888; Merlhès 1984, no.182, p.284.

12 Sketchbook in the collection of the Israel Museum, Jerusalem (Sam Salz donation 1972), edited by René Huyghe, Paris 1952, pp.72–3.

13 According to a handwritten list of works on deposit with Boussod & Valadon c. 1890. Among the No.30 canvases (92 × 73cm) is listed '*Femmes en prière et lutte d'anges. 600*'. The list is reproduced in Rewald 1973, p.49.

14 J. Huret, *L'Echo de Paris*, 23 February 1891, p.2.

15 Cat.no.25, auctioneer's book, no.6. The auctioneer's list is reproduced in Paris 1949, pp.95–6.

16 The auction was attended by the poet Stephane Mallarmé, who was delighted with the outcome and reported to Octave Mirbeau: 'I have just left the Hotel des Ventes. It was very satisfying. The pictures sold, on average, for 250 to 400 and some (including Jacob and the Angel, 900] went for more than that.' S. Mallarmé, *Correspondances*, ed. H. Mondor and L.J. Austin, Paris 1959–85, vol.IV, p.201, no.MLXV.

17 I am grateful to Isabelle Cahn for providing me with information on Meilheurat des Prureaux.

18 Gauguin 1930, no.XVI, p.34. This letter

is wrongly dated September 1893 in this edition and was more probably written in February 1894, after a visit to *La Libre Esthétique* in Brussels. I am grateful to Belinda Thomson for pointing out this reference.

19 Cat.no.43, auctioneer's book, no.41. The auctioneer's list is reproduced in Paris 1949, p.98.

20 According to Vollard's diary for 15 Feburary 1910, he bought three works by Gauguin from Mme Meilheurat: '*Acheté et payé à Madame Meilheurat des Pruraux 3 Gauguin pour la somme de neuf mille francs*'. The entry reads as follows: '*Lutte de Jacob et de l'ange … 6,000 francs; pastel … 1,000 francs; Marine […illegible] … 2,000 francs*': MS 421 (5,5), agenda 1910, Vollard Archives, Musée d'Orsay, Paris. I am grateful to Isabelle Cahn for providing this reference.

21 Anna Robins has identified the majority of paintings by Gauguin at this exhibition. See London 1997, pp.186–7.

22 Bullen 2003, p.3.

23 For the critical reaction to Gauguin at this time, see Robins 1997, pp.28–30 and Bullen 2003, pp.3–12.

24 W455, *Te Nave Nave Fenua (Terre délicieuse)*, bought from the *Vente Gauguin*, 18 February 1895 (cat.no.18) for 500 francs and W456, *Two Tahitian women on the Beach*, which was a gift from Gauguin to O'Conor. The references in this case are to Wildenstein 1964.

25 London 1997, p.9.

26 Sadleir 1949, p.196

27 *Ibid*., p.229.

28 *Ibid*., p.227.

29 *Ibid*., p.32.

30 *Ibid*., p.227

31 *Ibid*., p.397.

32 *Ibid*., p.232.

33 *Ibid*.

34 'I urged him (following up Michael's previous suggestion to him) to have next November a small carefully selected exhibition of fine pictures by Gauguin and Cézanne at his Gallery': from Sadler's personal notes, Tate Gallery Archive, ref: 8221.5.23. See also Robins 1997, p.52.

35 Sadler's personal notes, Tate Gallery Archive, ref: 8221.5.23

36 *Ibid*.

37 Letter from Druet to Sadler, 21 October 1911, Tate Archive, ref 8221.6.82. The pictures are listed as '*Le Calvaire*', '*Le Cheval Blanc*', '*Le group de*

Tahitiennes avec un chien' and '*Personnages allaitant un Bébé*'.

38 See catalogue of 'Exhibition of Pictures by Paul Cézanne and Paul Gauguin'. Cézanne's *La Maison abandonnée* was cat.no.5, *Christ in the Garden of Olives* was no.20 and *Manao tupapau* no.22.

39 Wildenstein, no.475. The reference to this consignment appears in Vollard's diary for 17 November 1911 as follows: '*Remis à Mr Dollfus* [?] corporated Londres [?] Gauguin lutte Jacob et l'ange … 18,000 Bretons … 9,000 Cueillette … 1,000 I am grateful to Isabelle Cahn for providing this reference.

40 Michael T.H. Sadler, 'L'Esprit Veille', *Rhythm*, vol.I, no. 3, Winter 1911.

41 Vollard Archive, 1912 diary, Monday 11 March: 'Nevill 15,000 fr cheque received in payment of the painting by Gauguin 'Jacob and the Angel', as cited in Wildenstein 2002, vol.II, p.476

42 London 1997, p.191.

43 Sadleir suggests this picture was bought by Sadler in October 1911. Madeleine Korn has tentatively identified this work as *Parau na te Varua ino (Paroles du Diable)* c.1892 (Öffentliche Kunstsammlung, Basel, Kupferstichkabinett). See Madeleine Korn, *Collecting Modern Foreign Art Before the Second World War*, unpublished PhD thesis, University of Reading 2001, vol.I, pp.144–5. Sadler lent this picture to the Gauguin exhibition at the Leicester galleries in July 1924 and to the Kunsthalle in Basel in 1928.

44 Sadler's personal notes, Tate Gallery Archive, ref: 8221.5.23.

45 London 1997, p.55.

46 For information on Rutter, Sadler and the Leeds Art Club, see Michael Paraskos, 'Herbert Read and Leeds', in Benedict Read and David Thistlewood (eds.), *Herbert Read: A British Vision of World Art*, London 1994, pp.25–33.

47 London 1997, p.117. See also Susan Drees, *Urban Enlightenment? Northern Collectors and a Loan Exhibition of Post-Impressionism, Leeds 1913*, unpublished BA dissertation, University of Leeds, 1995.

48 Letter from Rutter to Sadler, 4 Sept 1913, Leeds City Art Gallery Archives.

49 London 1997, p.120.

50 *Ibid*.

51 'Ion' on 'Some Phases of Modern Art III: Post Impressionism', *The Scots*

Pictorial, 6 September 1913, p.573.

52 See F. Fowle and B. Thomson, *Patrick Geddes: the French Connection*, Oxford 2004, pp.31–3 and 52–60.

53 Nous sommes invités à Bruxelles, probablement aussi à Glascow [sic]. Il serait donc d'un grand intérêt pour nous d'avoir plusieurs expositions l'année 88 …' Merlhès 1984, no.138, p.168. I am grateful to Belinda Thomson for pointing out this reference.

54 'Impressionists in Glasgow', *The Scots Pictorial*, 8 November 1913, p.116.

55 'Impressionists in Glasgow – Second Notice', *The Scots Pictorial*, 15 November 1913, p.154.

56 S. Cursiter, *Looking Back: A Book of Reminiscences*, privately published, Edinburgh 1947, p.44; see also Robins 1997, p.184.

57 The RGI exhibition ran from 22 September to 15 November 1913.

58. Cutting from the *Herald*, 17 November 1913.

59 M. Korn, 'The Davies Sisters in Context', Appendix 4 ('Collectors of Post-Impressionist Art in Britain 1888–1918'), *Journal of the History of Collections*, vol.16, no.2, 2004, p.218.

60 John House, *Impressionism for England. Samuel Courtauld as Patron and Collector*, London 1994, p.94.

61 He bought the former from the Leicester Galleries and the latter from Reid & Lefevre. He soon returned the still life (in under a week) and it was bought by Mrs Workman.

62 Korn 2001, p.158. Letters from Sadler to Courtauld are in Trinity College Library, Cambridge, refs. RAB D29/27.

6 F. Fowle, *Alexander Reid in Context: Collecting and Dealing in Scotland in the late 19th and early 20th centuries*, unpublished PhD thesis, University of Edinburgh 1993, vol.I, p.287.

64 *Daily Record*, 7 July 1924.

65 Reported in the *Glasgow Citizen*, 10 July 1924. According to Reid's stockbook (Lefevre Fine Art), Glasgow Corporation acquired the woodcuts for £35 on 31 July 1924 (against an asking price of £42).

66 Between 1925 and 1929, in order to fund such investments – most of which were made in the late 1920s and 1930s when the art market was severely depressed – he sold *Vision of the Sermon*, *Poèmes Barbares*, *Manao tupapau*, *Self-Portrait with Idol* and the pastel study for *The Devil's Words*

(Paroles du Diable).

67 National Gallery of Scotland Board Minutes, vol.IV, p.28, 21 January 1925.

68 Quoted in letter dated 27 January 1925, from James Paterson to Caw. Picture file, National Gallery of Scotland. In the same letter Paterson states, 'The National Gallery price to the Society of 8 is £1250. I thought it best to leave you to make the announcement to the press, which perhaps you will do as soon as possible, as it will be a good advt. for the few remaining days of our show.'

69 Letter dated 28 January 1925 from Caw to Paterson, National Gallery letter book.

70 Letter dated 29 January 1925 from Paterson to Caw, National Gallery picture file. Paterson writes: 'I am in receipt of your letter of yesterday offering on behalf of the National Gallery of Scotland, the sum of Eleven Hundred and Fifty pounds for the picture by Gauguin "Vision After the Sermon", as present in the Exhibition of the Society of 8. At a meeting of the Society, held here today, it was unanimously decided to accept the offer, as already intimated by telephone. I have been asked to say that the Commission charged on sales in present exhibition is 20%, but in consideration of the distinction of the picture, the Society is satisfied with your Board's offer of £1150, Sir Michael Sadler, the seller, to receive £1100, as agreed to by him …. Please send the remittance to Mr C.E. Stewart, W.S., 23 Castle Street at your early convenience.'

71 It was bought from David Croal Thomson, a reliable and long-standing source of French paintings, and was apparently widely accepted as genuine and praised by Impressionist specialists, including Frank Rinder, who recommended it for purchase by the National Gallery of Art in Victoria.

72 National Gallery Board Minutes, vol.IV, p.34, 18 March 1925.

73 James L. Caw, *Hours in the Scottish National Gallery*, London 1927, p.138.

74 *Ibid*, p.140.

75 Sadleir 1949, p.226.

142

1 Gauguin to Vincent van Gogh, c.25-7 September 1888; Merlhès 165, pp.230–2.

2 Examination techniques available in the Conservation Department of the National Galleries of Scotland include X-radiography, infrared reflectography and use of a stereo-binocular microscope to examine the surface under magnification. In addition minute samples of paint were taken from the edge of the surface, embedded as cross-sections and examined under ordinary reflected and ultraviolet lighting conditions. It is impossible to overestimate the importance of inter-institutional collaboration for the sophisticated instrumental analysis required for this project and without which this research would have not been possible. I am especially grateful for the enthusiasm and expertise of the following colleagues: Raymond White, National Gallery, London who carried out the media analysis using both Gas Chromatography-Mass Spectrometry (GC-MS) and Fourier transform infrared (FTIR) microscopy; Jim Tate, Kathy Eremin, Anita Quye and Lynn McClean of the National Museums of Scotland who carried out fibre identification, examined the cross sections with a Scanning Electron Microscope – EDX and Laurianne Robinet who looked at several cross sections using a Raman technique at Edinburgh University.

3 Recent research consulted includes: Kristin Hoermann Lister, Cornelia Peres and Inge Fiedler, 'Appendix: Tracing an Interaction: Supporting Evidence, Experimental Grounds', in Chicago/Amsterdam 2001, pp.354–69; Charlotte Hale, 'Gauguin's Paintings in the Metropolitan Museum of Art: Recent Revelations Through Technical Examination' in New York, 2002, pp.175–95; Jirat-Wasiutyenski and Newton 2000; Carol Christensen, 'The Painting Materials and Technique of Paul Gauguin' in Conservation Research, National Gallery of Art, Washington DC, 1993, pp.63–103; A Closer Look: Technical and Art Historical Studies on Works by Van Gogh and Gauguin, Cahier Vincent 3, Cornelia Peres, Michael Hoyle and Louis van Tilborgh (eds.), Rijksmuseum Vincent van Gogh, Amsterdam 1991.

4 Extensive contemporary documentary evidence exists detailing Gauguin's life. While constituting an invaluable resource, it is worth remembering that the artist's own words are not always accurate, contain many contradictions and should therefore be treated with caution. Only when backed up by technical analysis of the paintings themselves can we rely on written descriptions. For a discussion of how the appearance of paintings of this period have altered with reference to various examples, including works by Gauguin, see Robert Bruce-Gardner, Gerry Hedley and Caroline Villers, 'Impressions of Change' in Impressionist and Post Impressionist Masterpieces: The Courtauld Collection, New Haven and London, 1987, pp.21–34.

5 Lynn McClean, Head of Textile and Paper Conservation and Anita Quye, Analytical Research Chemist, both of the National Museums of Scotland, took and analysed a fibre sample from the tacking margin using a low powered microscope. It was found to be composed of predominantly bast fibres mixed with raw cotton. The thread count is 24 per cm in the vertical direction and 26 per cm in the horizontal direction. With no apparent selvedge edge it is impossible to establish which is warp and weft. (No cusping evident.) A standard size 30 canvas is approximately 73 × 92cm which corresponds very closely to what is estimated to be the original dimensions of Vision of the Sermon prior to the lining treatment.

6 Christensen, 1993, pp.67 noted in her extensive survey that; 'Throughout Gauguin's career, there is no correlation between subject matter and fabric choice'.

7 For a description of Impressionist painting technique see Anthea Callen, The Art of Impressionism: Painting Technique and the Making of Modernity, New Haven, and D. Bomford, J. Kirby, J. Leighton and A. Roy, Art in the Making: Impressionism, New Haven and London, 1990.

8 Bruce-Gardner et al., p.23, footnote 4; 'Lining, sometimes executed as a "precautionary" measure, was occasionally an early necessity, as Gauguin was cogently aware; in a letter of 1897 to Daniel de Monfried, he even recommends such action to remedy any structural damage incurred in the transport of his work from Tahiti'.

9 The change in dimensions is as follows: height from 72 to 74.4cm, and width from 91 to 93.1cm.

10 Keith Morrison, National Galleries of Scotland Frame Conservator, has identified the present frame as Italian in origin and dating from the seventeenth century. It is constructed of poplar wood and has a silver gilded surface with a toned lacquer finish. For a description of Gauguin's frames see Christensen, 1993, pp.88–90 and for a discussion of framing issues in general of this period see Eva Mendgen (ed.), In Perfect Harmony, Picture and Frame 1850–1920, Van Gogh Museum 1995. Relatively few nineteenth-century paintings remain in their original frames. One notable example is Breton Women in a Meadow by Emile Bernard, noted by Jirat-Wasiutyenski and Newton Jr, 2000, p.103, footnote 38. However, this painting is now in a close copy of the original frame, constructed by the Van Gogh Museum for the 2001 exhibition Van Gogh and Gauguin Studio of the South.

11 Quoted in Jirat-Wasiutyenski and Newton Jr, 2000, p.136, footnote 47; Merlhès 1984, p.284, letter no. 182, late November – early December 1888 to Bernard.

12 See Jirat-Wasiutnski and Newton Jr, 2000, Appendix B, p.207 for reference to Gauguin ironing his paintings as part of a consolidation technique; also Christensen, 1993, pp.90–1 where the use of newspaper has been detected on the surface of The Yellow Christ, 1889 [plate 100] as faint print remains visible on part of the surface.

13 Cooper 1983, pp.251 and 253, no. GAC 34.

14 Raymond White identified protein indicating an aqueous glue as the binder in a fragment of ground taken from an exposed left edge using FTIR. Christensen, 1993, pp.71–2, footnote 51; 'Henri Delavallee, a painter and printmaker who knew Gauguin in Brittany in 1886, wrote that during the late 1880s Gauguin's priming layer consisted of a mixture of Meudon White ('a white chalk or clay powder used both as a pigment and as an abrasive used for cleaning tiles and flagstones, also sometimes known as Spanish white) and animal skin glue [colle de peau]'.

15 For a more detailed description of ground layers used during this period see Voytech Jirat-Wasiutnski and Travers Newton Jr, 'Absorbent Grounds and the Matte Aesthetic in Post-Impressionist Painting' in Painting Techniques, History, Materials and Studio Practice: Contributions to the Dublin Congress of the International Institute of Conservation 7–11 September 1998, London, 1998, Ashok Roy and Perry Smith (eds.), pp.235–9; Callen 2000, p.52; Christensen, 1993, pp.70–3; Chicago/Amsterdam 2001, pp.359–63.

16 Gauguin wrote to De Monfried in September 1899; 'For the last twelve years, as you know, I have been painting on absorbent canvas and I have had to my own taste the desired colour effects and colour stability', Chicago/Amsterdam 2001, p.359, footnote 23: Joly-Segalen 1950, letter 58.

17 Hale, 2002, p.195, note 80; Gauguin's letter to the Danish painter Jens Ferdinand Willumsen from Pont-Aven, 1890; Les Marges (Paris), Paris, March 15, 1918. T. Newton in Peres et al., 1993, pp.103; Gauguin was also secretive about his painting technique.

18 Examples of paintings where sketches were used and transferred either by tracing or squaring up include Four Breton Women, 1886 [plate 24], Aux mangos, 1887 (Van Gogh Museum), Breton Boys Wrestling, 1888 [plate 50] and Breton Girls Dancing, Pont Aven, 1888 [plate 64].

19 See Thomson, chapter 3.

20 Jirat-Wasiutyenski, 1991, p.100, footnote 28; Merlhès 1984, letter to E. Schuffenecker of 14 August 1888, pp.210–1.

21 Prussian blue was used frequently by Gauguin, for example, Martinique Landscape, 1887 [plate 6] where blue outlining is clearly visible around the foliage of the trees on left. Bernard's claim that he introduced Gauguin to the pigment Prussian blue is therefore clearly false as it has been found used in paintings that pre-date the two artists working together in Brittany. For discussion of the prolific use of Prussian blue outlining see Hale, 2002, p.179 ; Newton, 1993; Bruce-Gardner et al., 1987, p.32.

22 See Thomson, chapter 3, p.55

23 Also see speculation in Jirat-Wasiutnski and Newton 2000, pp.97–101 and Christensen, 1993, pp.81–2.

24 See Appendix 1 for description of analytical method. For a comparable

study see R. White's discussion of media analysis in Vincent van Gogh's *A Cornfield, with Cypresses*, *National Gallery Technical Bulletin*, 11, 1987, p.59.

25 Identification of the medium employed in the vermilion underlayer is slightly ambiguous as Gauguin may have used a poppyseed diluent to his linseed oil which would have affected the relative proportions of the acids identified. However it is clear that two different media bound the two different red paint layers applied. Heat-bodied, so-called 'stand oils' are treated chemically in order to decrease their drying time.

26 Leslie Carlyle, 'Authenticity and Adulteration: What materials were nineteenth-century artists really using?' *The Conservator*, no.17, 1993, pp.56–60; J. Townsend, L. Carlyle, N. Khandekar, S. Woodcock, 'Later Nineteenth Century Pigments: Evidence for Additions and Substitutions', *The Conservator*, no.19, 1995, pp.65–78.

27 Christensen, 1993, p.93 points out that Gauguin insisted on using pigments supplied by Le Franc even from the isolation of Tahiti in 1890s, although he did use other manufacturers and complained about their quality Poppyseed oil was frequently used for white pigments and lighter colours as, although a poorer drier, it was known to be less yellowing than linseed.

28 For a description of Degas's practice of painting *à l'essence* see Bomford, *et al.*, *Art in the Making: Degas*, London, 2004, p.25. The technique of leaching oil from a paint layer was also noted by Newton in Peres *et al.*, 1991, in discussion of *Portrait of Van Gogh Painting Sunflowers*, 1888.

29 Christensen, 1993, pp.86, footnote 108: 'After finishing a painting Gauguin occasionally washed the paint surface, a standard practice among French painters of his time' Frédéric Auguste Antoine Goupil Fesquet and P.Steck, *Traité méthodique et raisonné de la peinture à l'huile*, re. ed. (Paris 1904), 63. Newton in Peres *et al.*, 1991, p.107, letter no 563: 'Gauguin persuaded Van Gogh to wash his paintings to get rid of the grease in the impasto: the colours would thus retain their brilliance.'

30 Rotonchamp 1925, p.251; 'It may be useful to explain that the fairly large number of colours used by Gauguin when working in his definitive style consisted of:
For blues, ultramarine, Prussian blue and cobalt.
For yellows, light chrome yellow, lemon cadmium, dark cadmium, yellow ochre, red? ochre.
For reds, light vermilion, ordinary red madder, carmine lake.
And for greens, veronese green, emerald green, green earth?
Add to this list silver white [n.b. this seems to be distinct from lead white (blanc de céruse) and zinc white (blanc de zinc)], and you have the complete composition of the painter's palette, from which browns, bitumens and blacks were totally excluded.

Gauguin had a predilection for ultramarine, chrome yellow and veronese green, that's to say for the richest tones in each colour range. He was relatively careless, in spite of what he said, about the greater or lesser permanence of certain colours and never made a serious effort to avoid ill-considered mixtures of chemically opposed elements.'

31 Newton in Peres *et al.*, 1991, p.109.

32 The appearance of the cross sections may seem to contradict the description of a thinly applied paint layer. The difficulty encountered sampling this lean surface meant that it was only possible to do so in the more thickly painted areas, usually at the very edge of the painted surface thereby giving a somewhat skewed impression of the actual thickness.

33 Similarly, Hale, 2002, p.191 noted that in *Tahitian Landscape* (The Metropolitan Museum of Art), dated to 'probably 1892', prior to the recent conservation treatment the bare canvas at the edge of the uneven original paint had been overpainted 'to make the picture look more finished and thus more salable [sic]'.

34 Hale, 2002, p.182; Christensen, 1993, p.92, 1895 description, note 152: three paintings out of the 142 examined in this study (one third of Gauguin's œuvre) had their original surface coating.
Jirat-Wasiutnski and Travers Newton Jr, 'Paul Gauguin's paintings of late 1888: reconstructing the artist's aims from technical and documentary evidence' in *Appearance, Opinion, Change: Evaluating the Look of Paint-*

ings, United Kingdom Institute of Conservation, 1990, p.27 notes that the earliest surviving unvarnished painting by Gauguin is *Still Life with Flower and Book*,1882 (Ny Carlsberg Glyptothek, Copenhagen).

35 Christensen, 1993, pp.88–90, 92–3; Jirat-Wasiutnski and Newton 2000, pp.98–9.

36 For a description of beeswax see *The Organic Chemistry of Museum Objects*, J.S. Mills and R. White, London, 1987, pp 41–7.

37 For a fuller discussion of this topic and specifically this pigment, see also Paolo Cadorin, 'Colour Fading in Van Gogh', in Peres *et al.*, 1991, pp.12–19, also K J van den Berg, A Burnstock, L Carlyle, M Clarke, E Hendriks, J Kirby and I Lanfear, 'Relative rates of fading of red lake paints after Vincent van Gogh', preprints of the fourteenth triennial meeting of ICOM-CC, the Hague, September 2005 (forthcoming preprints).

38 A minor bromine peak was detected by a Scanning Electron Microscope when sample 2A was examined at the Instituut Collectie Nederland (ICN) in Amsterdam. This suggests that it is an eosin-based lake pigment that Gauguin used, which distinguishes it from madder lake which fluoresces in a similar manner but is generally considered to be more lightfast. The author is grateful to Dr Ineke Joosten at the ICN for carrying out this analysis and also to Jo Kirby and Marika Spring of the Scientific Department of the National Gallery, London, with whom cross sections containing this pigment were examined and discussed.

39 It is fortunate that in recognition of its sensitive unvarnished surface *Vision of the Sermon* has been glazed since it came into the National Gallery of Scotland's collection. Due to the inherently 'soft' nature of the wax coating it is particularly vulnerable to the accumulation of surface dirt. Any dust resting on the surface could easily become 'imbibed' into the wax and would therefore be impossible to remove at a later date.

40 Jirat-Wasiutyenski and Newton, 2000, p.94, suggest Gauguin may have intended 'a white Impressionist frame like the one on the Cezanne still life from his collection visible in the background of *Portrait of a Woman*, 1890 (Art Institute of Chicago) or a plain wood frame, in fact a flat molding [sic],

such as Van Gogh reported they would use when Gauguin was in Arles'.

41 The author is grateful to National Galleries of Scotland colleagues, Keith Morrison, Frame Conservator and Paul Rimmer, Conservation Technician for making this reproduction frame for the photograph.

APPENDIX
Analytical Methods and Experimental Condition

RAMAN Raman spectra were recorded on a labRam microspectrometer using a blue laser at 488nm or a red laser at 632nm. The power at the sample surface was kept below 2 mw.

SEM-EDX METHOD The sample was placed directly onto a small sticky carbon stud and examination using the CamScan mx2000 sem in Envac (controlled pressure) mode using various pressures between 20 and 80 Pa. The analysis was done at a focal distance of 35mm but the images with the sample as close as possible, around 10mm. Selected areas were analysed using the Noran Vantage system at various magnifications, using both the spot mode and area.

FOURIER TRANSFORM INFRARED (FTIR) MICROSCOPY This is described in: J. Pilc and R. White, 'The Application of ftir-Microscopy to the Analysis of Paint Binders in Easel Paintings', *National Gallery Technical Bulletin*, 16, 1995, pp.73–84.

GAS CHROMATOGRAPHY-MASS SPECTROMETRY (GC MS) A summary of the gc-ms conditions is in the note on p.161 of R. White and A. Roy, 'gc-ms and sem studies on the effects of solvent cleaning on old master paintings from the National Gallery, London', *Studies in Conservation*, 1998, 43, 3, pp.159–76

THE DERIVATISATION PROCEDURE is described on p.95 of R. White and J. Pilc, 'Analyses of Paint Media', *National Gallery Technical Bulletin*, 1996, 17, pp.91–103.

143

PHOTOGRAPHIC CREDITS